IRISH
WORKING
LIVES

IRISH WORKING LIVES

MARIE LOUISE O'DONNELL

Photography by ERIC LUKE

VERITAS

Published 2019 by
Veritas Publications
7-8 Lower Abbey Street
Dublin 1, Ireland

publications@veritas.ie
www.veritas.ie

ISBN 978 1 84730 834 4

10 9 8 7 6 5 4 3 2 1

Extracts from 'The Thatcher' (p. 41) and 'Begin' (p. 76), both by Brendan Kennelly, taken from T. Brown and M. Longley (eds), *The Essential Brendan Kennelly: Selected Poems*, Northumberland: Bloodaxe Books, 2011. Used with permission.

Extract from 'Night Mail' (p. 168), by W.H. Auden, taken from E. Mendelson (ed.), *W.H. Auden: Collected Poems*, London: Faber & Faber, 2004.

A catalogue record for this book is available from the British Library.

Designed by Clare Meredith
Printed in Ireland by Anglo Printers Ltd, Drogheda

Veritas books are printed on paper made from the wood pulp of managed forests. For every tree felled, at least one tree is planted, thereby renewing natural resources.

CONTENTS

FOREWORD

Over the past few years I have had the opportunity and the privilege to spend time with people from all over Ireland; learning about their work, the sense of pride they derive from it, and how what they do every day informs who they are and the lens through which they view the world.

I broadcast their stories first on *Today with Pat Kenny*, and then on *Today with Sean O'Rourke*, both on RTÉ Radio 1.

I visited projects, organisations, places and people, travelling across mountains, through the middle of cities and towns and down the hedged laneways of our country.

I told the stories of the energy of horse fairs, seasonal farming, festivals on sea and land, motor racing, walking tours and trucking. I witnessed the boundless skill and talent of Ireland's artisans and craftspeople.

I learned about beliefs and rituals, retirement and beginnings. The tragedy of human loss. The human heartbeat of everyday life in Ireland.

But it was always the energy of the people behind these various activities and stories that stayed with me. The fresh everyday uniqueness and morning-to-evening ordinariness and extraordinariness of what people do for a living.

I told the story of occupations made sacred through unwavering commitment, courage, and creativity. Occupations that said so much about the people who filled them. The inextricable pride link that gave each one purpose and value to their lives. Their internal everyday belief in work well done, interwoven effortlessly through their lives.

Throughout the radio programmes, I tried to give the listener the opportunity to see, touch, smell and feel the reality of these working lives. What they did. How they did it. And indeed, the best question of all, why they did it, and continue to do so today.

Radio is a marvellous medium. The aural theatre of my youth was brought alive for me through the music and melody of the human voice and the spoken language of the village. The radio in the corner of the kitchen became, for a young ear, a new and safe place for this word music to find expression.

Radio is where sound sense and music sense are dominant. It is a clear and creative space for the story and the voice of the storyteller to shine and to captivate.

However, it is also a place where the clock is dominant. Throughout all radio programming, timed beginnings and timed endings curtail the best of voices, stories and experiences.

My pen on these pages has fewer boundaries. Here my time was my own and I could travel with the fourteen occupations I had chosen, like Raymond Briggs' Snowman, high above and through their worlds, without fear of dilution by any clock.

Each of the encounters is written as a moment in time. Their time.

I tried to capture their lives while they were working. I walked with them, observed them, got to know them, and stayed with them until it was time to finish their day's work, and go home.

The book is an evocation of those fourteen work experiences.

Each one is unique and has something to tell us and to teach us.

Each one made me think again about the great emotions of courage and joy. And most especially, acceptance.

Each working life I met has been a greater education than I could have imagined. An education that will remain real and lasting.

I have been extremely fortunate that the award-winning photographer Eric Luke has shared this journey with me. His magnificent images capture the grace, integrity and uniqueness of each individual. He has used his lens creatively as an extension, as a reflection and as a gesture to the writing. The eye of his camera has brought to life the individuality and the personality within each chapter. Beautifully and brilliantly.

I have tried through writing this book to illuminate the strength of all those I met, their grace of purpose and their commitment to a deep belief that it is only in the service of others you will find the best in yourself.

Marie Louise O'Donnell, 2019

ACKNOWLEDGEMENTS

I wish to thank the fourteen people whose working lives inspired this book: Frank Brudair, Lillian Cassin, Kieran Connolly, Joe Cronin, Susan Fitzgerald-Giffney, Martina Goggins, Brendan Hughes, Paul Johnson, Monica Lawless, Duncan McLean, David Meskill, Vincent Sherwin, Margharita Solon and Ricky Whelan.

I thank them most sincerely for their time, their honesty and their inspiration. In every way they are a credit to themselves and to our country.

My sincere thanks are also afforded to Jane Lehane. Her contribution remains unmatched. She has been an outstanding friend, reader and advisor throughout the process.

I wrote much of this book on Achill Island. An island I loved all my life having been born in Foxford, Co. Mayo. I thank Elizabeth and John Barrett of The Bervie on Keel Strand. They allowed me to sit for hours in their guest-house garden, beside the power of the great Atlantic and against the backdrop of the Minaun Cliffs, remembering and writing.

I would also like to extend my gratitude to Kay Sheehy of RTÉ. She gave me my first storytelling moment on Radio 1. And she encouraged me to find and produce the voice that had been hanging around in my ether for years.

The storytelling began with the RTÉ presenters Pat Kenny and continued with Sean O'Rourke, and his producer Tara Campbell. To all of them I owe great thanks.

I would like to especially thank Veritas for the publication opportunity to hold these fourteen lives on paper. All lives are sacred. Especially when their work, and what they do, has others at their heart.

Finally, my personal gratitude is extended to Angela Edghill. She has been my truest and greatest friend since we met at university. And we are both still here.

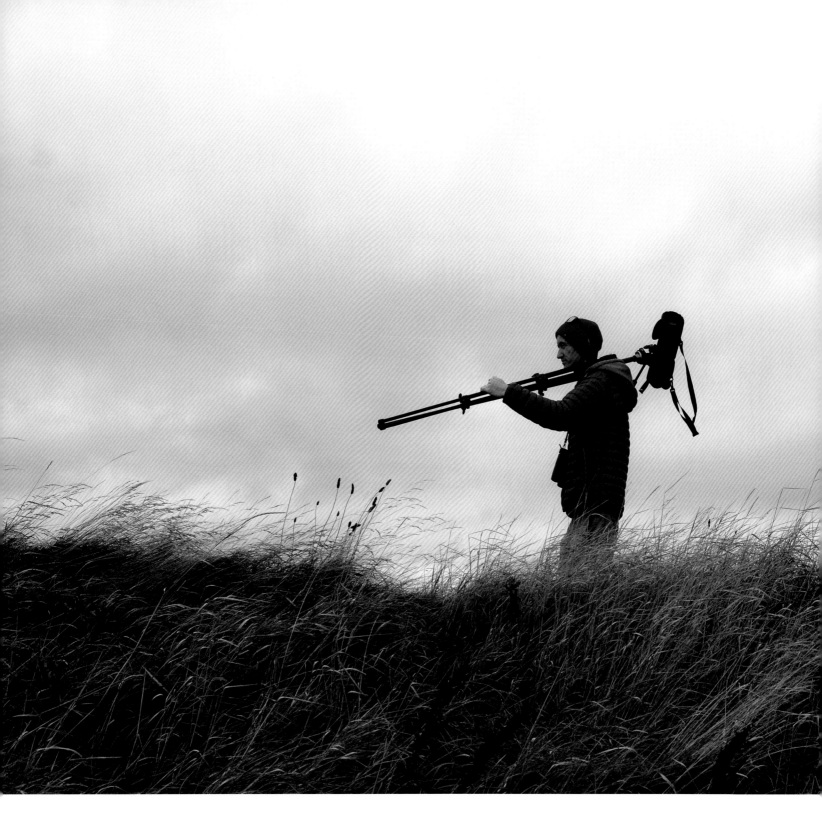

THE BIRDMAN

Ricky Whelan

ON THE WING

Ricky Whelan can see the church spire from his window, where the peregrines hang out. There's a local pair flying about early in the morning. They're courting and catching pigeons. Ricky knows there are always starlings, house sparrows and a few crows flittering about. And pigeons. The ubiquitous species that everyone hates, except the starlings. He knows that no matter where you are in the world, whatever your situation, there are birds.

The environment at Peterborough City Hospital in Cambridgeshire is homogenised, mundane and dreary, but the care is good. Ricky loves the birds. They are his friends. He has his bird book and his binoculars by the bed. The doctors are intrigued by him. They don't understand that the birds help him to remain grounded. Chemotherapy sessions have a certain silence, a stillness of self, but the birds bring him back to the outside world. The birds link him back to a sense of never-ending energy and activity. And hope.

He lies in his bed and thinks of Charlie, Ray and Mick, uncles who taught him to fish down on the Owenass River, a tributary of the Barrow at home in the Irish midlands. How to catch minnows in a jar, and crayfish and trout, and teaching him all about salmon spawn. Nature walks at school through the trees, finding nests, and looking for hares across the fields. He remembers long summer days, with jars on the end of strings, and friends Adrian and Donal, down by the river looking for pinkeens, building camps, getting stung by full bees, and bringing back wild flowers. With nobody to tell them this was this, and that was that, just drinking it all in themselves. Maybe one of the last generations to be totally free, outside immersed in nature's glory, he thinks to himself. And later Mr Murray, who was obsessed with freshwater ecology and built a huge tank at the back of the classroom. And Mr O'Connor, who gave out to him for not concentrating, but knew he loved biology and was delighted when he went on to study science and zoology at Galway University.

The leukaemia has sapped his strength, even though he is only in his early twenties, but it can't be forever and he can still spend all day peering out the window at the antics of the pied

wagtails, even around all the sickness. He always thinks of his mother when he spies the wagtails. Little bird geezers, doing their own thing and minding their own business. His mother called them willy wagtails and pointed them out from the kitchen window. She wasn't too fond of the robins because his granny believed they carried a certain symbolism of final departure. He smiles to himself when he thinks of the superstitions around this red-chested bird, who only lives for about three years. And the hawk, or what Mum thought was the hawk, hovering over in Frank Delaney's field. It wasn't a hawk, it was a kestrel. He never got to tell her. She died the year he qualified. He would have loved to share his passion and study of ornithology with her. Every time he sees the kestrel he thinks of her. It's a very rare bird. So maybe it is a connection.

He remembers all his volunteer work with the Irish Peatland Conservation Council, BirdWatch Ireland, the Irish Wildlife Trust, An Taisce, and Coillte, trying to get some field experience. And the Bird Atlas project, for which he spent months monitoring the presence and absence of certain species to build a map of birds coming and going off the island at home. He thinks of all the experience you have to build up, layers and layers of it.

He wanders around the room. Thin and weak. He stares out the window across the Cambridgeshire skyline. He had big dreadlocks when he came to work here with the Royal Society for the Protection of Birds. A wild, six-foot Irishman on their flagship reserve, Minsmere, on the Suffolk coast. He remembers his first night on the reserve. It was dark and yet he could hear the bitterns booming in the near and far.

That was the real beginning. The training and the knowledge and the leading expertise and the learning, and the exposure to everything, everything around the unique and extraordinary world and life of birds.

And then the sickness. And the chemotherapy and the bone marrow transplant, thanks to his sister, Faith.

He spends the afternoon following with his binoculars the winged courting couple flying high above the spire, and when he gets tired, takes his medication and goes back to bed for the evening.

'Do you know anything about crows?' asked Niall Kavanagh, a family friend from Portlaoise. 'I hear you studied birds. Well, there are hundreds of them roosting and nesting in the trees on the Downs, up the Stradbally road. Find out about them, and tell us about them. We can have an event around it to celebrate the Downs rookery.'

Ricky was at home, sitting in the pub drinking lemonade, when Niall asked him, asked the bald, home-from-hospital ornithologist. And so it began. And in one way he began, like in some way and at some time we all begin. He began to study the crows, counting and observing the four thousand five hundred who roost there every winter and the two hundred and fifty who nest there in the summer. He read widely on these black and dark, night-coloured birds. Studied and digested all he could about them. He made slides of their lives and detailed the seven species of crows native to Ireland: the jay, the magpie, the rook, the jackdaw, the hooded crow, the chough and the raven. He knew how crows connect with people on many levels, especially in the country where people will shoot a crow and hang it over their hay and silage bales to stop

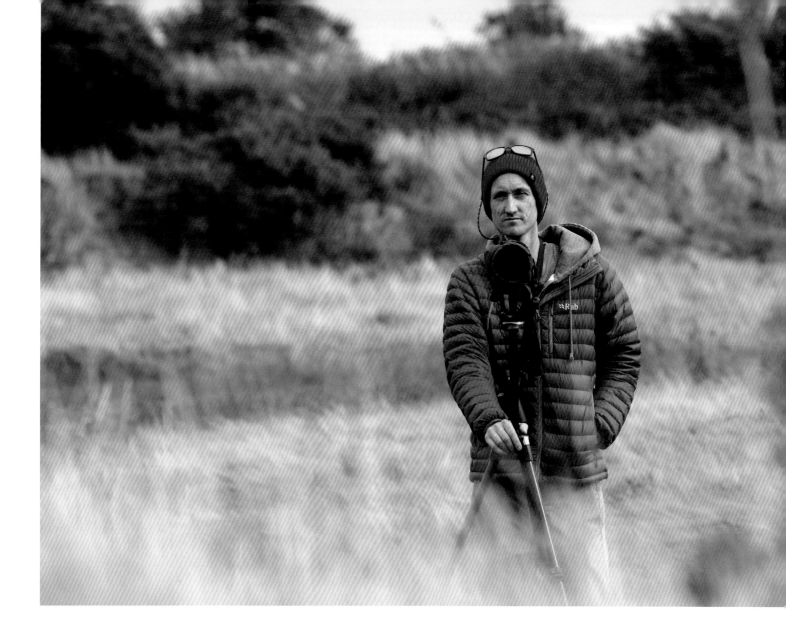

the other crows from pecking. He was aware of this basic relationship and how it extended to theatre and dance, film, poetry and the macabre. He researched and observed the characters and ecology, differences and similarities, of jackdaws and ravens and jays. He studied the brilliant social hierarchy of their roosts. They began to fascinate him. The celebration of the rookery event took place and he gave a talk about these ordinary but brilliant birds blackening the sky on the Stradbally road. Niall was thrilled.

The lecture became very popular around the country. Ricky got a job with BirdWatch Ireland and works with them today. And he still watches the Stradbally road crows and counts them every month to this day.

'Tell me about birds,' I say, when I meet Ricky on Bull Island early on a crisp Sunday morning. His hair has grown back.

'Well,' he answers, 'that is a huge question.'

He looks around his preserved universe.

'Birds are individual in form and function, in habitat and place. And in their flock and their flying glory. They have beauty of shape and colour and of song. They are one hundred and fifty million years old, descending from the flying dinosaur, and there are millions of species resident on this planet, long before we ever appeared. Many species are migratory. That means they cross borders and regions and climates and continents. Just like ourselves. Going away for the winter or coming here from colder countries to live and feed.

'Others are resident here, about four hundred and eighty species on our island, and do not leave. Just like ourselves. Birds are very good biological indicators. They are top of the food chain of worms and plankton. They will tell you what the worms are doing. If that chain is broken, they would be lost. If there are lots of birds around, it is a good sign that the ecosystem is in good shape. If you see a proliferation of seabirds or gannets or others, you know there's fish in that sea. Because that is also what they eat. They are ubiquitous. Just like ourselves. And they fly. They take off, hover and dive against the wind, alone and in formation. We cannot fly.'

I sit with Ricky in one of the covered stone shelters. It is early morning over the city. The sun is diluted, but the air is crisp with a cold breeze at our faces. We are in the centre of Bull Island on the north side of Dublin Bay. It is our national nature reserve and a paradise for birdwatchers and wildlife enthusiasts.

Ricky is content. This is his real home. I am the visitor. He sits in his world of the salt marsh, plant communities and sand dune systems. This is the terrestrial homes of birds, animals and insects, spread for miles on a carpet of mudflats, grasslands and marsh or on low-growing willows and purple gorse. We are surrounded by tides that come and go as the moon dictates, and by waters soothed and angered by the seasons. People have begun to wake and early-walk on the long wooden pathway in front of us, built out into the sea. I look around as, in the distance, both sides of the living coastline breathe in the morning, behind all hall doors. The great port of Dublin sits behind the Bull Wall. It has been there for two hundred years, but so too have the landscape and the birds. How can such a bird sanctuary sit alongside such port progress, I wonder?

'It has to,' answers Ricky. 'Dublin Port has huge responsibilities and is working with BirdWatch Ireland. Economic progress can bring in all the cruise ships it likes, but they must know about how the birds will be affected. This is a bird world here. Thirty thousand wading birds will arrive from all over the world and roost here on Bull Island. The variety is outstanding. Their species and lives must be preserved, and we must understand their dependency on this environment. It is my job to try and achieve that. I count, catch, tag, observe, preserve and I educate. I am involved in all surveys across the bay in my capacity as an ornithologist, and as a project officer on citizen science, which is research and data collected by volunteers. To preserve we must understand our bird population, especially for our coastal birds and our international species.'

A big group of black-and-white oystercatchers with long, heavy, carrot-orange bills swoops by. They skim along the water as though below the wind, like young flying acrobats.

'They've come down from Scotland and will breed here,' says Ricky. 'It's the start of autumn, and many birds are on the move. They'll come from Iceland and Arctic Scandinavia for food because there are fewer predators and it's milder here. The oystercatchers are a long-life bird and can survive for forty years.'

A large, fat, full seagull waddles boldly towards our seat, as if to join our conversation. It is fearless and flat-footed. I am terrified of its hard, snapping beak. I recoil, but it continues to approach unperturbed. I swoosh it away and it reluctantly rises off the ground and joins a chorus of its friends in the air, who have been hovering and watching our behaviour.

Ricky laughs to himself.

'That's a black-headed gull,' he says, 'and there's a herring gull behind it. They're quite big.'

'They're enormous,' I reply.

'Well,' he suggests, 'there is an upper limit as to how big a seagull can get. If you look at the tags, we know some of them fly to Cornwall to fish for discards, and fly back to a roof in Dublin to rear their young. Whereas others go down to Tallaght for a bag of chips, or follow us this morning in the hope of a Danish pastry. When they are attacking you walking out of the fast food outlet, it is because they have a little fluffy ugly yoke up on a flat gravel roof, a perfect habitat for a breeding gull all over Dublin. The roofs are warm and protected, with no predators apart from the odd peregrine. And they have food at their will. Why wouldn't you commandeer it? Our answer

to everything as humans in this country is to cull. It's the same with badgers. Let's not look for any alternatives. Let's load a weapon.'

I am well silenced. We begin to walk down the long path surrounded by shore rocks and the wide expanse of the bay. The sun is beginning to come through and the air has warmed a little. At our feet as we walk, there are hundreds of little brown birds fussing around the rocks. They move in and out of the crevices and uneven spaces, chatting and coiffing as though they have loads to do and much to say, like a young political meeting full of interrupting opinions.

'Juvenile speckled starlings,' says Ricky. 'They're very urbane. Starlings are a remarkably successful family of birds. There are many species, but ours is the Eurasian starling. In the summer they find their mate and breed anywhere from a space in your fascia to a hole in a tree. They nest semi-colonially and like to have other starlings around. At the end of the summer, juveniles and family groups begin to come together in groups and roost on power lines or in trees. And they will begin to grow and grow and grow. By October, they will become a murmuration.'

'I have seen such a spectacle,' I say. 'In Limerick, on the Croom to Ballingarry road, on an early autumn evening. I stood under gigantic flocks moving in unison like a global net making creative and imaginative shapes in the sky. I heard millions of wings sounding and echoing as they ascended and descended. I watched a sky spectacle of a mathematical black rain dance. The murmuration of starlings must be one of the greatest moving winged landscapes of the bird world. Hundreds and thousands turning and twisting, bending and winding as though they were one. They are

what the great artists call order and freedom, all at once, the stuff of creativity. Except this time the canvas was the sky.'

'Yes,' Ricky replies, a little bemused by my layered description. 'It is a hive mind. They follow the nearest bird. The real spectacle is when a sparrow hawk or a peregrine decides to have a go at the entire flock and the flock bursts out in an instant, scattering the middle of the murmuration across the sky.'

'And in the evening,' I continue undeterred by his knowledge, as though he has never seen this sight, 'hundreds of thousands of them drop down into the trees … Whoosh … and they're gone.'

'But if you're living under a starling roost, you mightn't be as keen on them. In fact, you'll need a power hosepipe after they have gone,' he laughs as he walks down the path.

There are hundreds of birds on the shore. Black and silver dots across a mile of sand. All at an eating party. The gulls are the most vocal. A curlew fishes in the distance, its elongated bony legs wading and paddling around in the muddy sand. It has a long, odd beak, like a sword with a bend in it. It casts its huge eyes around and then dips its head, the sword-beak disappearing down into the sands in search of molluscs and razor worms. It swallows them whole.

'They're a wader bird, meaning they cannot swim,' says Ricky. 'Curlews wade in the mud and wet sand. With their powerful hearing, they can hear the worms under the sand, but their eyes on the side of their heads can be limiting.'

'They are my favourite bird,' I say, maybe because of their misshapen heavy beaks and how they carry the load with such grace.

'And in danger,' continues Ricky, introducing the first note of worry. 'The breeding population has collapsed by 90 per cent. There are now only two hundred breeding pairs in summer.'

'Why?' I ask.

'Because up to five or six years ago, it was permissible to shoot a curlew. Because of the intensification of agriculture, they are in danger, like the corncrake and the hen harriers. Because of mismanagement of upland burnings, because of our abandonment to commercial forestry. I might not worry so much about curlews, but I do worry about yellowhammers and farmland birds and finches that would have happily existed on a low-intensity farm forty years ago.'

'Are we not paying attention?'

'No, we are not,' he answers. 'BirdWatch Ireland is, as are many other wildlife organisations. We are mono-culturing the diversity out of the countryside. All species need diversity. That is how they survive, everything from the bugs in the ground to the kestrel.'

'We are doing it to ourselves in every village and town,' I suggest.

'But the birds cannot protest,' he answers. 'In all of our lives, all nature should be protected. Totally. I do not distinguish. The birds, the flora and the fauna, the beavers, the slugs and the butterflies are all our universe. By protecting one species, the apex species in that ecosystem, you are protecting everything right down to the bugs in the ground. They all need each other, feed off each other and live by each other. If you destroy or neglect one, others will suffer.'

A great raucous call emits from a small pointy sea bird.

'That's the common tern,' says Ricky. 'It winters off the west coast of Africa, and comes in early

summer when our seas are full of fish. And there's the brent geese who will arrive in their thousands from Arctic Canada. They fly across the Atlantic via Canada and arrive here this time of year. They eat that Zostera eelgrass.'

I look down at the green algae, which lies like a fermented seaweed covering below.

'They will hoover all that up,' continues Ricky, 'and then move to common grass, and end up in parks and pitches and roundabouts. Dublin is the only capital city that has habituated them to live with humans.'

I have forgotten for a moment that I am part of the land created and populated by humans. Birds in the air, on the rocks and sitting on the sea, it is as though our worlds have been reversed. We walk over to the south lagoon. Birds gather with their bellies full and are beginning to roost, and will not move until the tide is full. Ricky points out the grey plovers who stand on the sands with big, black protruding bellies, facing into the wind. His favourite, the clever hooded crows, drop mussel shells on concrete to open them for feeding. The redshanks with long red spider legs wing in from Iceland and will leave in March. I look through the binoculars and can see the blue and yellow tags on their legs. Ricky knows where they have been. It is their passport. An army of bar-tailed godwits dives quick and fast and down to roost at the sea shore. The swallows swoop and swerve around and above our heads. Winter waders arrive at the international bird airport. The dunlin, a small wader, lands from the Arctic Tundra. Unnoticed.

'How do you know what all of these birds are?' I ask, looking through the binoculars at thousands of birds, all colours and shapes, soaring on the wing and fluttering as they land.

'I know from years of observation, reading and study. I know because of their actions and characteristics. I know a bird by where it is living, what it is doing, what time of the year it is, what habitat it has, how it flies in the air, how it lands. You learn this by field craft.'

We walk to the end of the island. The cormorants sit out on the line of rocks. They are like great dark oily vases, preening themselves, and watching each other under the sun.

'Birds replace their feathers once a year before and after migration. They are constantly grooming,' says Ricky. 'And when it comes to songs and voices, the male bird is more vivid to attract attention.'

'Can you identify birds from their sound as well?' I ask him.

'Ninety per cent of surveys can be done by sound,' he says. 'The tree-top canopies and leaves develop the ear. You cannot learn it overnight. All species can be identified by sound. The one hundred and fifty song birds can be guttural and raucous. The thrush repeats a note three times. The starling is a mimic, the robin a winter singer, the herring gull a sound of the sea-side. The scream of the swift indicates summer; the cry of the curlew is always mournful; waders have a sweet, high sound. Did you know that birds have accents? The wren in Dublin and the wren in Poland have a different sound.'

'What is that bird?' I ask as a miniature fighter pilot nosedives past my head. 'Is it a swallow?'

'No,' he says, 'it is a swift. The world bird. Another of my favourites. He's very late leaving. This bird will go to the Congo Basin to feed for the winter. When it is here, it nests in cracks, trees, crevices, masonry, old roofs, tiles and churches.

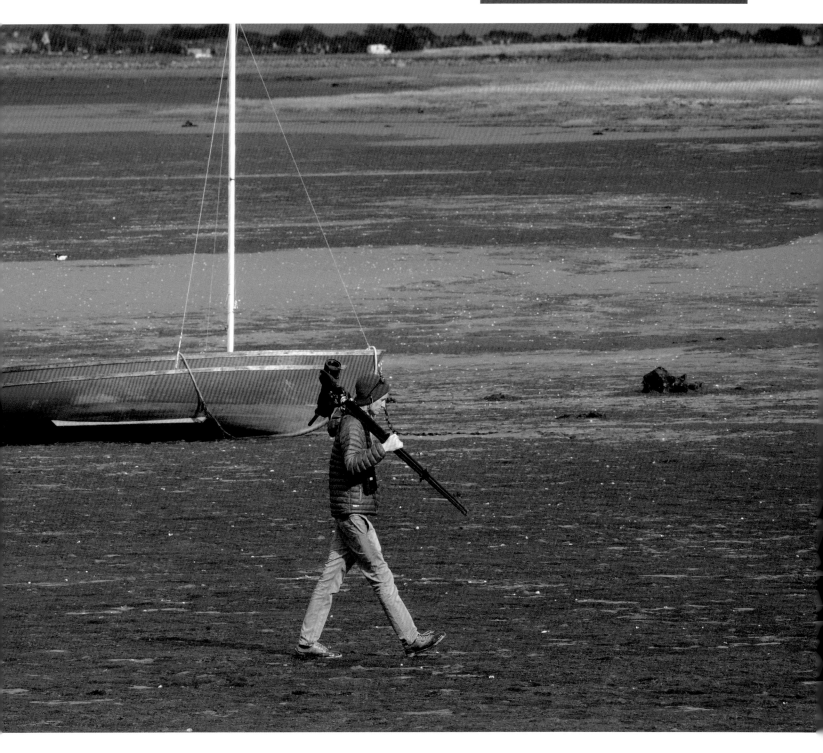

But it is losing its nesting sites. The swift is 40 per cent in decline.'

This is the first time I have seen Ricky getting angry.

'We have a conservation project in Offaly to try and reverse this. What this bird is capable of is truly extraordinary. They live their entire life on the wing. Can you imagine that? After they fledge they do not land until they breed. They mate on the wing. It is the only group of birds known to do that. They drink on the wing, skimming the water on a river or lake. A fifty-mile commute for a swift is nothing. If they see inclement weather coming, and they know they won't be able to feed because of the downpour, they'll just stay ahead of it or fly above it and above the clouds. If we see swifts in Clondalkin on some Monday afternoon, they could be breeding in Abbeyleix. And they've just come up because that's where the weather has driven them and that's where the insects are. They are incredible creatures. They sleep on the wing by switching off one side of their brain at a time, switching to autopilot, flying around in a circle overnight. And they carry their faeces away from the nest. They need to be on a list of incredible species, not threatened.'

We walk back in the midst of this winged world along the path to our first shelter. Ricky is pleased with the day. The weather has held. Birds don't like bad weather. They don't like to venture out and have to hide in bushes and trees and hedges to preserve their energy. It's only the ducks, geese and swans that don't mind. Today is a good time for bird-watching, as the birds are not tied to nests, and are active all day. Summer is for nesting and babies. They live by the seasons. We live by the calendar.

'We are a hundred years behind and failing wildlife in this country,' Ricky says, with a bravery I sensed when we first met. 'Our natural environment should not be looked after on the edge of someone's desk in the Department of Culture, Heritage and Gaeltacht, where it now resides. That is not good enough. The National Parks and Wildlife Service, which is responsible for wildlife and habitats, should be at the core of the Department of the Environment. At the moment it is not. Conservationists must be listened to. They have scientific knowledge, they don't stop progress, and they offer solutions. Advertising and marketing companies with absolutely no shame are allowed to make millions using the murmuration of starlings for telecommunication advertising, gannets and puffins for Skellig Michael and other great species for the Wild Atlantic Way. But not one penny of their profits are directed to BirdWatch Ireland or other wildlife conservation organisations. That would be interesting legislation. If you use our wildlife to advertise, market and profit, you must pay a percentage to that trust. That is not on any political agenda. They don't even know they are doing it.'

'I suppose we think we are the rulers and commanders at the top of the tree,' I venture.

'We are not,' he answers. 'Ornithology has taught me that. It has given me a certain perspective and consciousness about my surroundings and my impact on things. Every day it leaves me in awe. I just feel this profound responsibility because of that. In hospital when they asked me what I did for a living, I said I'm a scientist, because if I said ornithologist, they would not know what it meant. I'm very proud of being an ornithologist. I think of it as a normal job. Protecting the environment.

In twenty years' time, if a child asked me, "What do you do?" and I replied, "I'm an ornithologist" and their reaction was, "Cool, you look after and protect birds. I want to be an ornithologist too," that would be serious progress.'

'Are you philosophical about your illness?' I ask Ricky.

'Most illnesses can be cured, eradicated or controlled,' is his philosophical reply.

We sit in silence looking at the birds fly and glide. The light is just beginning to fade and the birds have things to do and places to go before the evening draws in. He breaks the silence.

'If you told me in the morning, everything is being covered in concrete, and asked me what I wanted to save, I would say without hesitation, the Owenass River. The Owenass River. Because that is where I caught my first minnows and my first trout. That is where I went with Dad and Granddad and my uncles, and that is where it all began. I could have the choice of saving the Zambezi rainforest, but I would choose the Owenass River. I was always a bit of a hippy and into nature. My wife, Claire, knew that when she met me. Our first child will be born in November. More wonderful awesome nature. Wonderful, truly extraordinary nature.' ●

Ricky and Claire's son, Art, was born on 22 November 2018.

THE EMBALMER

Joe Cronin

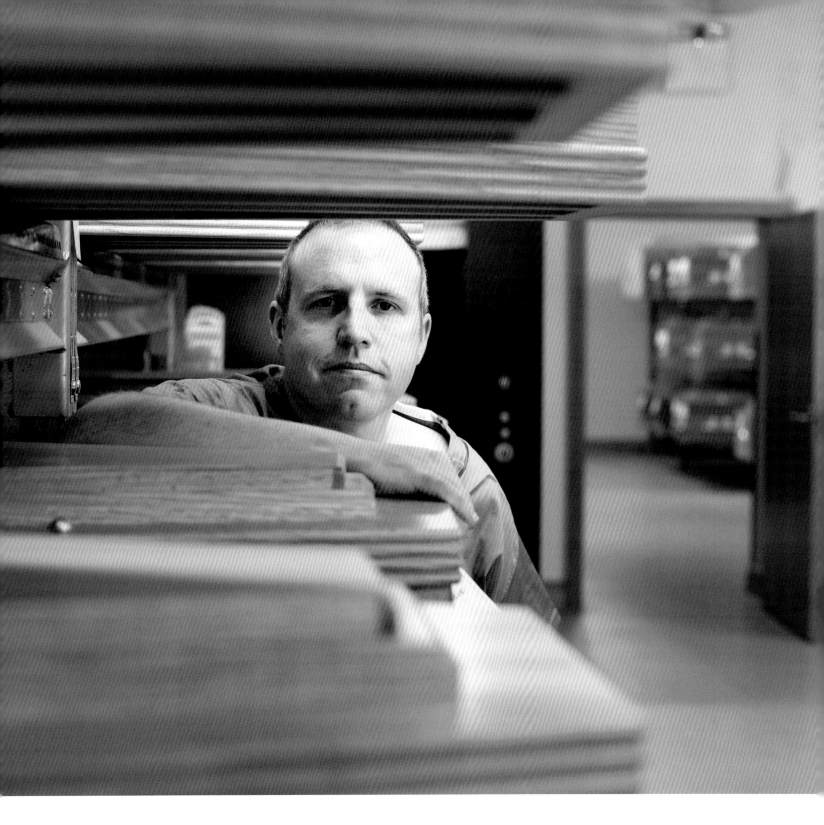

THE LAST LOOK

'Dignity.' He began with one word. 'Dignity. That is what the dead deserve. We are servicing the living and we must keep our promises to them.'

David Fanagan, the Director of Fanagans Funeral Home, has an aqualine profile and speaks with a rhythmic order to his sentences.

'We are one of the oldest funeral homes in Dublin,' he continues, taking a mahogany seat by the Victorian window of their premises.

'It has been our family business on Aungier Street for over two hundred years. We originated in Cook Street, then called Coffin Street because everybody made coffins there, delivered them, removed them, looked after them, and the idea of a funeral director was born.'

He relates his family's story with the same purpose and pace with which he had climbed the stairs.

I do not reply. I am conscious of this eternity dialogue within the strange nature of an upstairs parloured living room. It is yellow-walled, proportioned and carpeted; graceful and unrushed. Like the funeral director. A room where maiden aunts with solid cordial faces might have sat on solid furniture, staring at the fireplace, lamenting loves lost, speaking quietly, while offering tea from the good china and visitor sandwiches with the crusts cut. Despite the warm and comfortable atmosphere, I have no way into the ritual of funeral information, so easily related by the funeral director.

'Most people are arranging a funeral for the first time. They do not know what to do. They are in a kind of childlike haze between hospital, nursing home, church, cemetery, paper, obituaries and RIP notices.'

His delivery is succinct and factual and his solid professionalism echoes the order and warmth of the room.

'Why do you want to meet our chief embalmer, Joe Cronin?' he asks.

'I want to find out what he does and how he does it,' I say.

'That's unusual. It is not to everybody's taste.'

'I know but I'm interested,' I reply.

'Well, he certainly has very unique skills. When a person dies, the body assumes the same

temperature as its surroundings. It would be very difficult and upsetting for people to see their loved ones deteriorate. A body must be preserved to save them that trauma. The embalmer provides dignity to the dead, and his skill allows the body to be viewed as families would want it. The ritual of death is certainly about loss, but it is also about not sanitising it or hiding it. Embalmers help people to accept the dead and to grieve.'

'I don't understand being dead,' I say quietly.

He doesn't answer, but just looks at me with a silent sigh. He rises, without warning, from his chair.

'Maybe the embalmer will be able to help you. I'll get Joe for you.'

When he closes the door, I hear the echo of the handle clacking, and the pad of his footsteps fading back down the stairs. Through this echo I am reminded of all the funerals and wakes I went to as a child. Bodies semi-raised in the lace-lined coffins. Old men with tweed caps on one heavy knee, tea and over-buttered soda bread piled high on floral-patterned chipped plates, and the low-lying choric hum of the sorrowful mysteries in the corner. But today I am no longer a child looking through the country town window. Today I am older, more worldly, and yet full of nightly dark terrors.

The door opens. A young man walks in. He is strong, stocky and solid.

'I'm afraid of death,' I blurt out, as I shake his hand.

I have forgotten to introduce myself. It is as though I have known him all my life and therefore have a right to dispense with all the manners of meeting for the first time. I let him in, without discretion, on my darkest secrets of the night.

'There is nothing to be afraid of,' replies the broad-faced and mannered chief embalmer. 'It is as easy to come as it is to go. Sure, we are just flesh and blood, and we are all going to die, no matter nor despite what we do. You are no different. There is no need for unease or fear.'

'Everybody says that, but I am terrified of the nothingness.'

'The nothingness! That's an interesting way of describing it. But no matter what language you put on it, nothingness cannot hurt or terrify you. Death cannot hurt you. Neither can being dead, and certainly a dead body cannot hurt you. I leave that to the living.'

He laughs to himself as he opens the door.

'But are you not frightened of the whole process, the awfulness of it? The darkness?'

'How could I be frightened of any of that? In fact, I have learned a lot from the dead.'

'Learned from them? What have you learned?' I ask.

I feel I am holding him up, making him stand uneasy in the doorway, because of my own fears and my inability to take in the awful infinity of what he does.

'I have learned a very simple truth about the necessity to live and to take care of ourselves and each other. Captains of industry, or wealthy men, or people of social status who have done great deeds, or those who are well-known and celebrated, or tramps on the street who have nothing, when they are dead, are all the same. Imagine that. All the same. It's the only job in the world where that is a guarantee. It is very enlightening, freeing, in fact. The dead have taught me that we are fragile creatures and nobody ever knows what is around the corner. Death is the great reality. I believe it is

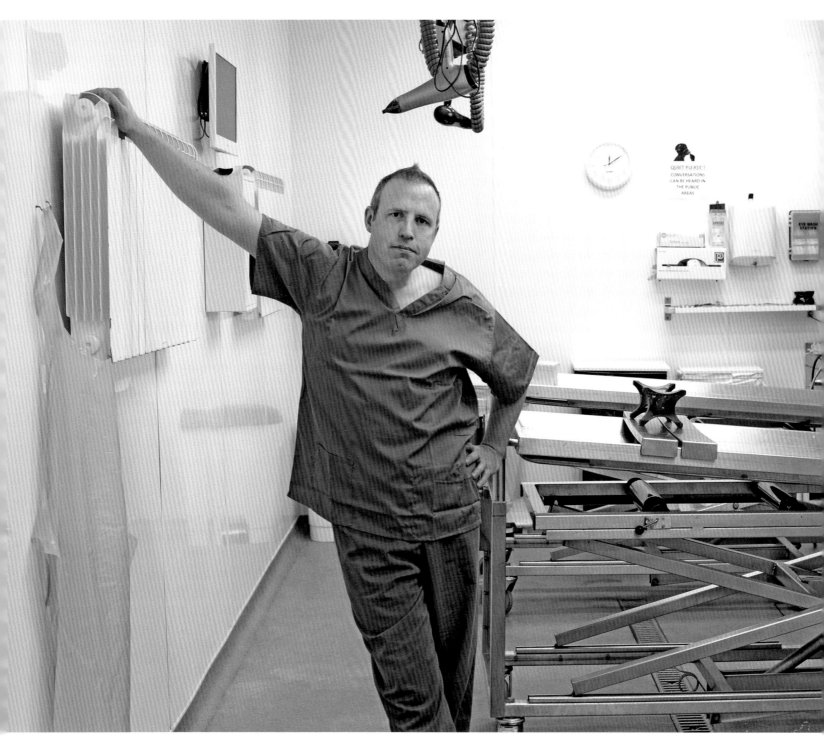

the only one, and the greatest truth-teacher of just what we are. We are nothing outside our spirit and breath, nothing. When we die, we cannot, and do not, come back. Death is the authentic lesson against self-pride. It makes a huge fool of pride. If we were to think more mindfully of how minuscule our decisions really are, when compared to being on a cold marble slab, we would make much better living judgements. Sometimes we do not respect life, and we take our happiness, our freedom and our health for granted. We should be more observant of our own lives. Saying goodbye to the dead is not the same as saying goodbye. We must love people in the living years. That is what the dead have taught me.'

We begin to descend the three flights of stairs into his world.

'The dead can also be very clever,' he says. 'They can tell you great truths about the living.'

'How do you mean?'

He pauses on the stairs, but does not turn around.

'Neglect. A dead body can tell me whether or not it has been neglected, when it was alive.'

'Is that upsetting?'

'Yes, it is.' He pauses again but still does not turn around.

'Especially with the old.'

He is quiet. I follow this thirty-eight-year-old Mayo man down the final steps into his small office, adjacent to his embalming suite. The office is plain and tidy, with no clutter of pictures or gadgets, pens, pads or ornaments.

Joseph Cronin is from Ballina, on the Crossmolina side. As a young man he was very influenced by an embalmer named David McGowan who had studied in America and had come home to set up a funeral business. Joe became aware of his skills and his particular expertise of reconstruction. He learnt from David McGowan that this skill was the greatest and final gift anybody could give a bereft family.

I feel that I am in the company of somebody dignified and special. I calm down and begin to cut through my own personal fear, and to find out about his distinctive profession.

'What does embalming actually mean? What does it entail?'

'Embalming,' he answers with ritual intonation, 'is about the preservation and presentation of a dead body.'

'That sounds very mechanical.'

'Well … it is and it is more than that. What I do is prepare, preserve, sanitise and present the dignity of the deceased to a family. I do this so that loved ones who die can be viewed, and the family can grieve.'

I watch him as he speaks, filled with a certain incredulity that he can be so contained, even joyous, among such loss and death-eternity. He seems so at ease working with the end of life. Can he possibly sense what I am thinking?

'We are just creatures of the earth,' he says, 'like any other creature. Our body is a machine. I work with this machine in a shut-down form. I am not a martyr or a great person. I do my job, which is caring for the dead. I have embalmed eighteen thousand deceased, and every individual had a story.'

'What kind of stories? How can you tell their stories?'

'The dead are lifeless; they are in a different state. But all the dead tell a story. They tell it through their muscular form, their bone and

sinew, their face and hair, their hands and their body structure. Faces of wear and tear, smokers, drinkers, hard and soft lives, lived well and lived badly. The human form is a majestic form. It operates like a machine. We cut and we heal. We are operated on and we heal. We are so fragile and we are so strong. I have seen every type of body story. As a race, we are getting bigger, while cancer and hardening of the arteries is becoming very prevalent. I can tell whether people have looked after themselves or not.'

'What happens when people die? Will I know I am dead?'

He leans forward, graceful and gentle. He leads off with the physiology.

'I do not think you will. But I will know whether you are dead or not, because when the body dies, the internal flora starts to decay and to turn in on itself. With no oxygen and no resistance, the body decomposes of its own accord. All bacteria get a day out. I am the enemy of this day out, this bacterial holiday, this decomposition.'

'What do you have to do to stave off such decomposition?'

'There is a process called "aspiration". Come, I'll show you.'

Joe Cronin pulls back the large, heavy door of the embalming suite, a room for his sole use. I cannot breathe. I am afraid to go in, but it is quiet and spotless. It is like an operating theatre with its sinks and machines and stainless steel instrumentation. On the white-tiled and ice-cold walls are maps of the body's venous system and arterial diagrams.

Sharp-pointed instruments hang loosely from the wall just above the long, muted silver steel tables.

'What are those hooks for?'

'They are aneurysm hooks and implements I use to raise arteries and elevate emaciated features. When someone dies, I take in the body from its brief time in a cold room, and I undress it. First, I assess the body and then it is cleaned from top to toe. I release the body's blood and replace all fluids with formaldehyde through the raising of the common carotid artery. This spreads through the cardiovascular system, which replenishes, rehydrates and preserves the tissue. This is what is known as the aspiration process. The hair, face, make-up, teeth, nails, hands and eyebrows are also attended to.'

His knowledge of physiology and the human anatomy is immense. He has honed his embalming skills in England and America. He begins to speak to me about the brains of smokers, indicated by black threads around the brain mass and a hardening of arteries and fat around the heart. As he is speaking, I follow with my eye the route of the thin, twisting tubes, moving like mustard eels in and out, up and down, between tables and shelves. I notice used candles dotted around the high shelf borders, their black stubby wicks a reminder of flames once lit, now extinguished.

'I like to listen to music,' Joe says, as we pass a lone radio on a short shelf. 'These are all my personal items.' He moves around his domain with a steady, dignified walk, picking up the instruments and items of his profession and pointing to the tools that craft out our eternities.

'My gown and items of personal protection, my boots, my surgical scrubs, apron, head visor, mask and my final examination gloves – all these are essential. You can get an infection from the dead, if the dead themselves are infected. My gloves are my barriers, both psychological and physical.'

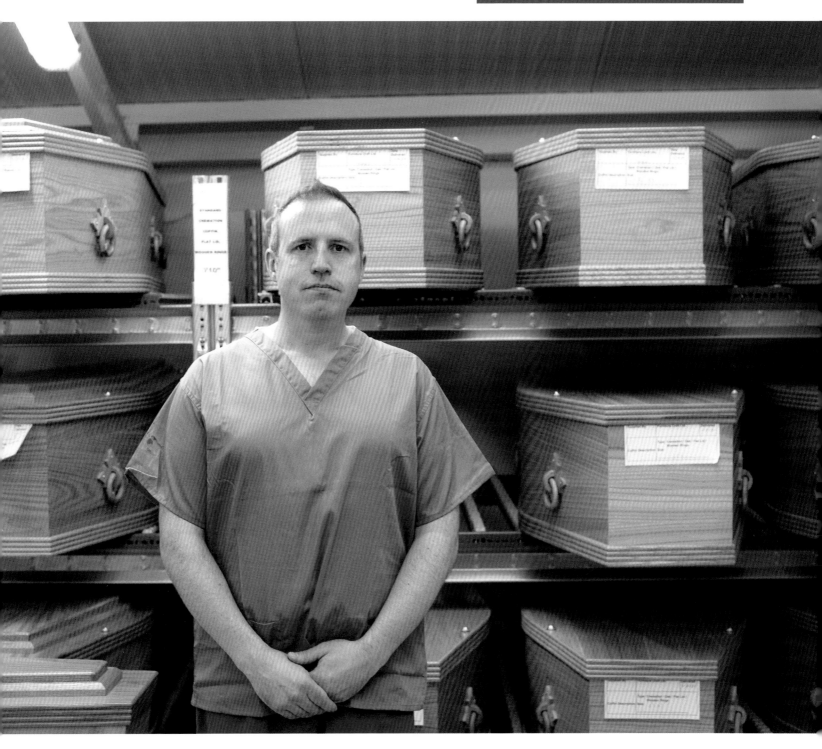

'Do you need barriers? What kind of barriers?'

'Yes, yes, you need barriers. I do not get involved with the dead. My job is objective, with respectful attention to detail. I do not pat their heads or hold their hands, or rub or caress. Regardless of the death trauma or the individual's age, I will do my job professionally for the family. All dead bodies should look restful and beautiful. They should be outside suffering and exude an aura of painless peace. I dignify death. That is my job, nothing more.'

'Do you spend a long time with the deceased?'

'I spend as long as is necessary.'

'Tell me what it feels like to touch all those dead bodies every day.'

'It does not feel like anything. I do not feel anything. A dead body does not have any feel. It does not matter how much you touch it. It is cold forever. The dead are empty. They are not with the embalmers when we are working. The dead cannot have any feel for me. We are so linked to our bodies. We forget that when we die, that link is broken for all time. When I deal with the dead, I am seeing living human beings in a completely different light. When that life link is broken, it is my job to give the dead, whether they are old or not, whether they have had a good life or not, whether they have lived life well or not, a respectful farewell, since they cannot look after themselves.'

I have stood beside and heard the coffin farewells, repeated and mumbled in homes and funeral parlours. 'He never looked as well.' 'All the pain is gone.' 'All suffering spent.' 'Just marble.' 'Sound asleep.' 'Ah, she would have loved this, looking so well, and everybody here.' The funeral observational ritual of seeming alive and well bringing ease and comfort to those left behind.

'What about the death of children? How do you cope with those tragic deaths?'

'I won't speak about the death of children. It is too difficult. Whatever the age, the embalming process is the same. All I will say is that I recognise everybody as a human being. I always ask myself the same question. Did I do my best for the deceased? Did I give my best? Care is my profession.'

I stand by the white wall.

'Joe, why do you do what you do?'

He answers me without a hint of hesitation.

'I do it because I love my work. The atmosphere around the dead is always and ever serene, graceful and painless. It may be difficult for you to understand, but my work allows me a personal peace. I rarely ever experience this peace around the living. I even miss the deceased when I go away on holidays. At work, I am never in a state of anxiety, and I never go home agitated. The dead give me such a sense of comfort. I am privileged not to see the death process. I deal only with the dead. I am privileged no matter what the death task requires. It is not for everyone, but the silence is comforting. I never forget a name. The dead need my best. The dead depend on me.'

'But what about the everlasting darkness?' I ask once again, knowing that our meeting is coming to an end, and I am anxious to get some final easement to my greatest fear.

'There is no darkness,' he replies quietly. 'There is no darkness. Lifelessness has no colour, no breath, and can have no fear. Fear is all in our world and created by the living. Death is just the end of our life as we know it, on this planet. Nothing more. I am the person you meet when life has finally ended. I am your final exit. I am your last look.'

It is time to leave. I say my goodbyes, and I watch Joe Cronin walk away down the corridor. His gait is ordinary, but I know that *he* is not. I want to stay around the comfort, the attention and the depth of understanding that he exudes. I want him to shepherd me into the forever darkness. It is always other people who die. It is never you. I want him to help me experience what it will be impossible to experience. My own personal contradictions and terrors seem, if only for a moment, pacified by what I have learned, from the remarkable wisdom of this young man.

I re-enter the world of the breathing city. The street is alive with anticipation. I'm back in the push and shove of commerce and profit. I am part of the inhalation and exhalation of thronged, peopled pathways. Living lives. I'm one of them. Purposeful, or maybe even pointless, everyday pathways of one foot in front of the other, and no time for words everlasting or eternal.

The embalmer hadn't much time for words like those either. He never mentioned them. He didn't need to. He saw his job as a kind of elevation, a preservation around a physical ending for us all as human beings, and for those left behind in memory and loss. A kind of getting ready for a new and very different journey. The embalmer will meet us all sooner or later on that journey. And if we meet Joe Cronin for our 'last look', we can be assured of that elevation and dignity. ●

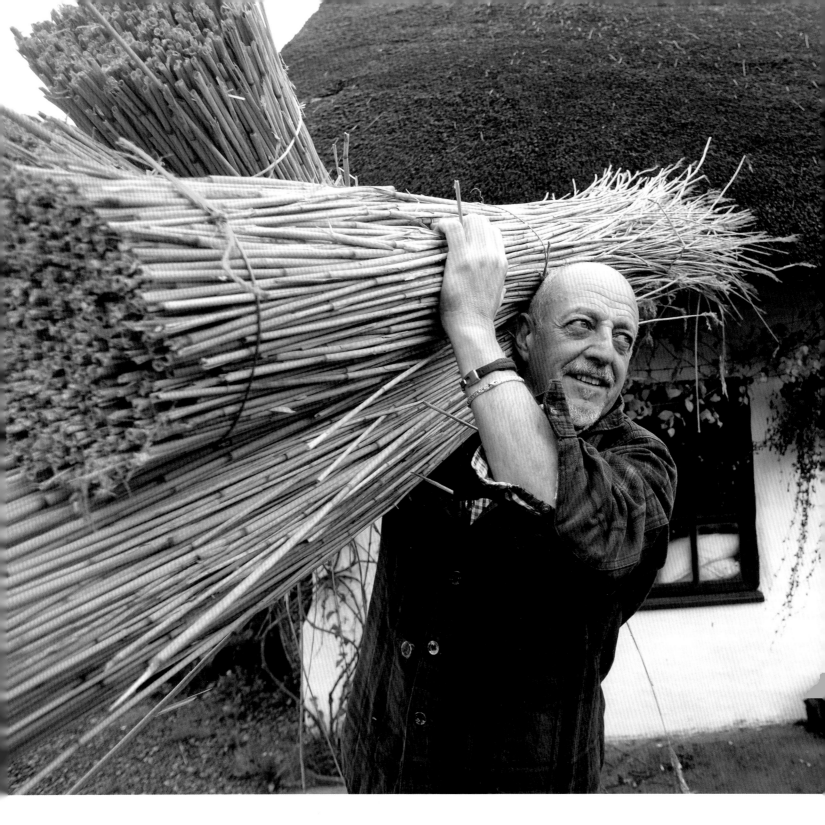

THE THATCHER

Paul Johnson

A ROOF OVER SOMEONE'S HEAD

I was sitting in Kinvara, Co. Galway, in a small café looking out the window. Waiting. It was a fresh, light-sun morning in early spring. I was thinking about my life, and whether it had any impact on anything at all, considering the power of nature and our bend to it. A jeep pulled up outside the café window and a tall, thin man got out. He looked like a craftsman. His hair was cut tight to his head, he carried no weight and his face was chiselled and weathered. He had large leathery hands. But when they shook my hand, I knew by their feel that they were still supple and expressive. Meaningful.

'I'm Paul Johnson, the thatcher,' he says.

'That's a powerful job,' I reply, thinking of my previous cold-tea thoughts. 'You are rare and your skill is rare.'

'Rare, am I?' he replies. 'I've never been called that! Come on, we've work to do,' and he laughs as we leave the restaurant.

We drive down the road and out of Kinvara for a good few miles before turning up a long, low-hedged side road. Standing in the distance under the now-breaking morning sun is a golden roof skirt in the making. The beginnings of a thick, buttery crew cut for a roof. A big-bottomed hedgehog settling down for the comfort of a day in the sun.

'Isn't that some sight?' says the thatcher, pulling up towards the half-roofed house. 'This is a great house to thatch. The roof is very perpendicular and pitched well.'

We sit in the jeep looking out at the roof's thick and wide straw hat in the thatch-making morning.

'It is some sight,' I answer. 'It's as though it has emerged from a golden earth. You might call it nature at work through men's hands.'

'And what hands!' he replies. 'Centuries of hands, centuries. My grandfather's house was thatched in Knockbridge, Co. Louth. I remember seeing photographs of myself as a young boy, sitting outside these old thatch houses. Thatching must have been evolving in my subconscious. There used to be a celebration in Dundalk during the Maytime festival and it included pavement art. There's a picture of a thatched cottage drawn

by Paul Johnson, aged ten. I spent my summers stacking ricks of straw out at Fagan's farm in Cooley. So I had a connection to nature, I suppose, from that early age.'

'Is thatching a special connection to nature?' I ask.

'Oh, it's more than that,' Paul replies. 'To put a roof over someone's head is a very noble thing to do. It is a respectful occupation. It has a deep connection to my psyche, to my Irishness, and to my family. People love thatch roofs. Talk to any of the Irish who have had to emigrate. They'll remember a couple of things: a pint of Guinness, Tayto crisps, the Dubliners, and the thatched roof. All the classical stuff. I am one of those people. When I'm up on that roof, I'm disconnected from everything. I'm just plugged into nature. Into my architectural heritage.'

The thatcher has had a long road back to his own thatch roof. He qualified as an electronic engineer and was working in England on the M40 every day just like 'a trolley of other people'. He played bass in a rhythm and blues band called The Wang Wang Doodle Band. The drummer in the band, Perry Smith, was a master thatcher. Paul began to spend time with Perry in North Oxford, Buckinghamshire, Aylesbury, Oxford, the Cotswolds and Devon. He learned the trade of thatching over the next five years.

'The English have a different attitude to a man putting a roof over your house,' says Paul. 'For them, it is a noble trade. They take great pride in their rural villages, far better than we do here. And the heritage system in England supports the whole system of thatch.'

While Paul's love of thatching might have been re-ignited in England, it was as a young boy in Co. Louth, throwing straw with a fork on a hot summer's day, that his real love for the skill began.

We remain in the car looking at this two hundred and fifty-year-old cottage, which lies in the eye of Curranroo Bay. It is the home of Paddy and Anne Kavanagh and it is in the middle of a re-thatch. Paddy spent sixty years farming. Growing wheat, harvesting wheat, threshing wheat, getting grain from wheat, and even thatching his roof with wheat. Today, the thatcher is stripping back the roof. He will create a new thatch for Paddy and Anne. And after twenty-five years of shelter under it, Paddy will still be able to use the old straw for animal bedding.

'When you come to a thatch,' says Paul, looking at his work, 'the first thing you ask yourself is: how can I make this roof look beautiful? How will I make the roof become sumptuous and alive and draw your eye to it? All thatches perform a function. But its greatest function is to remain dry as a roof should.'

'When you thatch,' he continues, 'you climb up and down the ladder, stand back and look at the roof, then climb back up again. As you get more experienced, you can judge what you're doing from a distance. Or you want to observe the undulation from the street, just like we are doing now – the congregational side, as they used to call it. People going to Mass would say, "Jaysus Jimmy, the roof looks great," and you'd thatch the congregational side first. The back might be rotten, but you'd get everybody talking about your thatch on their way to Mass.

'But we'll have nobody talking about anything if we don't get on with it today,' says the thatcher. 'I have to work. *Ní hé lá na gaoithe lá na scolb.*' [You don't thatch on a windy day.] The weather

is good today and we must be worth our price in spuds.'

He laughs as he gets out of the jeep.

'Come on. We've loads to do and you've much to learn.'

I watch the thatcher lift a large bunch of golden reeds, balance them perfectly on his shoulder like a carpet, and climb the wooden biddle ladder, on which he can stand and kneel at its summit, and which lies with ease against the roof. It is held on by giant hooks embedded deep into the thatch.

'This is a reed thatch,' he says, as he rests the bunch against the sloping roof. Bunches and bunches of custard-coloured, bone-dry reeds lie on the ground at my feet and on the roof's ledge, ready to be fixed through.

'Why are you using reeds?' I ask, as I climb an adjacent ladder to follow all he is doing. Cautiously.

'I'm using reed from the Shannon. Water reed lasts twice as long as straw, and there's no seed, and it's tougher. A reed roof will last twenty-five to thirty years.'

The thatcher shakes and moves and feels the reed bunch as though it is satin.

'This is very physical work,' I say. 'Your hands seem to be your head and your heart.'

'"Have you got receipts for those?" asked the tax man of an old man surrounded by chairs he had made. "There's my receipts," answered the old man, holding out his hands. And these are mine,' says the thatcher proudly, opening up his large hands. They are like gravedigger's hands, big brutes of instruments.

'You could cut a millimetre into my skin without drawing blood. But it is only through them that I feel alive, unstoppable and strong.'

He continues to twist and push, mould and gather the reeds. Finding a length and a breadth uniformity. He smooths out spares and wrinkles, assembles and neats down the bunch in shape and size.

'One of the unique elements about thatching is that you can make a lot of your own tools to suit how you thatch. This is a tool called a leggett,' he says, and he shows me what looks like a giant butter pat, but a lot more fearsome.

'I made it from an old school desk, a piece of oak. I cut the desk into a twelve-inch square piece of wood and hammered old horseshoe nails into it, and with this handle on it I use it to pat the reeds into shape and level them. You only use it on reed. It looks like a hobnail boot, but when it is used well you can get a nice, lovely level line.'

'And how is it used? Why did you make it? How does it help you?' I ask eagerly.

'You need the leggett to help your hands because every single bundle of reed has its own nature, its own character,' he continues. 'They all grow individually as a single strand and have their own twist and turn, and you're trying to comb each bundle of straw, each bundle of water reed with your fingers, and trying to feel where the actual run is. And you're trying to imagine that you're flowing like water as well. If I cut this down, where will the water flow? You can feel with your hands, see with your eye and twist and manipulate the straw and the reed, so that it actually lies in the flow that you want it to lie in.'

I listen to his words and look out over the bay, leaning securely against the roof. The smell of the reeds and the emerging thatch is earthy and enveloping. Browny and tweedy under my nose. There is a crank and nut-crunch sound of

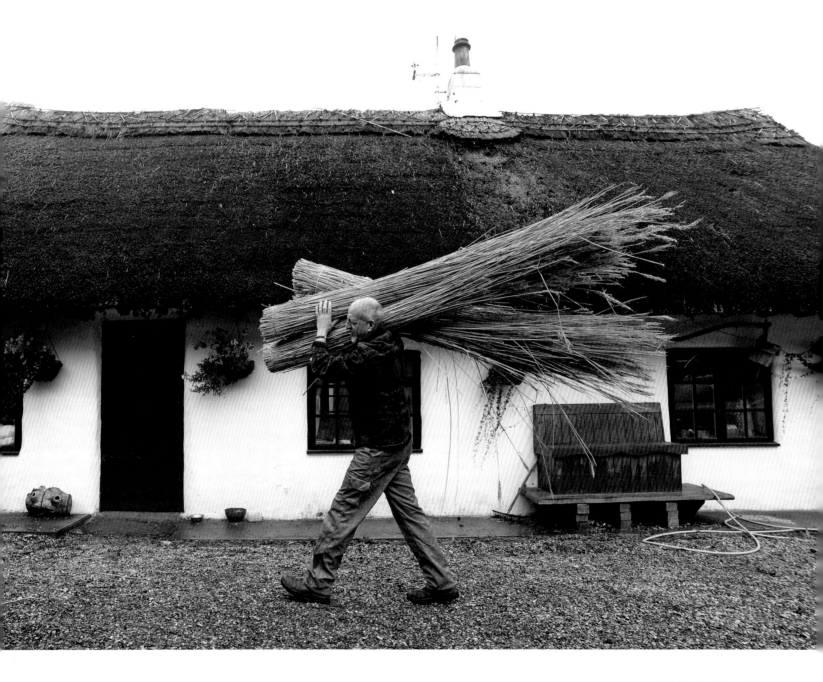

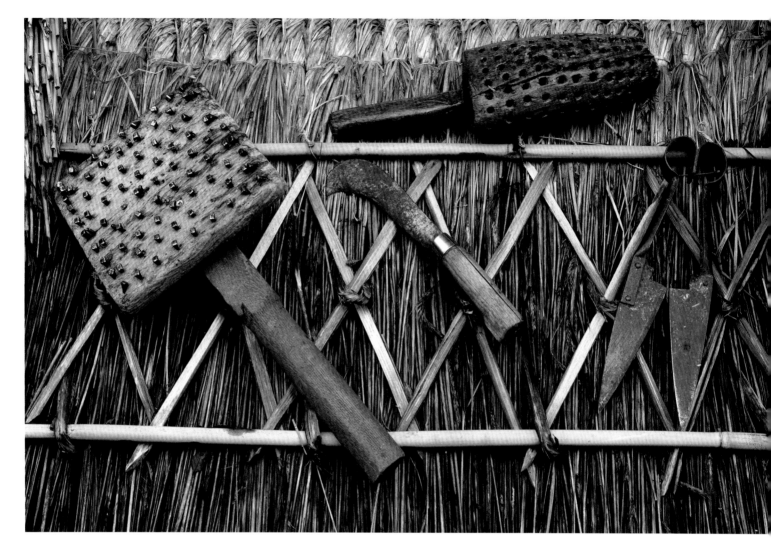

the leggett against the bunches of reed thatch as the thatcher arranges and positions them. The sound and smell bring with it a memory of my childhood summer fields and haystack climbs. My memory is always about smell and touch. Turf and bread and wet-hedge village smells, and the feel now under my hands is that of the warm knuckled and layered beds of reed and straw, soft yet strong but mostly, secure.

'You're a romantic,' says the thatcher, sensing my mood miles away and distant across the west coast of Mayo. 'The feel of reed and straw is the feel of blood, sweat and tears lodging in your eyes and under your nails,' he says to upset my dreams of things past and not yet faded.

'How can these reeds really become a roof?' I ask, leaving my dream behind.

'Ah,' he answers, 'they have been doing just that

for hundreds of years all over the world. Reeds covered our earliest thatched structures, the crannogs. And they still do. You can thatch with oak straw, barley straw, wheat straw, flax, grass, sedge grass, and in parts of Scotland they even thatch with heather.

'You have to think of all these bunches of reeds as thousands of very long drinking straws all lying together side by side and on top of each other, with air inside as the great insulator, and as an acoustic insulator too, for a quiet house.'

The house is half-roofless, exposing rafters. Battens are held down with wooden pegs. Scraw – a thick grass embedded in clay – has been skimmed off and is lying on the rafters, held down with wooden pegs.

'You're very ordered with how you lie the reeds down on the roof,' I say, watching the thatcher as he places the reed bunches with pin-like precision side by side on the roof.

'Look across the roof,' he says. 'You can see that we have the rafters and the base ready. Now these bunches of reeds are thirty inches long, tapered off and thinned at the top. We'll begin to layer from the bottom up. We will lay the bunches of reeds on the base. As we lay, we must remember that a thatch must always be able to breathe. Like you and me. You must thatch securely and evenly but always a little loose, to let the water fall off and not get sucked up and held in the reeds to rot. The wrens and the birds and the tits must be able to nest in the eaves. It's a good thatch if they can. We have all got to live.'

'But how will you get them to stay?' I ask, imagining all the great and strong bunches of reeds upping and offing one night in a great wind like the house in *The Wizard of Oz*.

'We will pin them down with the scallops, the stuff of thatching and the essential component of any thatch,' he answers.

Before he speaks again, Paul takes the hazel reed and with his crafted, adept hand, he twists it lightly, turns it around a little and then crooks it some more, until finally bending it back just enough, until it has a kind of swing, but still holds its strength. It becomes in his palm a giant, hazel-rounded hair pin.

'That's a scallop,' he says. 'I'll use this and put it into the reeds and it will hold them in. All thatchers must be able to twist a scallop to bend or turn the hazel or willow. I've given this to big, strong builders, and they'd just break it in half in an instant. Because they would twist it beyond its centre, and it would snap. For the thatcher, it is like channelling energy from your stomach into the hazel wood. It's not a strength. It's a knack. It's a trade, it's a skill. It's an art to be able to know and feel when the sinews of that wood are just about to crack or when it is going to break and to move your hand musically, in such a way that this does not happen. You are doing a dance with the wood with your hands; you feel where the give point is and then you twist it.

'When you're twisting ten thousand of those scallops on a job, and you're breaking half of them, you have to learn very quickly how to be in unison with the wood. That's the lovely part, when you are in resonance with nature. Your hands sympathetically twist those sinews and learn through the wood. It's almost like a blooding. Your hands develop calluses and build up strength on your skin to support the twists. We'll use four thousand to five thousand scallops on this roof, and about twelve hundred bundles of reeds.'

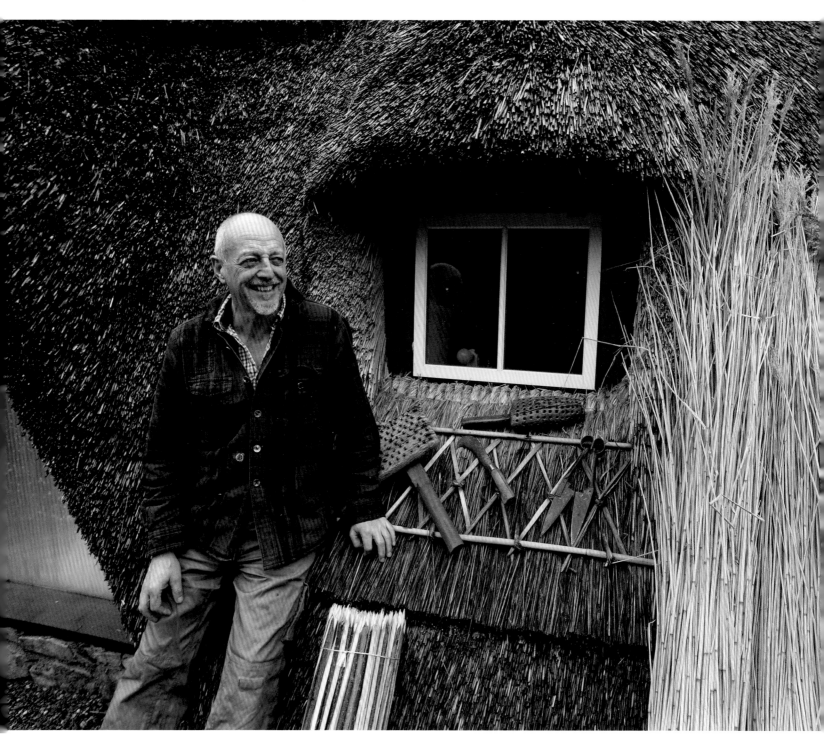

I am reminded of Brendan Kennelly's poem, 'The Thatcher'. I speak it aloud as the thatcher works the reeds across the roof and settles them safely down beneath the twisted hazel hair pins. The poet's words move on the wind, and I feel I am being held firmly – if only for a moment – in a past, now lost forever among box estates and high-rise apartments.

He whittled scallops for a hardy thatch,
His palm and fingers hard as the bog oak.
You'd see him of an evening, crouched
Under a tree, testing a branch. If it broke
He grunted in contempt and flung it away,
But if it stood the stretch, his sunken blue
Eyes briefly smiled. Then with his long knife he
Chipped, slashed, pointed. The pile of scallops grew.

'That's powerful,' says the thatcher. 'Powerful. We call it "coppicing". The hazel is grown and cut back so it can become straighter and longer and stronger, and when it is strong and long, I split it in thirty-inch lengths and these are the scallops. Do you know that there is nobody growing hazel now? I have to go out to the woods to find it and cut it. It could be a great cottage industry if only people thought well about it.'

The thatcher layered and pinned, and pinned and layered. I studied the rhythmic movements of his arms and hands. It was as though he was playing a tune, with the movement of his whole body in harmony through the strength of the reeds, and holding them as they moulded and formed into a natural, useful and organic roof. A house height fit for the palaces of historical kings.

The bunches grew like a summer petticoat against the roof. The thatcher steadied and evened the reeds with great accuracy. He worked along the rafters, sculpting the reeds with the leggett, patting them up and up and up, until all the reeds were flush, gracefully beating them into place as the layers rose and rose. He held his work down with a wooden stretcher, which lay across the roof to create a balance and firmness, while all the time pinning the scallops through, and hammering the hazel hairpins home for final settling.

'All the scallops are put in uphill so that the rains run down and not through. The water must run off the end of every single individual reed. That's how the roof is kept water tight, yet breathing,' he tells me.

I watch the creation and build of a layered dress for the roof built from the bottom up. Its full expanse drops down like a regal curtsy from across the eaves. These layers are our history, our home and our hearth.

The thatcher stops his work, and leans against the roof. It is as though he is part of it, ingrained in it, fuelled by it, despite the technique and the precision necessary to create it. His brow is sun-brown and wet with the physical work. He begins to relate stories remembered as though they had happened yesterday.

'Every year, thatchers added layer upon layer upon layer to the roof. At some point, the thatch is just too thick, so you have to pull it back, and as you pull it back you are revealing time. A layer of thatch reveals twenty-five or thirty years of history. When I thatched a pub in Oranmore, we had to get seed savers involved because we found one hundred and fifty-year-old rye straw seeds in the thatch that could re-germinate. They preserved these seeds and kept them in the national seed bank. Another thatcher found a scabbard just

above the door, dating back from when the fusiliers were approaching, and it was just there to hand. Another thatcher found a fiddle buried in the thatch, and the thatcher brought it down to the eighty-five-year-old man who lived inside and the man said, "Ah Jaysus, this is like a bad penny, coming back to haunt me. My mother had my head wrecked learning that bloody violin. I buried it in the thatch to hide the thing." The fiddle had been fully buried in the thatch in its case. When we opened it up, it was completely intact. I have found hats and knives, and as soon as you find a knife you pick it up and know that a thatcher had used it one hundred years ago. We have lost hundreds of knives in roofs. You stick it in straw, and all of a sudden you put a layer of thatch over it, and the knife disappears for centuries.'

'How will you finish it off so that we will know it is your thatch?' I ask.

'I'll seal it with my comb at the top. My diamond pattern design, made out of reed or straw. Some thatchers make a stuffed pheasant shape or a fox or a rabbit. It is a fashion above a door or a window called a *graineog*. I learned this in Connemara from the great thatcher, Jerry Joyce. He trained me in the Irish way of thatching. We must always remember that a thatch, although natural and strong, is also very vulnerable and can be easily set on fire. Sure it was a great way to get people out easily for evictions, and that goes right to our DNA and the fabric of our history and beliefs. The biggest threat to the thatch is the chimney. It must always be three to four feet clear of the roof from the top of the thatch. The price of insurance is killing the thatch now since it is about four to five times the price of slate.'

I climb down. Carefully.

I look back at the thatcher's work. It is beautifully formed, golden and brilliant.

'Will it always be the colour of the sun?' I ask.

'No,' he says from the roof, 'this thatch will begin to perish on day one. It is beautiful as you say, noiseless, warm in winter and cool in summer. But it needs maintenance. It needs to be free of moss and fungus, and it doesn't answer well to sprays as they kill its natural growth. Depending on how well the thatch is put on, if it is very tight it will not last very long, if it is too loose, it will fall off. And it also depends on where it is. If there are loads of trees nearby, it will lack wind exposure and be open to tree fall of all kinds, and it will hold moisture, which will get sucked up into the thatch and begin to perish it. Thatchers, like farmers, always know where and where not to build houses. They know about nature and how to live with it. This thatch has air and open surround.'

'But what about its golden head? How will you keep it vibrant?' I ask, not wanting to see his work begin to fade any time soon.

'We clean the thatch every year with copper sulphate. Bluestone. That was the old stuff, which was used to spray the potatoes for blight. This holds the golden colour and brings back the colour every year. You brush it down, take all the debris off it, and then just spray a copper sulphate all over the roof, and that brings a beautiful golden, coppery colour to the thatch. The straw really comes back to its vibrancy.'

The thatcher climbs down and sits beside me as we contemplate all he has created over the day. I hold that image in my head. A golden-brushed crown, flared and flaming in common and in competition with the wild honey-coloured

broom fattening the spring hedges. An earth roof unchanged for centuries. Still useful, still beneficial and always natural, like the thatcher himself.

'Why has all our great progress dragged us willingly away from what and who we are?' asks the reflective, graceful and slow-paced thatcher as we sit together on old garden chairs.

I understand what he means but I have no answer to his question. The thatcher loves his job. He does not see it as a way of making money. He pursues his work for the love of it. He is fuelled by preservation and a sense of connection to his earth. I thank him for our day together and for all that I have seen and learned. He says goodbye, and within an instant, he is back up the ladder with the history of our island, as reeds, on his shoulder.

On my way home I stop the car and climb a gate into a forest overgrown and dappled in the evening sun. I am propelled there, looking for the hazel magic of wizard wands, the mystic hazel of divining rods, and the turn and twist of the spring movement of hazel scallops. I am looking for a piece of the thatcher's skill. The home and strength of the willow. The echo of his enchantment and purpose. He has spent hours and days here in this forest picking hazel for his scallops, piling them high for his best thatch. He has made things that find their raw material in the land and that give and bring heat and warmth and function to our lives.

The forest floor crunches and crackles under my feet. I am surrounded by whispering *piseogs* and fairies and elves living beneath the greenery.

I am lost among the lichens and the soft damp moss, immersed in the shades of shoe-polish browns, emerald and olive greens and every other coloured shadow thrown by the over-hanging trees and living earth. Layers of blues and purples, lemons and reds peep through as the tiniest of flower petals under fallen leaves. I remember the thatcher's words:

'If my creativity was taken away from me, I would die. I would just shrivel up and die, if I could not create something with my hands, be it a lovely frame door made from wood that I spotted, or a stool, or a thatch roof or music or painting or something. To create something is to be around the nearest place to God. We spend all our lives consuming and very few of us actually create anything. I try. I grow all my own vegetables. I've got hens. I've got a wind turbine. So I'm creating, hopefully, some power, creating some good food. If somebody, anybody, asked me, who are you? I would tell them, I'm a thatcher.'

A divine answer. ●

Paddy Kavanagh died in June 2018. His two hundred and fifty-year-old cottage, thatched by Paul Johnson, stands proudly in Curranroo, Kinvara, Co. Galway.

THE BUILDER

Margharita Solon

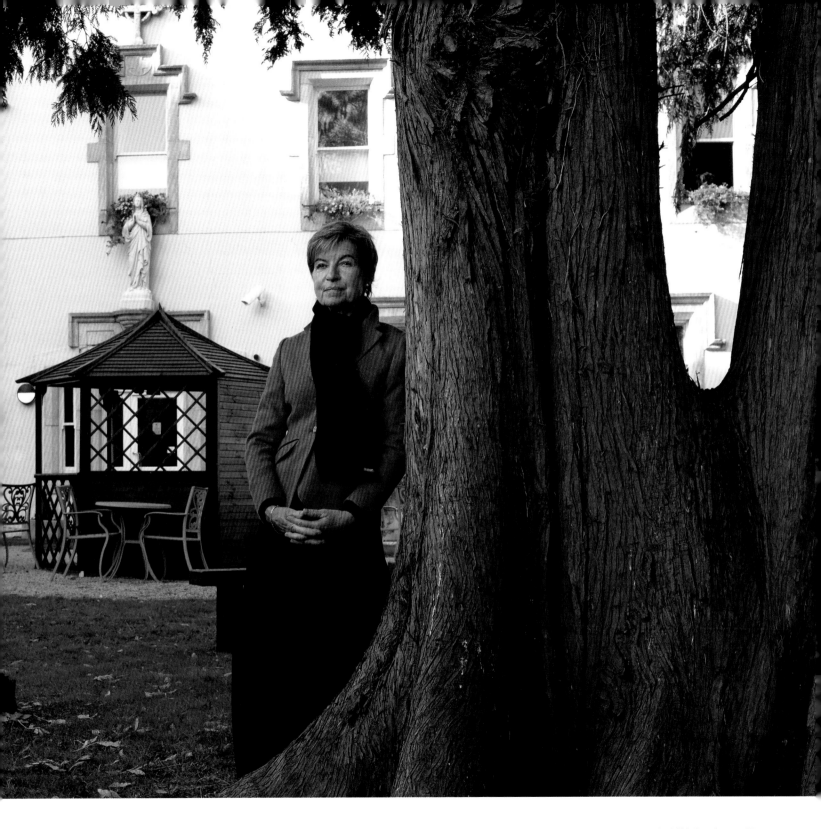

EXPECTATION OF THE UNEXPECTED

My father died when he was ninety-one. My mother who is ninety-five is still alive. I write this because watching them age was a privilege and a kind of terror. They became frail. Silent. Accepting. And grateful for any little kindness. My father said as I was trying to put on his coat at the front door, 'Sure I'm only a nuisance.' He wasn't. But he felt growing old was. And maybe that is what we think of our elders, as nuisances, when we forget they are individuals. Only a little older.

I had never heard of Atul Gawande. In 2014 he published a book, *Being Mortal*. It was recommended to me. I bought it. It was an extraordinary and frightening read, and it had a profound effect on me. It still does. Atul Gawande is a physician and surgeon and his book asks many questions about how, as a society, we treat our old and our aged.

In the book, he questions our entire system of care for the elderly, for the dependent and for the debilitated. We give virtually no thought as to how we will live out our later years alone. Life for older people can be better than it is today. Gawande is really asking, how do we make life worth living where we are weak and frail and cannot fend for ourselves anymore? How do we make old age better? We have got to do something.

Nursing homes were never created to help people facing dependency in old age. They were created to clear out hospital beds, which is why they were called nursing homes. They are places largely cut off from wider society and built for safety but not necessarily for happiness. This place where personal independence can no longer be sustained. This place, where half of us will typically spend a year or more of our lives, was never truly made for us. Gawande believes we should get rid of nursing homes. We haven't because we find it hard to believe that anything better is possible. We haven't had the imagination for it. Margharita Solon has. She recommended the book to me.

Margharita was born in a small village in Co. Meath. She had three great influences as a young girl growing up. Her father, a local GP, who cared for his patients at whatever hour they needed it.

Her grandfather. He suffered from contraction of the fingers, and as a young child she would sit beside him at the fire trying to release them. He lived until he was ninety-six. And the village community. A community who looked after each other, fundraised for each other, came together to protect each other and preserve their landscape, and grew up and grew old together. That was a very strong start for a young mind.

While she was waiting to start in UCD, Margharita did summer work in St Luke's Hospital.

'I learned over that summer that doing the tiniest little things for people could make the greatest difference. I went home to my father one weekend and I said, "I want to be a nurse." Nursing chose me. I did not choose it.'

She trained in the Mater Hospital, qualified, worked in Ireland and England, trying all the time to make her way back to St Luke's and Ward 1C of that formative summer. She married and moved to Mayo to work in a geriatric unit in Castlebar. And that is when everything changed.

'I fell in love with nursing old people. I learned so much. What is the reason I am getting so much from my work in the geriatric unit, I asked myself. Surely others should be getting just as much value. On night duty outside all the general routine, I was privy to all the stories. I could listen. I could communicate. How are you? Tell me. And I could do things. I could make the elders comfortable. And intervene to make a difference. Make a cup of tea, change the sheets, turn them, lift them. Talk to them. I loved it. It was what I had known and grown up with in the village. All these older people, who I did not regard as old, just part of the community.'

When I hear Margharita Solon speak, it is like I have met her at a time in my life when she is most needed and most relevant. For all of us. We watch our parents and our grandparents ageing and becoming dependent before our eyes. What to do? Where to go? What is the choice? Is there one? What is it? Neglect, strangers or institutionalisation? Hoping in some kind of fantasy that this decision will never have to be faced or made. Hoping in a greater fantasy that nobody will get old, that I will never get old. But Margharita began asking those frightening questions. The fundamental, end-of-life questions. Why are older people locked away in nursing homes? Why are they on the outskirts, on the edge and periphery of society, or up long avenues in greenfield sites? Why are they not in the centre of the town? Why aren't they integrated into society in a very real way? Naturally. She had seen old people lose freedom month by month as they became more frail and incapacitated. Lose all their autonomy and become confined to a sameness that was mind and heart numbing. Their freedom becoming confined to moving the salt cellar on the dinner table. But it was always moved back to its rightful place. And her questions continued.

'It is wrong that the same person is sitting at the same table, eating more or less the same food for years. No change. Why would you bother looking up from the table? What would be different in this place if you did? What would be new? How can the people living there bring new experiences to the table if they are all within the same four walls? Where are the new experiences to share? New stories to tell? Whose fault is it that we are not enabling people to connect beyond the realms of the four walls in which they are living? How can the brain be kept active?'

Margharita coined the phrase 'expectation of the unexpected' because she felt there was

none. She wanted to bring every one of these elders to her house, so they could have a sense of home. They could sit by the fire, mosey around, potter, mooch. Do what she does when home. What she wants to do, when she wants to do it. Tidy a drawer, go into the garden, hang up the clothes, put the dishes away. Activities that the awful routine made impossible for some and completely inappropriate for others. Where was the individual human being in the midst of all of this? The tea pot is coming. I don't like tea. I prefer hot milk. But the tea pot is coming.

'Let me tell you a story,' she said. 'There was an elderly couple living across the road, when I left Co. Mayo and first came to Naas with my husband and young baby. The wonderful Paddy and Essie. They had no children. I was lonely and isolated in an estate with my young baby, and a husband leaving for work every day. Paddy and Essie became our greatest friends. We learned so much from each other. We grew together. They were educated to primary-school level, but they were two of my greatest educators. And my finest friends for all the years of our growing family. The wonderful Paddy and Essie, old people living across the road.

'Paddy had a stroke. An ambulance came. His wife, for the first time in her life, was without her husband. She didn't drive. He was moved to another town, another country really. He knew nobody, he couldn't speak, and his wife couldn't advocate for him, because she couldn't drive. She wasn't there with him. Think about it. That is what we did as a society, and that is what we do as a society. We took him out of his landscape, away from his tribe, away from all his networks of support, away from everything that reassured

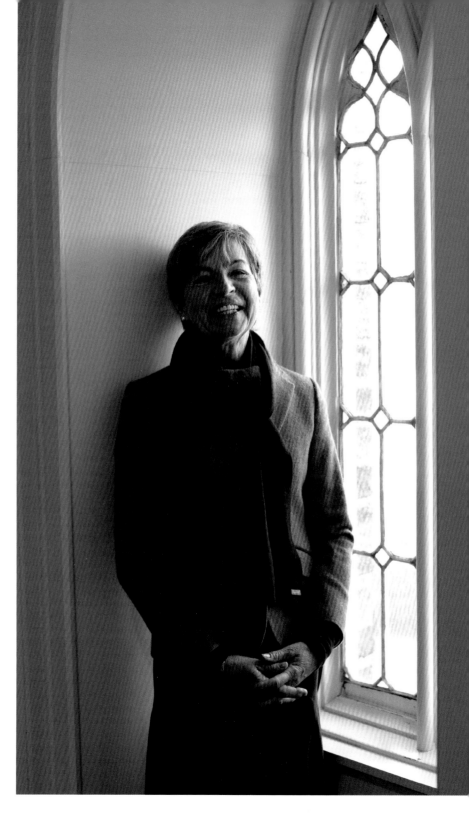

him, that he understood, and brought him to an assessment unit in this other place. After the assessment they realised, or decided, he was not going to get better. The plug was pulled, and he was moved into a long-term unit. Nobody said anything to him, they just did it to him. He was in this bed, in this ward, looking at the same picture. He was taken out of the bed and put on a chair. He was put back into the bed to look at the wall. He was taken out of the bed, and put in a chair. He was put back into the bed to look at the same wall. He was taken out of the bed, and put back into the bed.

'That was when the lights come on for me. If there was any remote chance that he might be rehabilitated, where could he go in Naas? Nowhere. I knew it was too late for Paddy. But what about me, or you, or the next generation? If we do nothing, we are going to inherit exactly the same situation or possibly worse. Because nursing care is now big business, private business, and its costs are going up and up and up. And whoever says, when I'm older, if I cannot manage, I want to go into a nursing home? Where the pictures on the wall never change, where people don't get out enough, where everything is static, and where stimulation is choked. Who says that? Nobody. Everybody says, if they are given the choice, I don't want that. Ever. That's why the lights went on for me. I had the brief and it could not be clearer. I had been given the brief. I had learned this brief over years personally and professionally.

'I decided I was going to build a place for the elders which contradicted everything about nursing home life as we knew it, understood it, and were used to it, within most institutionalised settings. I decided to contradict the stereotype in every way that I could. I decided to build a place for elders to live in, a home that had independence and no communal dining room. A tea room or a restaurant which the whole community could use. I wanted to build this place in the heart of the community. Somewhere I would be happy to live in myself. Somewhere residents could stay with their own tribe, their own community, within walking distance of everything, even for the walking wounded. A lot of people are put into institutions simply because they can't walk well or far. This place would not feel like an institution nor look like an institution. It would have to have pride in itself, and emanate pride of place.

'I wanted it to offer a diverse range of activities, so that residents might not be available for family visits, because they were studying or creating or singing or teaching. I wanted it to be a place of mind and spirit, outside the confines of what wheelchairs and battered bodies communicate. They do not relay the real person. I was not interested in a medical model. I wanted it to be a place of arts and creativity. A challenging and satisfying living environment. I was interested in the energy of experience and language and feeling. I was interested in all that the residents would have to give and be, if they were in the right place. A space where, if residents were unable to get out, stimulation, and loads of it, would come in the door every day, keeping everybody active and giving people a why. I believe if you have a why you have a how.'

I am afraid to ask but I do.

'What happened to Paddy?'

'He died after a few months in that same bed with the same pictures on the wall, and without

the comfort of his wife every day. We tried our best but he was too far away.'

'And Essie? What of Essie?'

'As Essie got older she couldn't walk up the town. She lost mobility. She was outside the heart and the happenings of things. Her world shrunk, her brain function decreased, because there was less stimulus and she had less stories to tell. Even though I went into her, and another lady, Maire, went in to her and spent a couple of hours with her every single day and there was another gentleman who visited Essie every evening. They will never get any credit for it. They are the unsung heroes in our community. However, enabling people to remain independent in their own homes is not the nirvana that it is presented to be. Living in isolation on your own, everybody around you working, and getting older by the minute. It's the other choices that I want to build. Essie died soon after. My vision was too late for Essie. Too late. Too late for both of them.

'And so my design brief came from what I knew, what I had experienced, those I had loved, and what I had seen others face, knowing that with imagination, vision and creative energy how different it could be. I wanted to create a village, not within walls, but within a building.'

I cannot speak. Everything Margharita has told me is part of a national truth and indeed a national trauma. We are not paying attention to how we might live well, when we are old and frail and needy, and still need to remain independent and stimulated, alive in spirit and imagination.

'What did you do?' I ask. A simple question with an enormous answer.

'I went to a local politician and I said, this is what I want to do. He sent me to the HSE. For a year I had hundreds of meetings provoking nothing but inactivity and frustration. I saw a programme on the television about St Brendan's Village in Co. Mayo, developed by Dr Jerry Cowley. I went to see him. He told me about the Irish Council for Social Housing. I formed a board and affiliated to this Irish Council for Social Housing.'

'Did they like your idea?'

'Yes. Then the Sisters of Mercy convent in the centre of the town, beside the church, came up for sale. It was a listed building.'

'Did you buy it?'

'We didn't buy it. We identified it. We told the sisters that we would like to buy it. They were happy to wait for us to get our planning permission and the funding from the department. They weren't going to sell it to anybody else. We fundraised in the local community because we had to pay our architects and our quantity surveyor, and the conservation architect, and many more. We applied for planning permission for apartments. Individual apartments, where people would have their own front door, sitting room, kitchen, bedroom, and bathroom, and where they could avail of the tea rooms, residents lounge, gardens, and an arts and culture centre. The tea rooms and arts and cultural centre would be open also to the entire community.

'After three years we got the planning permission. We went to the department for the promised funding. The department said, "No. We cannot fund you." They were angry we had not gone for a greenfield site, on the periphery of the town, where housing for older people always resides. They felt the building would have access problems throughout. The building had a preservation order on it. The building would be

hard to manage. A greenfield site would cost less. The centre of the town would be too costly. They could not possibly fund this building. They didn't understand the vision. It was a contradiction of what they were used to. Their refusal was very serious and very definite.

'We had to go back and tell all the people who had been fundraising for us that we had lost. We had to go back to the sisters and plead with them not to sell the convent. We had to go right back to the drawing board. What were we to do? What could we do? We would apply again. That was our decision. And we did. We got the second planning permission three years later. First planning permission in 2003, second planning permission in 2006. And then it took us another three years to get approval from the department for the funding.'

'What changed their minds?'

'We were not going away. I would have died trying. I absolutely knew it was right. And the board was behind me. We were united in this. This is what we wanted for us and for our community. Dennis Mullins joined me on the board at this time. He is still here today. He had seen three recessions and was not fazed by them. He didn't believe in them. He certainly did not believe in the word "cannot". An extraordinary man of the community. A brilliant man. I could not have faced it without him. And Jackie Birkett, an accountant, who did everything for no cost. That's determination. We got the funding. We opened the doors to the first resident in 2011.'

I drive down to Naas. Into the very centre of the bustling town. I don't have to seek out the Mercy convent. It becomes evident in the intersection of shops, restaurants, newsagents, chemists, cinema, supermarket, traffic lights, trades, companies, activity and passing towns people. The old Mercy convent, now McAuley Place, sits like a bright Georgian hotel one would read about in a Maria Edgeworth novel. It is tall and square with three storeys of original preserved windows, all of which are flattered by stone-carving curtain encasements, as is the Georgian front door. I walk past the town's church, which sits on the very edge of the building like an ancient and wise seer. Its large stained-glass window throws rays of light across the open and inviting front garden.

I enter into an artistic space. Pastels, oils, watercolours, intricate line drawings and photographic images adorn the walls, exhibits of artists' work that have been displayed at McAuley. On the mahogany reception desk, there is a sculpture of china tea cups built high and full and designed as though they are a vase of tall foxgloves. As the china cups drop and curve, resembling the bell and cup shape of the flower, I notice that each cup is individually lit as though it is capturing a memory.

Margharita Solon is sitting in the Convent Tea Rooms, chatting. The tea rooms have the atmosphere of an aromatic country kitchen in a welcoming house, which everybody wants to visit. It is warm and comforting. I am surrounded by dressers of old patterned china; fresh flowers; wall paintings and hangings; and tables for all. There is the smell and taste of fresh crusty bread, cakes, soups and food, made from scratch. The counter is filled with hot sultana scones, luscious cakes, brown bread and home-made apple tarts.

This is a space that ignites taste and communication and a sense of well-being. It is in the air and around the walls. I can feel it. Residents and community sit in anticipation of

all the wonderful homecooking they can choose from the menu. I am content among an energy and a vitality and the chatter of all ages. I have no idea who is a resident or who has wandered in from the community. But I know in an instant that this is the core and the centrality of Margharita's vision.

'I'll have scrambled egg and homemade brown bread,' I tell the volunteer server, with childlike excitement. Most of the people working here in the tea rooms are volunteers, young and old.

'Do you like working here?' I ask as my order is being taken.

'Yes!' comes the enthusiastic reply from Sally Logan, who started the volunteer programme. 'We are mostly retired or semi-retired. Some are younger doing summer work or transition work. We depend heavily on volunteers. This is a most important element of McAuley Place. As you get older, your social connection diminishes. Here it is increased, and results in well-being and networks of support. So if you volunteer here, you're actually paying into your own community. You're paying back what you got from your community. You're paying forward to what could be there for you.'

I think about what she has said. The purpose, spirit and community work ethic seems to be very evident here.

Everything comes to the table on china or in china. The teapot has a cosy. I feel I am being looked after. The simple touches and thoughts became a definition of respect. I remember Margharita's first words to me about small things making a huge difference.

I visit the self-contained apartments in the original building and around the courtyard at the rear. They are beautifully designed, comfortable and roomy with a bathroom that respects becoming old and frail, and a kitchen that allows very easy access for movement and cooking. Seventy-five per cent of the apartments are the preserve of residents from local authority housing or those eligible to be. Twenty-five per cent of the residents are people of independent means. They are all responsible for their own bills and apartment's internal costs. Everybody pays €100 a week. I wonder when I can get on the list for the future.

Downstairs, the Community Centre of large and small bright, clean rooms, a reception and information desk, and long glass windows opening out to the surrounds resembles chaotic order. I look in on parent and toddler groups as they enjoy rhythmic and percussive music, rocking and moving together to great symphonies. I watch the very young at their ballet classes, jumping and leaping and rolling with not a care in the world. A direct contrast to the yoga classes in a quiet room where the concentration can be heard outside the door. There is movement and focus and, above all, joy. Everybody here has something to do, somewhere to go, and something to share. This is the best definition of that difficult and overused policy word, 'intergenerational.' Here I see it in action outside definitions. The community hosts up to thirty groups, from active retirement to tai chi, pilates to counselling, and it is open every day, all day.

I wander with a sense of purpose and connection through the warm, twisting corridors, past paintings, batiks, display cases and framed thoughts and beliefs, to find the Arts and Crafts Cultural Centre, which was once the convent chapel. I open the door to the sound of

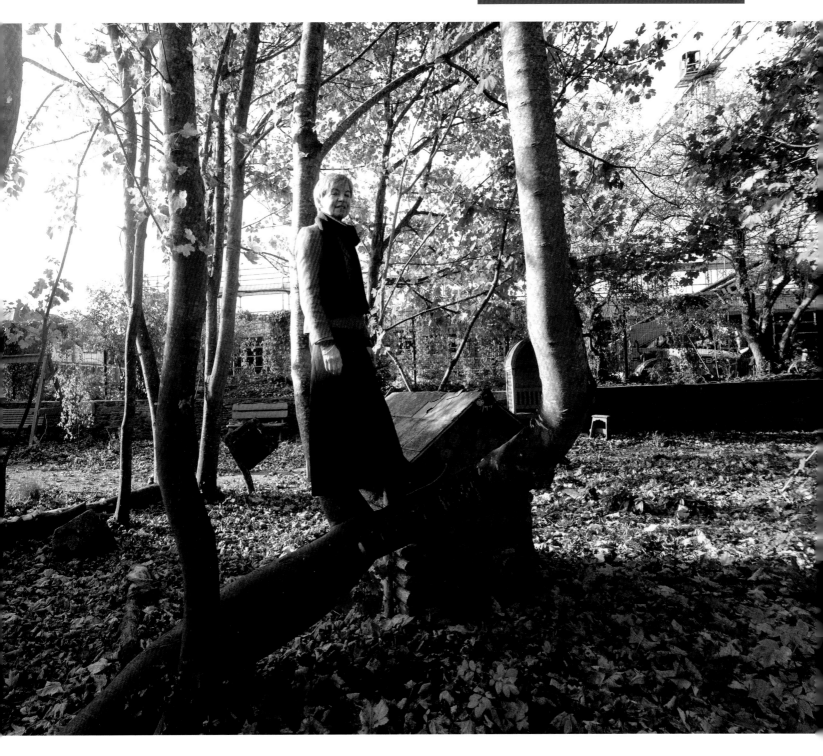

melody and harmony. The Alzheimer's choir are practising. The music is elevating and the choir participate with an energy and focus that belies their condition. We are in a perfect place. The old convent chapel is high-walled with Doric stained-glass windows throwing their ethereal rays down on us all. The exhibition 'Vanishing Ireland' is on the walls. There is a balcony where a small number of people sit quietly, listening. Poets and musicians and speakers come here to the cultural centre to perform and connect. There is accommodation for an artist in residence. The community and residents are their audience.

I walk outside into the woodland garden, and sit on one of the many handcrafted benches. The air is clear and clean, like fresh linen. The little river runs beside me like a friend; the trees are long and lanky and light and thin, ash and elm breezy, their branches see-through in the soft wind. The sound of children running and playing in their school yard drifts across the foliage, dropping as an echo into the lives of the elders who walk daily in the garden. I amble on through the garden, past bird boxes, tall grasses, thrush song and rounded performance spaces. The volunteers weed and sow in the soft heat.

Margharita is a grandmother, but looks like a young ballet dancer, lithe and free. Her long silk scarf is a perfect match for her swing skirt, and it moves in the wind as she approaches me down the meandering path of the garden. She has come to work this morning on a pedal scooter.

'You did it,' I say. 'You brought your vision to life. It is extraordinary. McAuley Place is everything that all the policy makers talk about, but are unable to realise. You have realised it.'

'And we are in the middle of all our senses here in the garden,' she replies, ignoring the praise.

'Sensory stimulation, sight, sound, taste, smell, touch, the core of what this environment is for all our elders. That stone building over there under construction will be our Health through Learning Centre.'

I look through the trees in the early morning at an ancient stone building under renovation, at the entrance of the garden. Its new architecture has preserved its monastic shape and prayerful atmosphere, and maybe some of the communication of old through the preserved stone work.

'The name means what it says,' she continues. 'Stimulation, challenge, creativity. Open to the residents and the entire community. Accommodation for an artist in residence and spaces for craft and artistry, looms, weaving, basket-making, sewing machines, all that is tactile. And of course access to this garden through all the seasons.'

Margharita is alive with the thought and finished potential of this new centre. It is yet another addition to her village vision.

'Did you know that as you sit here, we are one hundred and thirty-seven paces from the front gate to the bus, which will bring you to Dublin Airport and anywhere in the world?' she says.

'If I got sick in my apartment, what happens then?' I wonder, curious about the practical aspects of living at McAuley Place; and hoping for a brochure.

'What do you do when you get sick now?' she asks.

'I call a doctor,' I reply.

'That's exactly what our independent residents do. Government policy is to support people to live in their own homes for longer. It's none of our business what they do.'

'But if someone becomes incapable of turning the key in their own home,' I persist, 'where their physical needs become great, what happens then?'

'Then,' she explains, 'it's up to the medical support from the HSE or their family. There's one resident living here who needs almost round-the-clock care, which is mostly provided by the HSE. Originally people thought this was a nursing home or care home. It is not. People have homes. They live in their own homes, and they know that people around them care. Here they also have their own individual independent homes. We do not provide care, but we care. That's the difference. It's a different concept. We think that everything built for the elders is an institution. It's just stereotyping. McAuley Place is not a stereotype. It is original and unique.'

'Did you know all those years ago that you were going to become a builder?' I ask.

'I don't think of myself as a builder,' she replies.

'But you are one,' I tell her. 'You built a vision and you saw it completed. You are still building. Einstein believed for anything to happen, it needed imagination and energy. You had that. You used that, and you built McAuley Place around those qualities and integrated them through every wall.'

She is silent in thought for a moment and looks around the garden.

'I did not build this village for them. I built it for us. This is a very important distinction. Most things that are built for older people will never work. But if we build it for us, it will work because we are them. If it is not somewhere you would live, why would you build it for others or expect them to live in it? Why would you ever build something for somebody else? They were us and we will be them.'

I am reminded of the words of Leopold Bloom in *Ulysses*. 'How many! All these here once walked round Dublin. Faithful departed. As you are now so once were we.'

'I can tell you that there is a spirit behind McAuley Place,' Margharita continues. 'The spirit of all the people I nursed and who suffered dreadful end-of-life experiences. I am convinced that they are now a part of this vision. They gave me something so their final suffering was not wasted. I took the thread. It fed into something special that works. I also think of the energy of the Mercy Sisters, once young girls who entered the convent with grace and hope. There's a spirit in McAuley Place and it has underpinned the whole of this development.'

I pass a frame on the wall in the main reception before I leave. It is the printed words of the United Nations' 'Principles for Older Persons', emphasising the optimum physical, emotional, psychological and spiritual level of well-being all our elders should enjoy. It has pride of place within a pride of place. This is Margharita Solon's sacred vision. She has made it come true. Her vision found its roots in respect for our elders, and she recognised the power of independence and the power of the arts in bringing that vision to fruition.

I leave her village. This artistic space where elders of our island can live independently and yet be connected, challenged and cherished. People have come from all over Ireland to see what she has built. 'I would like a McAuley Place in our town,' is always their reaction. I understand now what Margharita meant when she said, 'McAuley Place is built by us, created by us. For us.' ●

THE FLY FISHERMAN

Kieran Connolly

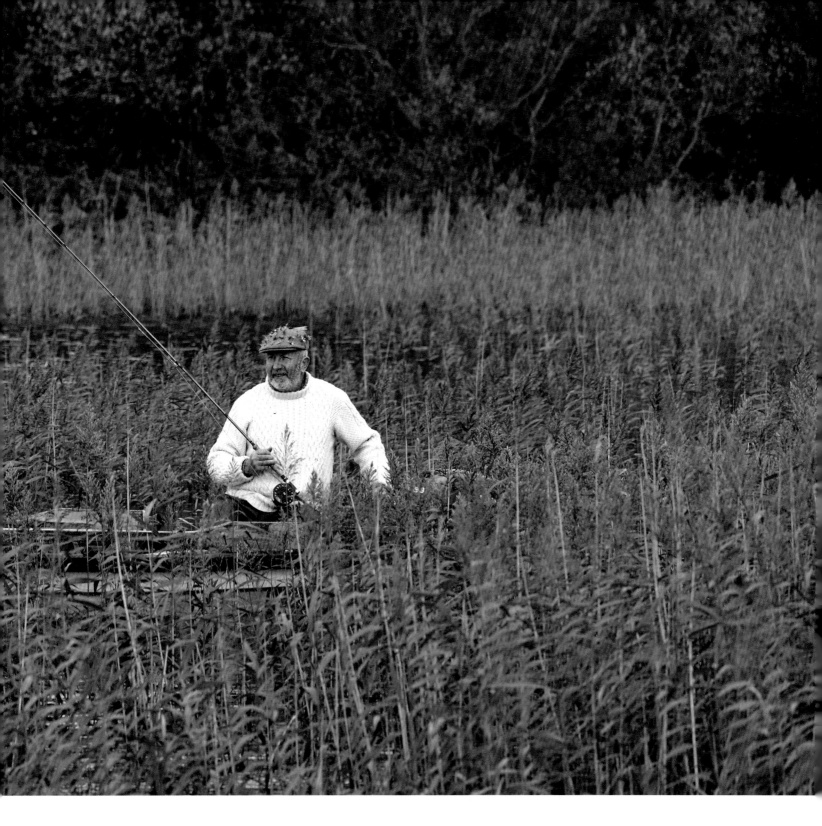

Kieran Connolly

THE BALLET OF THE ROD

'Hold the rod very lightly in your hand. Hold it a little more in front of you. Now bring the rod back over your shoulder, pause for a split second, and throw the line with precision and point out directly in front of you.'

I am standing on a grass lawn, on the edge of Lough Conn, in Pontoon, Co. Mayo, listening carefully to everything Kieran Connolly, the fly fisherman, is telling me. I grip the rod with intent, and try to practise the movements of hold, pause and throw. Our boat will not go out until the early evening, when the grey cloud has crept like a secret over the lake. I have plenty of time to learn. I let the line out on the grass with too much weight.

'Be gentle,' he repeats. 'You must land the line on the water like a feather, not flatten it down like a big pebble.'

The greeney fisherman is slightly behind me and to my side. He is moving my arm, willing it to be light and airy, lifting it back and forward, encouraging me to swing the rod with a natural easy rhythm.

'You must try and bring the very tip of your line down quietly and gracefully on the water. Just the way the mayfly lands, weightlessly and unnoticed, except of course, by the fish.'

I try again. I gently grasp the rod, bringing it back over my shoulder, pause and then with a quiet and steady arm movement, release the long silk line, lightly in front of me

'You are getting it,' the fly fisherman says. 'Just remember that we are trying to copy nature. That is what fly fishing is all about. We learn everything from nature. At least we do when it comes to fly fishing. When we go out in the boat, you must know how to put the line down, with ease, and present the fly to the fish. You must learn to cast gently but with confidence.'

The fly fisherman is strong and quiet and unknown, camouflaged beneath his báinín jumper, bulky waistcoat and waders. He wears the uniform of the lake. Shades of ivy green cloth, rubber footing, and myriad pockets all with a defined purpose for what a floating, lapping natural world might throw up. He has worn this uniform for years.

'Fishing is a way of life for me since I was a small gasúr here in Pontoon; I was surrounded by fishing,' he says, as we begin to walk towards the lake. 'I used to sit in the boats when I was only ten and my father, Michael Connolly, would let me use the engine. He was a ghillie for Major Threlfall and I spent my time watching him. I got a fly rod in the post and sure, 'twas like I won the sweep. My own fly rod. Imagine that! That got me going and then my father allowed me use our own boat. And from there on I started fishing on my own.'

I look out on the expansive waters of Lough Conn. It is one of the oldest fisheries in the world. The lake is nine miles long and six miles wide and boasts twelve islands. Pontoon is the place of my childhood, as it was my father's. The lakes are its garden, and they were ours as youngsters when we spent days and weeks paddling, swimming and jumping like young salmon in the still or choppy water, until somebody was sent out from the town to collect us.

The greying and purple-coloured late summer evening arrives quickly on the lake, making it all resemble a Paul Henry painting.

'Most fish are caught when there is a cloud on top of Nephin,' says the fly fisherman, as we continue towards the lake. 'Fish have no eyelids, so the darker and the duller the day, the more likely they are to appear. When the sun is up, they won't come to the water's top. So this is a good day.'

Three plank boards lie across the wooden fishing boat's hull. Buckets of worms sit in the middle; upright rods stand like reed pikes pinned into corner junctions; flasks and wrapped sandwiches are tucked in under the rain jackets.

There is a small motor to propel us out into the middle of the lake.

'We'll row for better precision once we find our spot,' he says, as he starts up the outboard engine.

I flounder in, taking my seat on the middle plank. We move away from the pontoon as the nose of the boat drives out and slightly up, slicing its way through the choppy lake. The world begins to look different. Majestic. I elongate my neck like a fox and position my face against the spray. The feeling is mighty and clean and refreshing. The sloe-black lake lilts and falls to the rhythms of the wind.

'The most important ingredient is wind,' says Kieran as he steers us deeper and deeper into this moving lakey-liquid world.

'Why?' I ask, still engulfed in the spray.

'Ah …,' he sighs, 'you must always have wind on the lake, so that there is movement around you. Wind teaches you how to follow nature, how to copy nature and how to lock into its rhythms.'

The lake is a watery home to salmon, trout and pike. It provides a habitat for mallards, woodcock, swallows, midges and spent gnats. Their seasonal houses are surrounded by thousands and thousands of reeds standing long and thin, creating feather-topped fortresses, bending only to the wish of the wind.

A gang of drakes skirt by with their tufted heads in the air.

'They're going out for the evening,' muses the fly fisherman. 'They have a great sense of purpose.'

Kieran slows the boat and closes down the engine. He begins to row through strong arms and precise movements, steering the boat around the back of Glass Island with its ancient church, traced back to the sixth century. The island was

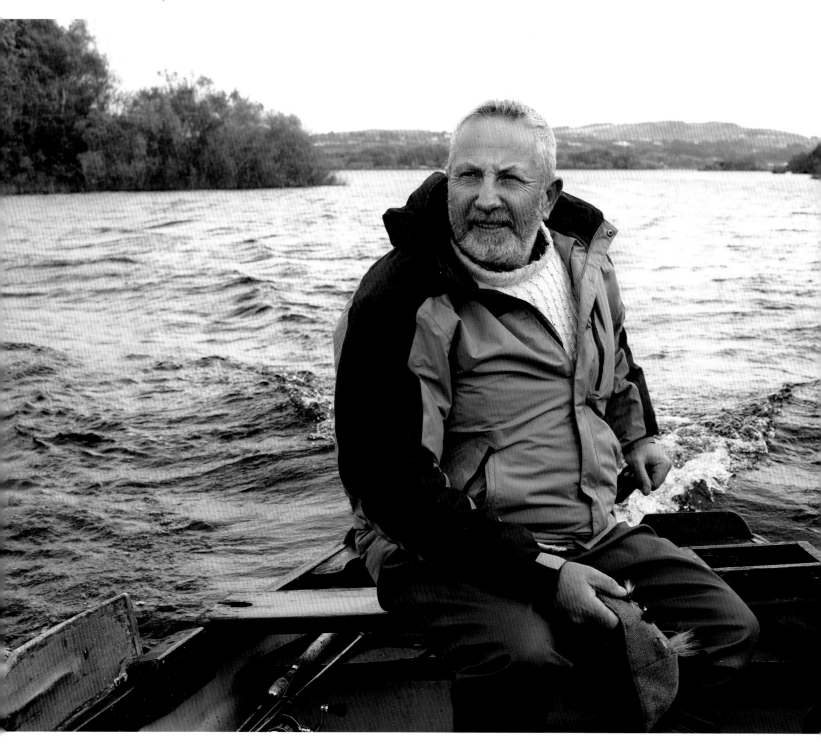

once inhabited by Franciscan monks but now lies deserted. Its religious history echoes around us.

As we slow up, there is a lip-lap-lip and gurgle of water against the boat's side, and a night-blue-caped giant Nephin at our shoulder.

The swallows swoop and swerve, fly and curve around the boat. They land on Glass Island's short fat trees and sturdy shrubs and pull their wings behind into a pencil point. They don't wait long, for on the first movement of the wind they are off again, soaring high and then low, fast and wild.

'The fish are watching the swallows,' says Kieran, as he pulls in the oars. 'Look out for the swallows. They love the mayfly. In early summer, they will tell you when the mayfly are going to hatch out. It's a chain. It's how we know where the mayfly are, and the boat must find the path of the fish from the mayfly. The trout love them, and the odd salmon will take them, and the terns and the seagulls.'

I am at an invited banquet for all, out on Lough Conn, under the light-grey velvet evening cloud of an early summer evening.

'Tell me about the mayfly,' I ask, as though I am a child who has discovered an underwater treasure.

Kieran settles back in the boat and begins to tell the story of this ephemeral creature.

'The mayfly is a gift from mother nature that has fed the lakes of the world and the fish tables of the land. It trained me as a fly fisherman and I have tried to copy its shape and texture and follow its short life on the water's surface. Do you know that it only survives for hours to mate and die? It hatches out in the mud at the bottom of the lake and swims up as a little nymph when the lake begins to warm up. I've seen them in the middle of April. You see a single one and a few days after you see two or three more. And then hundreds.

'It comes out of its shell here on the surface of the water and flies up. But it only gets a day in the air. Imagine that! It flies off into the bushes, around the lake and this small island, comes back out, mates and falls back on to the lake where the female lays her eggs which drop to the bottom and the whole cycle begins again. The male and female die on the water's top after they mate, and that's what brings the fish. There are thousands of them around. They start to hatch on Lough Cullen or the lakes that are the first to warm up. Lough Cullen is warmer because it's shallower than Conn. I've seen them in the middle of April right into June. Usually on Conn, now is the best time in very early summer. This is when we will see the big hatch.'

I watch the mating mayfly swarm. The sky is fogged with the whirring dance of mayfly, spineless wings on wings. The mayfly are tiny flying daddy-long-legs, moving and layering and creating a gossamer gauze across the sky. For a moment they are a sky veil, blowing around and around and off in the wind. But their dance is only momentary. For, after their thousands of mating swirls, the fisherman is right, I watch them fall to the water's surface and see them all around the boat. Spent.

'Isn't it extraordinary,' I say, 'that they both die, and they only get five minutes of life in the air as a mating swarm.'

'That is the way of nature,' says the fly fisherman. 'Their five minutes may be equivalent to our sixty years of life. It is the way of nature and its life cycle. Without the mayfly, the fish would not bite, and we might not eat.'

The boat is settling alongside the island, weaving its way through the water. Kieran looks intently down through the water's surface.

'It is among the rocks here that the trout lie,' he tells me. 'The brown trout lives along the shorelines and feed on snails and shrimp that live in between the stones. Do you know that I have often caught trout with their noses scratched from foraging in the rocks?'

I listen, enraptured.

'Brown trout are my favourite fish,' he continues. 'They're the most fascinating of all lake fish. They can survive in any environment, in a little river, in the middle of a town, or in a bog lake here in the West of Ireland. And they can adapt to any predators around them. I think they are the most beautiful fish to look at, and their life cycle is brave and enduring. They go up the rivers and spawn, put out their young, and come back down again into the lake, and survive the predators. They can grow up to be two or three pounds. I have never killed a wild brown trout. I couldn't, and I have seen loads of them killed in competitions just for the sake of a silver trophy cup. Can you believe that?'

The fly fisherman looks around his freshwater world, lovingly. He has been reared to it. He understands it. He loves this world and he is saddened by how it can be abused.

'Those infernal zebra mussels,' he snarls, 'there's trillions of them everywhere. Hard, small, sharp lumps, clutching the stones, nooks and crannies of the lakes, and all along their floors. They are the biggest threat to the lough and to fly fishing and to my job.'

It is the first time I have detected sourness and disgruntlement in his demeanour and voice.

'How did they get here?' I ask, following his eye line down through the water's brown well. 'They say that they came in from the Mediterranean on the boats from the Shannon. A complete disaster for the ecosystem.'

'Are they the only threat?'

'No, the cormorant is a big threat also.'

'Why?'

'Because it has to eat its own weight every two hours to survive. And it is protected.'

'The fish, like everything else, are endangered,' Kieran continues, unable to hide his anger at the pollution of the lake, 'and the stocks are not going to last. I see them every year getting fewer and fewer. Because of the storms and the sewage leaks and the slurry spills. All of these practices can wipe out a whole river or lake. I lie in bed thinking about that. I hate to see fish destroyed in any of those ways. Even the mayfly are decreasing. The lake is constantly threatened. There is always something. Pollution, over-fishing and greed. All man-made. The destruction on the lake is happening as it is in the seas and on the land.'

It is early evening and the light is fading. The last of the mayfly hatch is over. It is getting dark.

'This is my favourite time,' says Kieran.

I sit quietly in the boat as it moves to the rhythm of my heartbeat, to and fro, back and forward. The fly fisherman doesn't know it, but he is bringing the echo of my father's storytelling voice back to me. At ninety years of age, my father could evoke with an immediate and accurate memory, smells, sights, feelings and yearly happenings on Lough Conn when he was a boy. I remember him telling me:

'On feast days we would row out to Glass Island on Lough Conn, and picnic there on the small island. The parish priest, in black boxed hat,

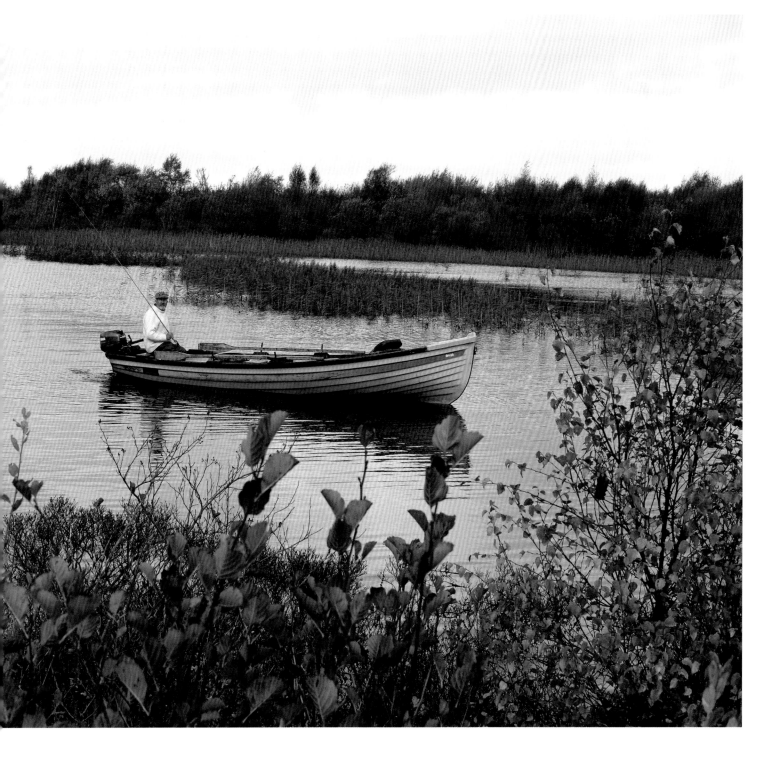

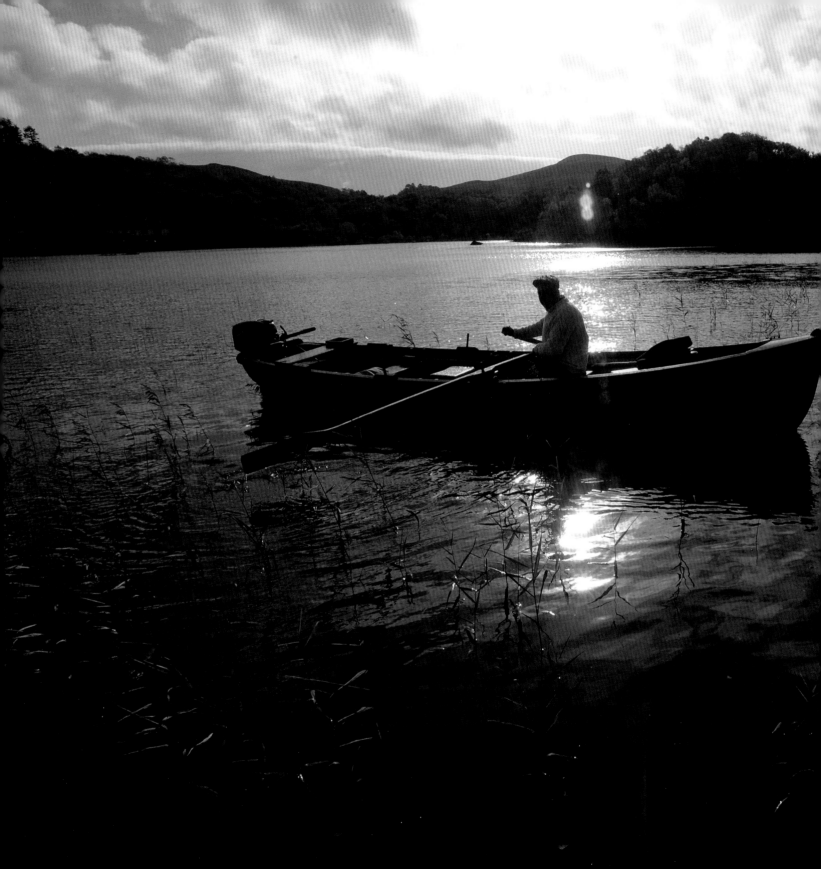

soutane and gabardine coat, would row in front like a medieval bishop. He would alight from the small boat and cause an anxious stir in the crowd, like an oily eel ascending from the water. Mass was said on a flat rock for the families that lived there. Everybody brought sandwiches and cans of hot tea. We did not take much heed of his sermon. I always felt it contradicted the natural beauty.'

And what beauty still surrounds us a hundred years later. All the colours of nature. Dark purple and night-blue shadows from the mountain reflected on the water, silver lips rising and falling as the water sprays against the boat, long green reeds standing guard in the distance, and the surrounding forests of full leaves rustling in the evening air.

'We'll cast now with the wind at our backs. It helps to blow the fly forward,' says the fly fisherman. 'The wind can create a white froth on the water, and that is where the fish reside. The froth is a great sign.'

It is time for my ballet of the rod and line. I stand with my legs slightly apart for balance, and lightly grip the rod as I cast out the line with the mayfly lure on the end.

'There are thousands of different flies,' teaches the fly fisherman, 'and we are constantly adding and subtracting, trying to replicate the real thing. The fish can get too familiar with one fly or another, and you need to keep changing them to keep ahead. The fly must imitate what the fish might like to eat.'

I allow the line to land on the water gently as I was taught, just as the mayfly might land. But I am immediately impatient for something to happen.

'Pay attention,' whispers Kieran. 'Take heed. Hold on to the natural sound and silence. Don't disturb it.'

He senses my giddiness and pulls in the line.

'You must watch the fly at all times. You cannot fish and be looking all around you. You'll catch a fish when you are least expecting to do so. You must try and develop a rhythmic sense of the rod, and get a feel for the fish. Do it again and this time keep your rod dead straight, no lassoes or big circles.'

I do so. I let the line out straight and skim the water's surface gracefully, just like the mayfly. I begin to relax. This is a place of splendour and meditation. It is not for high-pitched chatter or physical agitation. We are both silent for a time.

'I love fishing,' muses Kieran quietly as we wait for a bite. 'I love to catch a wild trout or a wild salmon. It brings out great emotion in me to see a wild fish rising to the mayfly bait.'

'What do you need to be a good fly fisherman?' I ask.

'You need patience, loads of patience, absolute patience, wicked patience,' he replies without hesitation. 'Out here on the lake, time passes in a different way. I am aware of the world in a different way. A quiet way. A serene way. A natural way. I am conscious of the seasonal changes but I am also very conscious of the threats. I do not care if I do not catch. It is the calmness of the lake that quells my frustration. Frustration has no place in this world. It upsets natural beauty.

'When I was very young, I got to see a great book by the Scottish angler, Muriel Foster. She was a woman before her time who fished all over the British Isles. She came to Pontoon in 1929. She sketched in a book all the different fish, their weight, shape and form, that she had caught over

her fifty years. It is now an unmatched record. I was very influenced by it, and it was my bible over the years. I have a copy now and it is my greatest treasure.

'The lake has been my school. I have learned about nature and fish in this boat, learned about salmon, grilse and trout. How they live, what they do and their life cycles. I learned dry flying, which is fishing with the fly on the water surface, wet flying, with the fly under the water, dapping with real mayfly, trolling, which is using the rod behind you as the boat moves across the lake, and the importance of catch and release in the preservation of our lakes.'

I am listening intently to Kieran, but I am also aware that there is no bite on my rod. None. Not even a slight movement beneath the fly. The fish must know of my lack of experience, must sense my urgency. The light is failing gradually but noticeably. The fly fisherman notices my disappointment.

'Fishing is about being out in nature,' he reminds me. 'It is not about catching fish at all. It is about being among living nature through the seasons. If you catch a fish, it is a bonus. It is a privilege to be here. Be content with that.'

'Are you always this contemplative?' I ask him.

'I just live a different life,' comes the reply. 'Slowly. And I see the world differently. Fishing has taught me to be calm and tranquil. I didn't start off knowing anything. I just loved the activity and learned this world from when I was young. I learned what I know as I fished through all the seasons. I meet people sitting here on my boat for hours, just like you. They talk about their lives and experiences. Their hopes, dreams and fears. Some of them tell me that on the boat, out in the middle of the lake, is the only place they can be themselves. Imagine that.'

I can imagine it. I have had to control my own sense of immediacy, while out here on the lake. Something I don't find easy to do.

It is early evening and time to return to shore. The light is fading and the mayfly hatch is coming to an end. The lake will quickly become dark and heavy. It is time to boat for home. The fly fisherman handles the oars and turns the boat. He starts up the engine and we begin to smooth through the slightly dimming light towards Pontoon. There is joy on both our shoulders for our day encased in nature. As we approach the shore, Kieran slows the boat to a stall, weaving it between hidden rocks.

'Look, look …,' he says excitedly, 'look up at the full bank ahead. It's an otter, a *madra uisce*. He came up along the bank at Pontoon bridge the other day. I think it's the same one. It's a lovely animal. A fascinating and completely harmless creature. They are very rare and very private. But if you're on the lake fishing, you'll spy one. They're territorial and will look for food in their usual haunt, their own little area. This must be his. Now that's a sight.'

And the fly fisherman's face lights up as though he is once again the young boy, receiving his first rod in the post. We edge closer. The otter wears a sleekly watered, black medieval coat. Its long hair tails are green-hued in the light and soaking against his skin. As we approach the bank, it looks around at us, startled, through clear, dark glass eyes. Its Labrador-shaped head stretches forward for a better view. In an instant it is gone. Underwater.

We reach the shore and I am reluctant to leave the boat for dry land. It is as though I have come back to a world of worry, away from the pure and healthy feeling the day on the lake has afforded me. I remain seated and quiet. He says nothing but continues to tie up and to empty out the rods. Finally I ask him, 'What is your secret and the secret of the lake?'

'Well,' he replies, 'fly fishing and the lake is a way of life for me. It has given me a real and great education. It is the purest kind of fishing on the finest of lakes in Mayo, and has taught me so much about the rhythms of nature and indeed my own life. It has been my mental health. It is where and how my mind works best. Where I am most alert and most observant. Where I am, I suppose, most alive. Out on the lake fishing. You should try it more often. Everybody should. The rewards are mighty.'

I climb out of the boat. The velvet dark moves like a shawl across the western sky.

The fisherman is still in the boat gathering the long thin rods and checking his boxes of flies. I watch him as he alights with perfect balance on to the small stoned pier. He begins to tie the boat up for the evening. He does not speak and I do not interrupt his ritual.

'It's not easy to leave the lake,' he says noticing my stillness, 'I never find it so. It dulls my feelings when I step on shore. The lake is a dangerous place when the light fades. But it is a gift that is always there. Thank you for your company.' His handshake is powerful.

'It was more than company,' I reply. 'It was an education.'

'Good luck to you now,' he says. 'Much luck to you,' he repeats, as he turns and moves away from me walking slowly and slightly bent, up the narrow stone-way towards the road.

I stand and watch the broad frame of the fly fisherman, Kieran Connolly, disappear gradually into the landed distance. The lake darkens. Its magic quelled until the dawn. ●

THE GARDENER

Martina Goggins

Martina Goggins

THE CIRCLE OF LIFE

There is a strange warmth in the garden. Strange and comforting. Even though the day is cool, and the garden is built against a Galway limestone surround, looking out over the choppy Salthill shore, there is a warmth. I can feel its encasement through the light wind. And I feel it through the silver hue of the stone.

I walk around the garden's inner circle of five tall druidic stone structures. They sit like great Celtic kings surveying their domain. And in the very middle of this amphitheatre stands a powerful stone from Clonmacnoise, the spiritual centre of Ireland in history and culture. It rises like a colossus as a reminder of how the thoughts, the words and the writings of our spiritual ancestors have something to gift us, something to teach us, a way to influence us and remind us of history in our living years. Our connections past and present.

Grey-silver stoned rockeries follow the garden's path. The rockeries are full and low, and their stones wide and flat. I sit on them at intervals for longer than I am aware. The garden feels timeless, even though the seasons will answer the rhythm of nature.

The flowers growing here are wild and joyous and free, like the waves on the Galway coast, ebbing and flowing, coming and going, echoing in the distance. Wonderful long, feathery ferns fan the breeze, and wild grasses move like green exotic Indian scarves, lifting and bowing to the wind. I run my fingers through them. It's as though I'm touching silk. The ferns sit throughout the garden overlooking the heather, groups of hawthorn, herbaceous wild plants from the Burren and the blue and purple delicate scented lavender. There are lipstick-pink roses covering the soil; they spread across the earth like expensive carpets, while junipers – the first plant to colonise Ireland after the Ice Age – take their place, sturdy sharp and erect, along the borders.

Leaves and grasses, long and short, rustle against the strong, hand-placed stone.

In the upper part of the garden, a pond is home to green water lilies that loll around like gigantic moving planets and mirror the mature trees surrounding it. There are places to sit or walk, and

the undulating pathways rise up to the hill and foliage behind the pond, and sweep down to the sea as they reach the boundary wall.

The garden is full and evergreen as the sun shoots its beams through the ice-clear air, illuminating great stone seats, a gigantic stone candle, stone walls of commemoration and celebration, and stone design features inscribed and set throughout the garden, as though they have always been there. I sit and marvel at the pattern of stone and flower, earth and anvil, married so elegantly within this sanctuary.

Martina Goggins comes walking towards me. Her step is graceful. Quiet. I hardly hear her approaching. She brings with her an aura. I can feel it, like the warmth I felt on the wind when I first entered the garden. She sits beside me on one of the rockeries. Martina is the gardener.

'This is a very unusual garden,' I say. 'It's quite extraordinary.'

'Why do you say that?' she asks.

'It's the atmosphere,' I answer. 'It's rare and very comforting. And I find it reflective. There is so much to think about because of the edifices and all the other magnificent stone elements that surround the garden. And it's hidden and yet it's not. Why did you create it? I have a feeling that it came from somewhere very deep inside you. Tell me how it evolved.'

She is silent. She looks around her creation. And its beauty seems to give her strength and the power to lift her reason out from her heart, once again.

'My son, my only child, Éamonn, was born in 1980. As a young boy and throughout his teenage years, he loved music. He lived for it. It was his passion. His heartbeat.

'He got that from me. I was steeped in it as well, working with De Dannan as a promoter and manager. I went on to perform as a singer in the group Deardan, and we toured all over the States at festivals and throughout Europe and Eastern Europe. It was a wonderful time.

'When Éamonn went to school, I gave up touring and was very involved in arts and crafts and the creation and development of a craft centre in Spiddal. I organised the craft fair in Galway every year. It was hugely successful as a platform for crafts people.

'Éamonn pursued the music and became a sound engineer in the Cuan Studios in Spiddal. When the studio wasn't busy, he would work with my husband, his father, Denis, in his stone salvage, restoration and carving business. It is a creative business. Denis is a true restorer. Éamonn was a true musician, but he was also beginning to understand his father's business. One Friday, he spent the day working with Denis, carving a stone bird bath for a garden. In the evening, Denis said to me, "I had a special day with Éamonn today. For the first time since we worked together, I saw him as somebody distinctive. I know he's twenty-six, but I felt a unique love for him today, as we worked together in the garden. A kind of pure, unhindered feeling. A love and a connection above anything else I have ever felt before."

'I think his father just felt a pure love for him at that moment, on that day. We had dinner in the evening and we all felt a kind of contented silence. We ate and talked of our expectations.

'I went into Galway to a concert in the Arts Festival, and Éamonn went to hear a new band in a pub in Spiddal. "Call in and hear the band on your way home, you'll enjoy it," he said to me

on the phone later in the evening. He rang me again when I was in town and asked me again, "Mum, come in to hear the band on your way home. They're terrific."

'I came through the village at about 12.30 a.m. I remember thinking, will I call in to hear the band or not? I decided not to, because they would all be drinking and I was sober. I went home.

'This is now an eternal regret. An unending, profound regret.

'At 4 a.m., I woke for some reason. I wandered the landing and noticed Éamonn's bedroom door open. I had a complete premonition of his death. When the knock came to the door at 7 a.m. on Saturday morning, I knew immediately what it was about.

'I said, "It's Éamonn. Where is he?"

'A local guard said, "He's in intensive care."

'I said, "Is he dead?"

'The guard said, "No, but he has a very serious brain injury."

'"He'll pull through," they all said. I said, "He won't. I've seen his funeral in our house. I've seen where the coffin is going to be. I have seen all of this." I told my sister, Maire. She believed me.

'There were three lads in the car. I don't know where they were going. Nowhere really. There was no reason for them to go anywhere. They all lived in Spiddal. I've never asked to this day what they were doing, because I don't want to know. It's not important. Éamonn was in the front passenger seat. The car went out of control. It was Éamonn's side of the car that hit the pillar. The others all survived the accident. They walked away without a scratch. Éamonn didn't. His head took the brunt of the impact. The life support was turned off.

'Everything changed. Everything totally and utterly changed. My music ended. I have a different life now. I never thought I could ever survive.

'I spent hours and days and months walking the bog. Walking the bog early in the morning and late at night, obsessed with the sky and the stars, where I might find some sign, some celestial happening. I was wracked by guilt. Why did I not call in to the pub? What could I have done? What did I not do? Walking the bog, questioning. I didn't want to meet people. I used to write poems to Éamonn. The writing became so important. I could get it all out. All the feelings, the emotional trauma I was going through every day, all day. So when I came home I wouldn't have to burden Denis or Maire with all the chaos going on in my head. Because they were dealing with their own grief.

'I captured my grief by writing it down. It was so important and it helped me greatly. All of those thoughts became poems in a book of poetry called *Under Connemara Skies Towards Light*.'

We sit in silence and take in the morning air. I open her poetry book inspired by and dedicated to her son. It is a moving lyrical tribute to his life, and her loss. Some pages are filled with a sense of desolation, others with the smallest beam of light pushing through. In the poems, she has poured out her sadness and despair, and the accompanying photographs of daylight and evening western skies illuminate her anguish. I read one of the verses aloud.

This Need

Now that these words are
written, what was it all about
this voyage to myself, this road of

discovery through loss and suffering?
What is this constant need in me
to reach out to you, to talk to you,
thank you and seek your forgiveness?
Could it be your way of helping me
accept there is no going back,
to see the road ahead with you
settled in my heart, but to still
feel deep sorrow at your death?

She reacts to the reading.

'I tried to live in the moment, and say to myself, I'm on the bog now, I'm walking, I can't think back, I can't keep thinking, regretting everything, and feeling guilty about absolutely everything. I tried to tell myself, don't look into the future because the future is a terribly frightening place, it will make you so unhappy. Try to stay in the present. At least for a moment.

'There were many times I felt I could not go on. But I had to go on. I had to survive. I read books about people who had endured tragedy and survived the concentration camps. I read psychologists and philosophers, to find out how the human condition can overcome such pain and grief. I looked to the poets and songsters and writers for answers. I needed to survive. Eckhart Tolle taught me about the power of acceptance. Acceptance that what happens, happens. If something good happens, fine. If something bad happens, fine. The word "acceptance" is such an easy word to say but it is a big word to live.'

'Can you ever accept what happened?' I ask.

'That's the question,' she replies. 'But there was a point when I did. I can accept what happened has happened. I can do nothing about it. I have to accept it and find a way through it. Not around it. You cannot do that.'

'What do you mean by that?' I ask.

'I had to remain alive,' she answers. 'I had to find a way through the awfulness and the despair. I could not see any light. No light at all. I wouldn't have said it, but Éamonn was my reason and my purpose for being alive. I loved him. We were great friends. He was a good and kind person. He was the best friend to both Denis and me. It is what I miss more than anything else about his loss. Not so much the son I felt I owned, but the great and powerful friend that was now gone, forever.'

I don't speak. I remain seated and silent beside her. I feel she is used to silence and to finding a space in which to put thoughts and feelings. To give them air. My own thinking life never waits to do so, or never seems to find time to let in the fears and terrors. Or find a space to give them language and some living order.

Her face lights up.

'We donated Éamonn's organs. He carried a card. I once asked him why he carried it, and he said, "Why would I be taking my organs with me?" His heart, his liver and his kidneys were transplanted successfully. Four people were given new life. That was hugely comforting to us.

'I got involved in organ donation. I looked up websites to find out about organ donation. I didn't want to know about statistics, I wanted to find out about the human element and loss around donation. There were no human stories. Denis said, "We'll set up our own website." Éamonn had taught me everything about computers. We released a CD single to promote the website. It was called "Strange Boat", a song of The

Waterboys, recorded with national musicians. We called the website and foundation "Strange Boat Donor Foundation". It is a resource for the organ donation community.

'But I kept thinking about the donor family. Everybody can see the benefit to the recipient who's had the transplant, given an extraordinary new life. But the donor family are given little space or place to understand their anguish and maybe to make sense of it. I decided to create a garden. A beautiful garden. A meaningful garden. I would plan and build a recess of tranquil refuge and meaning for those who have lost immeasurably, and given of their loss immeasurably. I had walked for a year in a bog when Éamonn died and I saw what nature can do to ease one's excavated heart. I became aware of nature's benefits, in everything. I wanted such a place for others, flowing and contemplative, at all times of the year, despite inclement weather. Denis, an artistic stone mason, could incorporate strong and lasting stone from our lands and our ancestry into the garden's design. The garden would never be bare, and it would be circular, reflecting the circle of life. That was my ambition.

'We trawled for places to build the garden until finally Galway City Council gave us this space. It had been a small park, but over the years, due to neglect, it had become a wasteland. Derelict and run down. A place of desolation, used for underage drinking and antisocial behaviour. A wasteland for wasted lives. The centre of the space, where we are sitting, was the most abused, overgrown with briars and brambles and human waste. But it had the most wonderful mature trees. They had survived all the abandonment. Maybe I had too. I knew when I first saw this wasteland that it would be my garden and we must create it no matter how hard it might be. We raised the money through Éamonn's greatest love and talent, music.'

The story I have just heard is remarkable. It is both tragic and inspirational. I am lost for words at Martina's profound and unspeakable loss, and her unique visionary creation arising out of that loss. I look around, soaking in her creation.

'Let's walk,' she says, with a sense of joy and energy.

We begin to walk through the garden. I am walking now in different shoes. Earlier, when I had ventured around the garden, I was captured by its beauty and form, but my sense of purpose was general, maybe even aimless. It is not now. Now I know what Martina has had to endure, to find her way back to some emotional human ease. I know, too, the gift the garden is and has become for all those who have both lost life and gifted new life to others. No matter where we walk or pause or sit, the garden paths lead us back naturally to its central core of dolmen stone structures.

'These are standing stones from Cong,' Martina tells me, 'and they reflect and represent the circle of life. There's a carving and relevant inscription on each stone.'

I am anxious to read them. We stop at the first standing stone.

The bounty of the universe begins with the gift of life.

A quote from Sr Stan, represented by a carving of the Madonna and Child. A universal carving for all new human life.

The second dolmen stone reads:

We cannot teach people anything, we can only help them discover it within themselves.

A quote from Galileo, represented by a carving of a bird enticing her young, not telling them.

I read aloud the inscription on the third stone.

He who binds to himself a joy does the winged life destroy, but he who kisses the joy as it flies lives in eternity's sunrise.

A quote from William Blake. Martina reacts to my reading.

'We must allow all young people to find their way in the world. All butterflies must be released. That is how they live.

'I like the quotation on the fourth stone,' she says, as we walk on. 'It is my particular favourite. It is from Virgil, and I think it is very relevant, especially for me.'

I stand in front of the fourth stone. She reads it aloud.

Let us follow our destiny ebb and flow, whatever may happen. We master fortune by accepting it.

It is represented by an oarsman in a boat out against the sea, facing the horizon. The powerful word 'acceptance' appears again. I edge towards the fifth and final stone. Destiny. The inscription is the words of the poet, Brendan Kennelly.

Though we live in a world that dreams of ending/ that always seems about to give in/something that will not acknowledge conclusion/insists that we forever begin.

It is represented by a sunrise or a sunset, the cycles of birth, death and renewal. The strong solid Clonmacnoise stone stands proudly in the centre of the dolmen circle. I place the palm of my hand against the hand imprint carved out in the stone. It is as though I am trying to hold on to some ancient teaching or advice, and channel it from my palm to my heart, through the indentations on this ancient stone. Once again I feel the need to read aloud the inscription.

We hold invisible hands with those who have gone down in history. We cannot let go. They are holding us.

'That is the inscription on Éamonn's memorial card,' Martina says.

In an instant, I become aware of the garden's great strength. A circle within a circle, within the arms of another. Stone, flowers, trees, structures, all in the round and encircled by rockeries, rising to an ancient altar, with a deep water font from the fourteenth century found in an excavation, and placed against a backdrop of a rounded, ancient stone wall. Spiritual strength renewed. Thousands of years of fissured limestone stand as a living and physical history of eternal lands. Physical strength renewed. Strength, spiritual and physical, from within and from the centre. Martina's spiritual and physical strength.

The fresh smell of blue and purple lavender sits in the air, and it lingers for a moment above my head as the aroma of sweet incense. We continue our walk, passing iconic stones sourced from heritage sites from every county in Ireland, and representing all donors and their families within that county.

'I love the bird song in winter,' says Martina. 'We put bird feed out and we are gifted with their sound. Look at the robin. Hi, little robin. Have you come to say hello? He's having a wee drink. And it's going down his throat like a pipe.'

We linger at the elegant, carved stone bird bath. I dip my fingers into its smooth, clean rainwater. Stone may be cold to the touch but I always feel it has a certain warmth, maybe because of the small stone walls of Galway inviting you towards

and within their landscape, and the stones' secret inner shine and shades of altar grey.

We walk into a small space dedicated to the bereaved parents of children. The names of the dead hang from the tree like delicate paper lanterns. Jillian, Theresa, Robert, Louise, Kevin, Brian, Anne, dancing on the branches of the trees. Free.

People find something spiritual and deep in the garden. The Irish Heart and Lung Transplant Association, the Irish Kidney Association, and Anam Cara, a bereavement group for parents and siblings of children who have died, come annually to the garden. It means so much to them.

We continue on our journey past the ancient national heritage stones. Their symbolism

for all of our island people who visit is an acknowledgement of their lives and a comfort.

'Donors cross boundaries,' says Martina, as we walk towards the hill. She shows me representative stones from the great continents of the world.

'Irish people have died abroad and many have donated abroad, or would have been transplanted abroad. It happens all the time. They need to be represented and their families must be able to come here and feel a sense of connection within the garden.'

We walk past representative stones from the ground of Ellis Island in New York, representing the millions of emigrants who have passed through; from the Groote Schuur Hospital in Cape Town, where Dr Christiaan Barnard performed the first heart transplant; from the city of Madurai, where Mahatma Gandhi first donned his dote, the dress of his people and those he wanted to represent; from the stadium in Melbourne, where Jim Stynes, who died in his forties, played Australian rules and set up the Reach Foundation; and from the Irish Franciscan college in Leuven, where centuries of teaching and learning was established by the monks.

'There are examples of these stones all over the garden,' she says, as we walk back to where we had first met by the rockeries.

'I wanted to keep the humanitarian work of people alive, to show the preciousness of life and how wonderful life can be and how connected we all are. Even when something terrible happens and somebody dies, when their organs are donated, something wonderful can happen.'

I am astounded at her generosity. At her willingness and ability to carry on, to find a way to some sense of tomorrow, hope and the prospect of happiness and human ease.

'Do you realise what you have created?' I ask. She laughs into the wind.

'Sometimes I ask myself that question. Did I really create this?

'You did,' I answer. 'You did.'

'Yes, I did, but always with my husband, Denis, the stone mason and the father of my dead son. And many others musicians, landscapers, designers, builders, friends, family, county council, civic trust and the people of Galway,' she replies.

'But you were the visionary, the energy and the gardener,' I say.

'I never thought of myself as that,' she replies.

Greying skies begin to gather and to heighten the green colours of leaf and grass like a brilliant dye, rising to the brim of their shapes. The grasses move at our feet.

'Do you think the garden saved you?' I ask, still unable to understand how such personal grief can ever be carried.

'Yes,' she replies, without hesitation. 'The garden saved me. It saved me. It took a lot of concentration and time and great effort. Denis put so much effort in with me. It got me through so much. The writing was hugely important, and the walking, where it all began, and nature and beauty, all nourished me back. Yes. The garden saved me. Yes, it did.'

'Is the garden your spiritual home? Is that its strength?'

She thinks about this question and replies:

'I created this garden for others. To be received and experienced by others, incorporated into their lives, and connecting them back to those they have lost forever, through death. I created it also for the recipients, so that they could come

and feel connected to their donors, even though they do not know who they are.'

She has revealed a secret. It is found in the thought for others, the giving to others, the respect for others, the consoling of others, the nurture of others, a place for others. The human support for others at their most grievous time. A hallowed ground for others to find solace and relief. This is a sacred message. I remember learning such messages when I was a child. I have found them again within the walls of Martina's garden.

She gets up to leave, and as she does she says:

'It's twelve years since Éamonn died. I have managed grief and I can share it with people. I have no other role in life at the moment. Grief doesn't go away but it changes. At the beginning, it is fully dark and you don't see any light. And then some days you get up and there's a certain amount of light, and it isn't too bad, and then it gets dark again. You have bad days and grieving days and guilt days, and other days that are not like that.

'Time is the healer. In this garden I can feel my son, Éamonn, on the breeze. I feel emotional clarity here, where I can talk to him. I hope that this garden can bring peace and hope to others who are in such trauma because of their human loss. I have learned that the only decision ever, is the decision to help others.'

She leaves the garden on the same light feet with which she entered, like a spirit of her son, on the breeze.

Before I leave I seek out my own county's representative stone and bring with me, as I find it, the memory of all those living and dead and my knowledge and remembering of their lives. As I leave the Circle of Life garden, I pass the holy well. I look into its deep water and I see myself reflected in its clearness. I am grateful and privileged that I have had the opportunity to meet this gardener and spend time in her creation. I am better for it. She is a prayer and an answer. I leave with a full and beating human heart, and a renewed sense of the majesty of the human condition when faced with eternal grief. I leave also with a thanksgiving for the sacredness of my life, and all our living lives.

Ar scáth a chéile a mhairimid.

In the shadow and shelter of each other is where we all live. ●

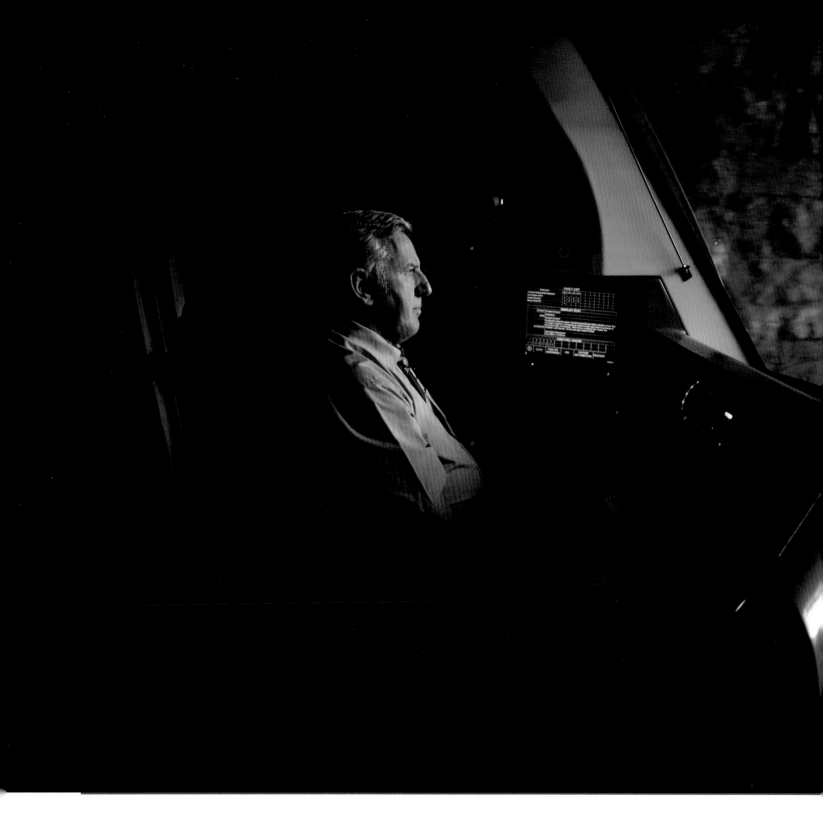

THE TRAIN DRIVER

Duncan McLean

Duncan McLean

SILVER BIRCHES, FARMS AND CHURCHES

Connolly Station is ice-wide and breezy.
Early on an autumn morning
muted and sleepy.
Blowey, blowey around the tracks, open crunchie
papers make their chocolate journey
stuck between the deep steel running girders.

Heavy-cased travellers write a play with their movements,
or backpack a poem with their eyes.
Mr and Mrs Comings and Goings and the all alones,
sit neatly amidst their train-tracking sadness.
Loneliness seeps through the broken tiled walls.

Maybe a break will come through the stations
or under the bridges.
Maybe a gap will appear or the grey hue disappear
on the 7.25 from Dublin to Rosslare.

'Did you know that Ireland has one of the most up-to-date train fleets in Europe?' asks Duncan McLean, the train driver. The two of us are making our way down the platform at Connolly Station. 'There are six hundred and eighty-six passenger trains every day in Ireland. Did you know that? Track upgrade, signal upgrade, and all rails welded for speedy travel. It is economical, computerised and smooth, like meeself!' and he laughs over at me, through the station's yellow tiled exits and entrances.

'Five hundred drivers work for Iarnród Éireann,' he continues. 'It's a very good company. Takes an interest in its staff. Prepared to listen. That's important. About three thousand eight hundred people work for the company. Passenger numbers are rising rapidly, and the trains are busy, yet not frantic. We are rehashing the timetable, for better ease and flexibility. Most of the drivers here worked their way up from passenger, and general station work, to the job of driver. I did that. We all have some connection with the railway. A father, uncle, or trains at the bottom of the garden. Most of the drivers, including myself, have been in the job for thirty years. I know all the signals, hazards, twists and turns of the routes.'

We're on the move as he talks, down the long, heavy, melancholic and well-trodden platform. I am frozen, and lagging behind. He doesn't notice. He carries his bag of locomotive keys, torches and manuals under his arm, as though it is propelling him forward. Unlike me, he is completely unaware of the arrow-landing cold.

'To drive a train,' he says, 'you must have a real night's sleep, and get your clock time right. With the normal motion of the train you can easily doze off. You have to be totally awake and keep your concentration, and not let your mind wander. You are in control of a machine with passengers, and it is travelling at one hundred miles an hour. You can never misjudge a signal. Drivers have to be free of personal issues. You have to be a certain kind of person to be a driver.'

'Are you a certain kind of person?' I interject.

'Maybe,' he says, not bothering to stop or slow down. 'Not everybody or anybody can drive a train. You need to want to work on your own, sit in a metal box, and like your own company. There is huge skill involved. Knowledge of the regulations, of the signalling, the procedures and, of course, memory of the route. Safety is paramount. We have a thirty-year record. Health and safety is very rigorous.'

We arrive at the head of the long, stationary, steel-seating compartments.

'Now take a look at this machine,' says Duncan, standing back from the track and looking at his forthcoming day's work with pride and anticipation.

'This train is a beauty. It is an ICR Intercity Railcar, the very best kind of modern train. It can do three-hour routes to the midlands, short inner city runs, or the longest route through the country. It is a real treasure.

'The railway is part of our Irish history. In 1834, the first railway in Ireland was built. It was from Dublin to Dún Laoghaire. Today, the 7.58 early morning train from Maynooth to Bray will carry one thousand four hundred and fifty people. That's what train travel really means. It is how I see my role as a public servant, and why we should never privatise Irish Rail. If we do, there will be no interest in the passenger. It will just be the interest of profit.'

He opens the iron-heavy door to his engine space. We climb inside. The cab is neat and designed for ease of hand movement to and from the controls and buttons. It is like a bank of computers or a sound studio, where everything is at the controller's reach. There are screens to the touch, and controls at the finger tips. The driver's instrument panel beneath the large window is semi-circular and surrounds a huge, comfortable high-backed chair, which he can never leave while the train is moving.

'The driver comes first when you are driving a speed machine like this,' says Duncan, with satisfaction and achievement. 'We were all consulted on the aerodynamics of the cab design. This train was made in South Korea. It has a Hyundai engine and cost €4 million. Some of the older trains were built in Japan, but some of the staff went to South Korea and had a say in this design.'

Duncan speaks about his train like an enthusiastic, wide-eyed boy and then like a fifty-year-old man, moving with ease from describing it as a child's toy to an adult steel machine. He arranges his coat and files, and begins to power up the system. I make myself comfortable in the chair beside him. I am, for the very first time, in the front of a train. I have a new view, a first view. No head strained out the small, half-opened rusty window as I remember when I was a child. No trying to catch within the eye and the heart the passing image. I am to have a full and a fresh perspective on a moving, fronted world.

'Dublin to Wexford is one of the oldest lines and one of the straightest,' he says, as he settles down into his large leather chair. 'You're lucky, it's a beautiful day.'

We are like an old weary snail carrying a heavy house, cautiously, lugging our way out of Connolly Station under an early smoky sky.

We gain some gentle speed, curving like a large, fat working rope in and out, above and through the tired city buildings, and the new and the old waste land. We pass the bottom of neglected and worn-out gardens and the backs of terraced houses with their uneven extensions. Overgrown buddleias fall like giant fans before us and across the many neglected and locked industrial steel gates. We move, without stopping, like a butter knife through the thronged, peopled platforms of Tara Street Station and Pearse Station. They are thick with young and old moving towards their early-morning destinations.

The Grand Canal Dock appears in the distance. It is slim, slick and sky-piled. Elevated shiny apartments peep through square, steel, prison-grey balconies. The courtyard neon sculptures shout out a symbol of modern two-roomed, compact urban living. We creep like the morning past the heave-ho of Lansdowne Stadium.

'A monument to a rugby ball in the shape of a glass roller coaster,' I say with awe, as the stadium's new bulbous frame glistens and gleams in the muted morning sun.

'More like a big glass arse hanging over the railway line!' says Duncan.

The world is waking. We leave behind the posh old houses of Sandymount and Sydney Parade. There are no horse-drawn carriages now, but croquet-lawned gardens and gated entrances survive as a reminder of a disappearing world.

A line of cars comes to a halt at the traffic lights, enabling our passage through the Merrion

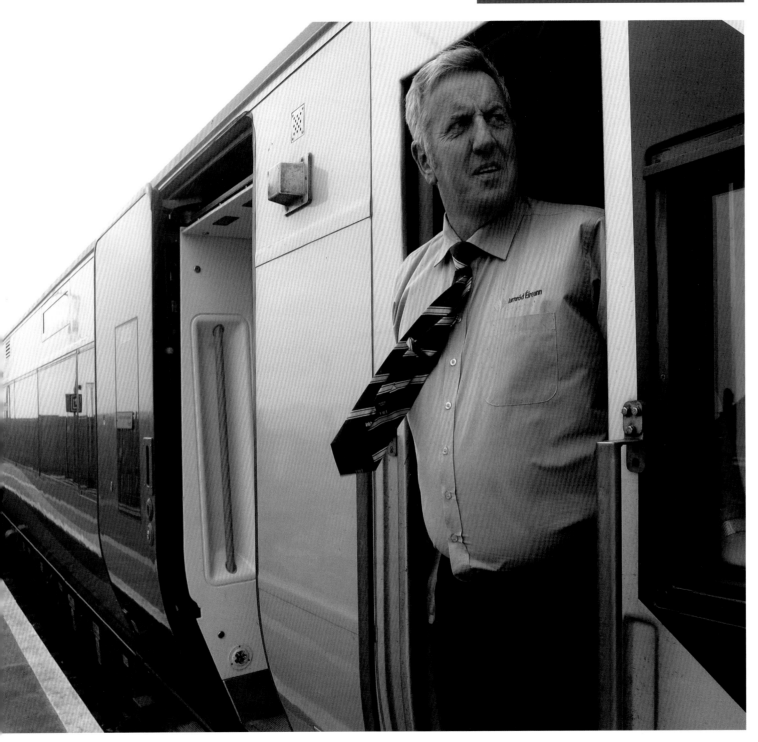

Gates, the level crossing at Sandymount. 'The busiest crossing in Ireland,' proclaims Duncan.

The sea sits on our left, low and still like a pancake. It will be our guide to Rosslare. A foggy sun is still trying to steal through early bored clouds, as the pointy spires of Blackrock churches pierce the sky in the distance.

On past the mud-marsh bird sanctuary at Booterstown we speed. A few lapwings and redshanks rise from their feathered sleep, disturbed by our thunderous approach. They elevate in flight above our carriages to find their own travel path in the wind. We pick up speed through Seapoint, Dún Laoghaire, Sandycove, Glenageary and Dalkey. The folding sea embraces the track's edges, and nearly kisses our speeding wheels.

The train slithers around the corners of Killiney, the affluent seaside suburb often likened to the Bay of Naples. Wealthy, castle-shaped houses sit at the foot of the rock face, or rise on uneven shelves along its precipice.

'You could never get angry doing this job,' says Duncan. 'The view will always calm you down.'

He is right. I watch the beginnings of the autumnal-fading green leaves becoming rust, carpeting the passing back gardens. On we go, past Shankill towards Bray Head, stretched and unyielding beneath its rising heavy coastline.

The train climbs high into the heart of the cliffs that drop sheer and sharp to the edge of the sea. We wind our way through the dense, ancient rocks, under the colossal boulders and into the dark deep tunnels. We are miniature passengers on a toy train, burrowing through caves, miles in length, and black as ink, above the fathomless sea. The only lights now are the pin lights of the instrument panel in the cab.

Ooooooohh … out of the darkness in an instant we appear, like some monster from the bowels of the earth.

On past Greystones, under cotton-wool clouds, along the spine of Wicklow and through its lush vegetation, surrounding us like luxury green eiderdown.

We rush past cut cornfields and hedgerows, farms and ploughed fields, past reed beds, and herons taking off like wide-winged jets into the sky above the hilly holiday homes.

'What is that sound?' I ask the driver, as a soft but evident alarm is heard in the cabin. It is not my first time to hear it.

'That is known as the dead man's pedal, the dead man's pedal,' he replies. 'It is a sound alert and a prompt which stays with me throughout the entire journey. I must acknowledge the prompt always, and if I don't, the train will stop. It is a way of keeping me and the train safe.'

I am glad to hear of this safeguard as we speed through the countryside like a fast and furious iron snake.

There are warning signs along the line as the train runs close to the walled sea. Warnings this time for the onlookers on pathways near the rail lines, warnings of danger at the level crossings, above low bridges and warnings for the odd early morning strollers.

I begin to compose a kind of poem in my head, to the beat and the rhythm of the train track.

Danger Danger … look out! look out!
Don't trespass on the country lines
The country lines,
The country lines.
Nobody knows, nobody knows

How fast the train will pass, will pass,
On the country lines, the country lines.

Metal wheels … look out! look out!
On metal rails … look out! look out!
A one cent coin touching the lines,
Touching the lines. The country lines
Someone is wandering
Onto the track, onto the track,
Touching the lines, the country lines.

Walking dogs, and earphones echoing,
Men looking through binoculars
Cannot stop, we cannot stop.
Passing metal on the country lines
the country lines.

Under the bridges, the pulse of steel.
The train will pass, will pass, will pass.
No Trespass
No Trespass
No Trespass on the country lines.
The country lines, the country lines.

A low horn of the train blows out. Warned walkers wave as though they know who we are, and the cows stand in the fields like black and white statues.

'Some people trespass with purpose,' sighs Duncan. 'Suicide is such a huge worry. All drivers have experienced this on the track. It has a terrible effect. The shock is intense and never leaves you. The train has had its share of other fatalities. Goats, cows, sheep and pheasants. Pheasants are the stupidest birds in the world. Sheep are no better. One evening in the coal-dark night, as the train drove through the countryside, a hundred big sheep eyes appeared in front of me, on the track. Some farmer had left his gate open.'

Duncan phones ahead to indicate that a young disabled man on the train will be unable to cross the bridge at Wicklow.

'I need to pull in on the main line to accommodate him.'

The signal man says, 'Yes.'

'As drivers we have dealt with hearts attacks, pregnancies and people locked in the toilet,' continues Duncan. 'Anti-social behaviour happens, but usually on suburban trains. There is always drink involved.'

On we go, past quiet graveyards, waiting for the rain, under a purple sky. Long, silver poplars stand like giant soldiers guarding the line. I am so near the sea, I want to jump out of the window, dive in, and still catch the final carriage. We ascend into the Wicklow pine-tree hills, where houses are dotted like flecks of snow, move on past deserted stations and into the centre of the many forests that surround the Wicklow terrain. The Sugar Loaf rises, like a meringue of coal, in the distance.

'This is the only way to travel in the snow,' says Duncan. 'It is like an Austrian landscape, especially at Rathdrum. Rathdrum is the highest railway station in Ireland. Did you know that when they were laying the long, straight lines in the country, they took the bellies of sheep and filled them with rocks? These were used as the foundations across the bog tables so the sleepers would not sink, especially on the Sligo line.'

No, no, I didn't, I answer silently in my head, as I watch the sharp weeds that have become a warm, ridged coat on each side of the train.

Houses are getting buried in the valleys as we travel on through the forest of Avondale. The line here has been forged out like an iron river, surrounded by angora woolly trees.

The driver breaks the silence.

'Did you know of the man in Co. Mayo who predicted that the last train into Achill would carry dead bodies? He was right. In 1937, in Kirkintilloch in Scotland, ten young Irish farm workers died. The last train into Achill carried their remains home to the island.'

The train rhythms and rocks through the maize flatlands. It is like a soothing cradle, and we sway through the time and shape of nature's architecture. We pass derelict sites and clapped-out weedy junctions. The old Lyons Tea Distribution Centre is now empty and rusting.

'The worst of places,' exclaims Duncan. 'We are unable to industrialise. We should be making something of a place like this. Re-inventing. We should be making the wind turbines ourselves. We should be laying freight lines.'

We travel on and on, past the old houses once used as landmarks in the dark of the deep night when we were without street lights. Past stone bridges crafted by hand over one hundred and fifty years ago. Stone bridges designed like small Romanesque monuments to remain when all the twentieth-century plastic and ugliness have rotted away.

Through the trees, there appears in an instant, high on a hill as we turn a corner, an exotic palace. A buttressed and joisted rust-coloured building of great beauty.

'What is that mysterious building from another landscape?' I ask.

'Saint Senan's Mental Hospital, Enniscorthy,' the driver answers. 'The old timers say it was an architectural mistake. The plans for an asylum for Ireland were sent to India and the plans for the home of the Raj came here.'

He laughs to himself at the thought of the reversal of such a design fortune.

We travel past golf clubs and manicured links, cut and combed like green-tinted tissue paper. Past the Irish National Heritage Park at Ferrycarrig, with its sculptured pinky crannogs nestling in the trees and the stuffed heads of a grey elephant and banana-coloured giraffe watching out, floppy-eared and long-necked, as the train goes by.

Along the great Slaney River now, the train driver and I become boatmen of steel, the river's watery turn and skim guiding us through to the great town of Wexford. I am reminded of the muscle and dominance of great rivers. The Mississippi giving life to the southern states of America, or the Liffey to Dublin, or the Shannon running through the centre of our island – all bringing breath and bounty to the villages and towns that grew up on their banks.

Duncan rouses me from my thoughts.

'There were brilliant railway maps of Ireland a hundred years ago,' he says, as the train runs alongside the Wexford quays. 'Every county had a railway. If we diverted three-quarters of what we spent on roads, we would have a unique track system. A railway to Donegal and the railway line restored to Achill.'

Arriving in Wexford, we move like an iron giant among street shoppers, traffic and general life, passing shopfronts, house doors and bus stops. We can see through the windows of all lives, getting ready for the day or not. We steel-glide along the pith of the townland, crossing the middle of the road at five miles an hour. We do

not disturb the busy streets. We are well known for years. We are loved and ignored. Schoolboys chat and chew beside the passing carriages, traders overlook us, and women with scarves and big bags cross at the large hazard lights, without heed.

The sculpted statue of Commodore John Barry, founder of the American Navy, watches our approach from under his Napoleonic-shaped hat.

We manoeuvre like a lasso through the broad expanse of the Wexford estuary, beyond the mussel fishermen out in the bay. Rounding our final sand and sea-cockled corner, we are, in an instant, pulling into the Europort at Rosslare.

'This is the weathervane of the economy and it is owned entirely by Irish Rail. Cars and cargo roll on, roll off, juggernauts and arctic units, two hundred cars, sixty freight and eight hundred passengers a day. From Rosslare you can go anywhere in Ireland in five hours,' says Duncan as he steadies the great iron ship to a halt.

Our journey is over. My steel-engined magic carpet, which has brought me through a sea shore, rock and forested world, from Dublin to Rosslare, has ended.

Station to station
Place to place
The travelling train on the country lines
The country lines, the country lines
A world from the front both fast and slow
Catch it now, latch it now
Metal wheels on metal rails
Winging through the country air
To silver birches, farms and churches
Slows to a stop by the edge of the sea
On the 7.25 from Dublin to Rosslare.●

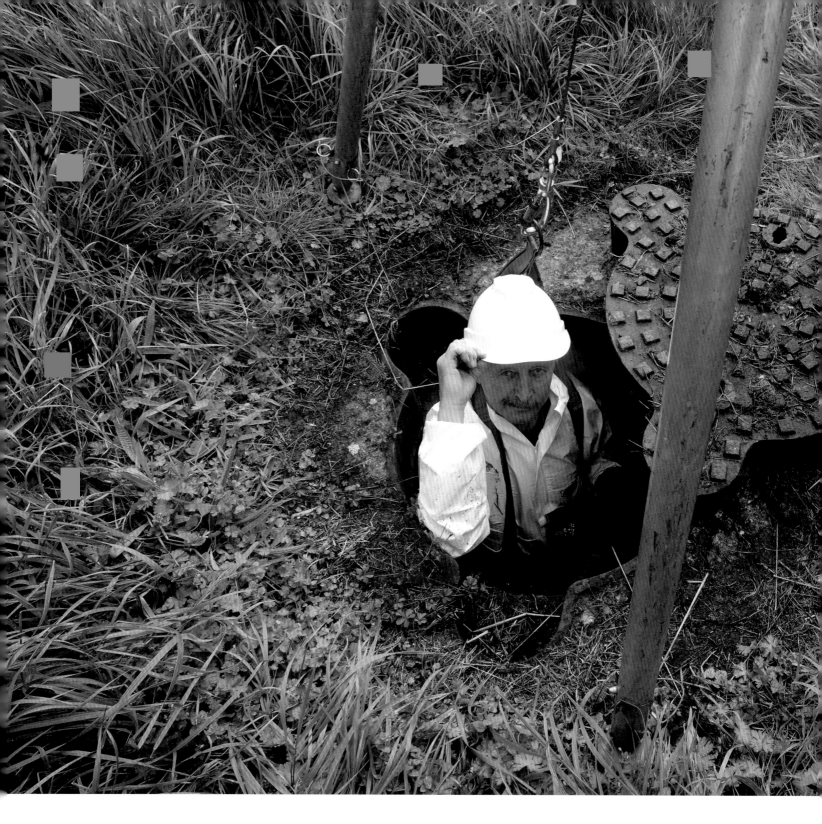

THE SEWER MAN

Vincent Sherwin

Vincent Sherwin

THE DEPOT OF THE DAMNED

'Nobody really pays any attention to where their poo goes,' declares Vincent with a nasal intonation. 'Once they have pressed the chrome handle and flushed a toilet, they just know that it goes away. Somewhere. Poo is awful. You know that it must be awful when you notice that, even in the snow, when all other ground is frozen over, the sewer covers are clear and free. That's because of the natural heat coming from the gases emitted by the waste.

'But as bad as poo is,' he laughs, 'it is the least lethal. It is the chemicals that are dangerous. Chemicals eat oxygen. And the sewer is full of them because we do not know what people are putting into their sinks and their toilets. And the result is that shite can kill.

'Ah! We're terrible creatures in relation to what we leave behind, terrible, terrible creatures,' and Vincent's repeated words disappear down into the black tunnel below our feet.

'If you throw a fifty pound note into this manhole, I'll tell you where to collect it. I'll tell you where in Dublin it will end up,' continues Vincent, without lifting his head to look at me, but at last ending his extraordinary introduction to the journey of poo. And what a journey, I think to myself, even for the paper money. What a journey!

We are looking down a Dublin inner-city manhole. Vincent Sherwin and me. A long look down into an underpass channel. A dark and heavy below-ground hole. Awful. Grey water gushes through from different outlets at its bottom.

'The water looks very clear,' I say, trying not to think of the unpleasant reality.

'It may look clear,' says Vincent, 'but it's not clear. It's sewage. You just think it's clear because it's moving so fast.'

And it was moving fast through the deep tunnels of heavy red brick. The sewers of the city of Dublin, built by the British in the 1850s, opened up and exposed now, seen through the iron grated coverings, the tarmac and the cement, into the brown bowels of the earth and on show for Vincent

and me. Vincent, the sewer man, now called inspector after forty years working for the North City Drainage Department. He is speaking with strength about his work, as our eyes travel down into the sewerage architecture of our capital city.

'Some of the Victorian sewers are beautiful, if you want to call them beautiful. Fantastic brickwork and extraordinary craftsmanship. They've lasted one hundred and fifity years and are in great condition. They were built in an Easter-egg oval shape, which gave them strength, also aided by the fact that they were constructed with bricks. Did you know that, up to 1913, the sewers went directly into the River Liffey or into our canals, our rivers and the Irish Sea? Can you imagine that?'

'No, I can't,' I reply.

'Well,' he continues, not stopping for breath, 'in 1914, the pumping stations were built and interceptors positioned all along the quays. The sewage was channelled into the interceptors through the huge pipes under the Liffey to Ringsend. We now have pumping stations all over Dublin, a new treatment plant in Ringsend and a submarine pipe that runs to it.'

'That's marvellous,' I say, not knowing how to react to this triumph of human waste movement. But I am interested to know all about Vincent and how he has remained committed to this most unattractive of jobs over the course of his life. He's certainly a real Dubliner. A man of natural dialogue. He speaks in long, drawn-out vowels and ends all his sentences in rising or lowering inflections. And his crisp consonants drive all his astute observations and sharp retorts like spears through all his conversations.

Vincent was born and bred within the inner city of Dublin. He's small in stature, quick-footed and wiry, which I learn later is a very useful shape when you are underground in low-lying, confined, dark tunnels. He's full of natural wit and good humour, other qualities that are necessary to counteract the essence of this dark, filthy and unwholesome job.

The drainage department is responsible for the sewers, and for the full flow of what we humans leave behind, across an expanding city. Clearing, cleaning and maintaining the sewers of the city is no laughing matter. There are different blockages every day, in different places, at different levels, between different drains and around different chokes. Working with sewage, detecting it and unblocking it, climbing down into it and moving it, needs a real if not unique commitment to work and a sense of absurdity. Vincent's attitude to his work, through forty years of his life in the sewers, among our human excrement and in the clearing away of all and every kind of obstruction, attests to those qualities.

'This job does not involve Max Factor,' Vincent says with a wide grin, straightening himself from the manhole to his mid-height. 'This is a job that sometimes defies description. It is a truly terrible job. Nobody wants to do it, but somebody has to do it. And you have to have humour and commitment around it, to find the sewer block, get it unblocked and get the sewer moving. In a job like this, you'd be useless without humour.'

In a job like this, I think to myself, you would need more than humour to get you through the day.

'But you couldn't have wanted to work in a sewer, could you? That's no kind of ambition for a young man regardless of the time,' I ask him, with

no sense of issuing insult to somebody whose job has had a real and defined function for us all. His answer is cool and definite, without any hint of offence.

'Do you know what I'm going to tell you?' Vincent replies, as he walks around the myriad heavy city manholes and among the drainage crew, who have yet to decide which one needs to be opened and attended to. 'I worked in a lovely job in the clothing industry as a hand iron presser. I used to do children's clothing, three to four hundred a day. I was like a machine at the end of the line. You kept ironing and ironing and ironing. I saw no future in the clothing, so I applied to Dublin City Council. I went for the interview and I got a job in Sewers and Main Drainage. It was 1977. On a Friday, I left a lovely, comfortable, clean job, and on a Monday morning, I arrived in Marble Lane. It's a desolate place and it's the same now as it was in 1977.

'When you went in, you knew nobody. You were given a shovel, a pair of hip boots, a pair of overalls and a pair of red gloves. You got one pair of red gloves for the week and one pair of overalls for six months. No industrial boots. They weren't part of the itinerary. You loaded yourself up onto the back of a lorry in a tin hut and you went out to the Camac River, a river full of sewage.

'In the middle of winter, you sat on an old lump of timber, with a little coke fire, and every morning when I came in, everything was soaking wet. My overalls were always sodden, and I used to dry them at the fire even though they had a million holes in them, because they had been burnt out from all the drying. I used to hold my rubber boots up over the fire to dry them. I rolled up paper and put them in the soles of my boots to stop getting pneumonia. And I sat in that hut, and if it rained you stayed all day in that hut. About nine of us and the ganger. We sat there in the depths of winter in that hut. Frozen, filthy and wet.'

'So, you had no real training, or you weren't aware of what this job would really entail?' I ask with a certain sense of stupidity and pity in my voice. He hears both and reacts immediately.

'Listen,' he says, 'when I came into the corporation to start, it was with the river gang, and then I was put on the big jack hammer for ten years in the middle of the city. People would stand around in duffle coats and big jackets at bus stops watching me. Breaking the road. The jack hammer wasn't easy. I used to have to get down manholes and bore a hole into the wall with a rock drill. Make a hole in the wall to do a sewerage connection to get the pipe into the manhole. You'd get into the confined space with a pick hammer and the noise. And the sweat would be pumping out of you.

'Or I would work on the bins. This is where we would take all that was caught up in the pumping stations such as sanitation rags. When the bin filled up, a lid was put on it and we collected these bins at pumping stations and then lifted and tipped the bins … the smell was unmerciful. I would have to run one hundred metres up the road to get away from it. We'd tip the bin out in Baltray out in Howth. This stuff would be toxic and you wouldn't even be aware of it. They had one gas mask and it wasn't working. Now it gets treated in the outfalls at Pigeon House Road, the main station. Everything is treated now.'

I lean against a wall, weakened by even the thought of the smell. He leans beside me. A great

Vactor drainage machine tank has pulled up on the other side of the busy city road. Vincent seemed to know it was on its way. I am silent. The over-ground city moves past us. Two seagulls savage a discarded box of cold chips. I look at the Dublin sky. Vincent knows that I am trying to find a fresh air cover for what I have heard.

'I cannot find language for that smell,' I say.

'Language,' he answers, 'there is none. It was demonic. Outside what the human nose could stand. Unsmellable really.'

I take so much of my product-filled life for granted. We all do. But the thought that someone has to make sure that what we leave behind is cleared and treated is even more disturbing. I am both appalled and amazed at what this man has worked at and worked for over his years in the cavities of the growing city of Dublin. But I had far more to hear and learn.

'There was also another bus called the "Maw Maws",' continues Vincent.

'The Maw Maws did a job that was unbelievable. We went out and we got down into the sewer pit. You climbed down the ladder into the sewer and you stood on the plank of wood on either side. And you daren't come off that plank or you'd go down into the foul as there were no ropes. You shovelled shite into a bucket. That's what we did. And the first fellow would go back ten metres with it to the next fella, and the chain went all the way back to the manhole.

'All of us down the manhole were bent over. You had to train yourself to be bent over. And when the fella at the manhole was pulling the full bucket up on top, if he hit the bucket off the step, the foul came down on top of your head. Some of them did it on purpose.

'That was your work all day. You shovelled and tipped excrement into catch pits. Shite from an area the size of Cabra. Raw shite and rats. And you had the same pair of overalls for months. You took these overalls off and went in and had lunch. Twenty minutes later you got back out and put them on again. There was no inoculation. Nothing. You'd put the same overalls on you every day and you'd bang them off the wall to shake off all the muck and the scum out of the manhole. Everything was soaking damp.

'Working on the North Dublin drainage system, we might have to divert the flow in the middle of the night. You'd get into the sewer on the Malahide Road and you'd put these timbers down into brackets. You'd open this gate and divert the flow so the lads at the pumping station could do their work. But sometimes when you were down there, the flow would be that bad and the slime that thick, that the timbers would fall into the foul.'

He notices me looking once again towards the heavens for some colour, or light, or breeze, away from this reeking underground world.

'The Maw Maws van had a smell that was eternal. Forever. It became ingrained in my pores and sat there. Forever. We didn't have sprays. Nowadays we have all of this disinfectant stuff. And I might have been looking to the sky just like you are now, to get rid of the smell, but I would have been wasting my time.'

'Vincent,' I say, in an official way and with a factual tone to my voice, 'it is very hard to believe that you were not unwell, all the time, or unable to work. How could you survive around such foul and filth, especially when we did not have the technology and machines to do at least some of

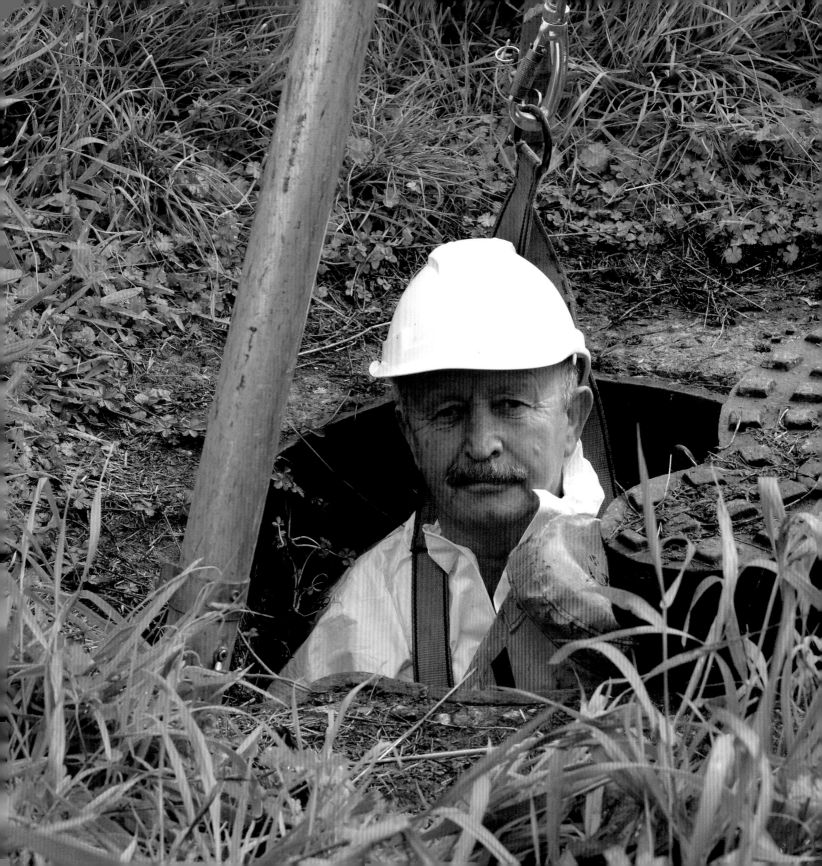

the most pitiful and dark work. It must have had an effect on your health.'

'I never got sick and I never got colds,' he laughs back at me. 'And I never missed a day's work. The foul made sure of that. Recently, we were doing a job in the mid-city and the smell was rotten. People walking by were white and weak with the smell, but I couldn't get it at all. Now that's an advantage.'

And he laughs some more over the passing traffic. Suddenly, his face becomes serious. Very serious. It's the first time I have seen him frown.

'And I never got a needle either. You have to be wary of needles when you're picking up anything in the sewer. Years ago you wouldn't see needles in the sewer. Now they're everywhere.'

I am saddened knowing that the awfulness of his job can be made even more dangerous. I wondered how Vincent could become so accepting of his work. It is difficult to imagine that anybody could. What lives secretly underground, and what is directed there, with our great resolve and our blessing, escapes our notice. In my own life, everything is so sanitised. We are the clean machine, or at least we purport to be, or try to be, with very little success. Overground, we are appalled at what we see dumped and how the environment is abused by our human garbage, excesses and remains. Underground we don't care to put language on our own discarded monstrosities.

'Come on,' says Vincent. 'Let's follow that Vactor machine unit. It's going to power jet a choke on the northside of the city. We'll follow it and you can see what happens.'

'Vincent,' I ask, as we walk towards his car, 'how do you maintain such interest in your work?

Where do you find the reason for the pride and the commitment?'

I ask him as though such a commitment were a contradiction considering what his job entails.

'Ah,' he says, starting up the car, 'people who come to work here now in the drainage department don't have the same interest. We get very few new staff. None in the last seven or eight years. Very few have any real interest in main drainage work or would have any pride in such work. For others, it is just a wage. I have been here for forty years. It was very tough at the beginning.

'When I was young, we were very poor. We had nothing. We always left the door of our house open, hoping somebody would come in and leave you something. There was nothing to rob.

'Maybe I was naive and young. I must have been to have gone down the sewer with a bucket and to have stood or bent over for hours, in the middle of the tunnel. This is how I got the experience. If you had no experience, you'd stand at a connection and someone would have a "hello dolly" and it would come out on top of you. So you learned very fast what to avoid and how to avoid it. Somebody had to do it.

'What we did, and how we did it, you wouldn't be allowed to do now. We were negotiating raw sewage. That was our work. Negotiating it. You never liked it. You hated it, really. Sometimes you were laughed at or jeered. There were no machines. Today it is different. We have power booms now. We wash down the manhole before we go down. But we still have to go down. Regularly.'

The car is spotless. We drive through the north city. Trucks and vans and cars are travelling alongside. The city is thronged with action and reaction, but Vincent is not thinking about the overground congestion. His concentration is still on his world beneath.

'I can tell you which way the sewer is going underneath,' he says. 'We could follow the sewer line across the city just as easily as that bus. The old sewers are in pretty good condition.'

I'm delighted with this information, but only for a moment, as Vincent continues:

'But the foul goes into the rivers in a storm, and nobody says anything about that.'

And neither did I.

The Vactor machine unit is parked when we arrive. We are given our yellow jackets, which notify that the drainage department is now here at work. Real work. I stand around with Vincent, who is greeted with relief and appreciation. I pretend I know what is going on. There is much activity as the great iron lids are heaved off the heavy cemented road. Big men with big stomachs and wide necks do the heaving. The sewers and the sweat and the smells are exposed and crawling around in the lids of the iron covers are hard-backed, fat beetles.

'Those beetles are known as clocks,' says Vincent, as though he was talking about some ornaments in a china shop. There are hundreds of beetles and moving insects in the crevices and grooves of the manhole covers. Cockroaches the size of golf balls and spiders and ants and termites twist and turn on grey-threaded long and short legs, in and out and on top of each other. Moving black choruses crouched over and together like humpbacked miniature witches, congregating and dispersing over and over again. I watch the cloaked black choruses collect and crunch under the frame and in the ruts of the sewer covers. An insect city.

'They're big black pests, and below them are the crawly woodlice. Millions and millions of them. It's like being in a black insect jungle. And that's just at the top on the covers.

'Come a little closer,' Vincent urges. 'You're missing something.'

He doesn't tell me what. I move cautiously alongside the sewer exposure. Floating on top of the choke, halfway down the long, dark grey tunnel, are brown and bulging dead rats. Dead rats as big as cats. I stare and don't speak. I'm afraid to move.

'That's the only advantage of a major choke,' says Vincent nonchalantly, indeed sounding somewhat elated at the discovery. 'The rats come floating up.'

I had tried up to now not to think about them, and had been afraid to pursue any conversation about them. This could now not be avoided.

'The sewers are full of bulging rats,' says Vincent, looking directly and boldly down at them as though he was giving a lecture to conservationists. I should have guessed that his knowledge about the habits and lives of these vermin, living nicely underneath our feet, would be unparalleled.

'Below down there,' he says pointing into the sewer, 'there is huge feeding. Bits of food and grizzle and scraps and waste, from all the restaurants and houses all over the city centre. It is like a free grazing area. There are a million rats in Dublin at the moment, or more. We're doing more poison laying than ever before. And the rats are the very worst. They are fat and full. They are living very well directly beneath us. The sewers are their home. Their five-star hotels.'

'Why are they the very worst?' I ask.

'Because they move with such ease through the human waste and foul as they make their journey through the bricked tunnels, tentacle pipes and connections. They can eat anything in front of them. They graze constantly all day long. They never feel full and they can eat themselves to death. They even eat the plastic Wavin that encases house toilets. Without a broadstrap, they can eat their way through housing sewage.'

'What's that?' I ask, with no knowledge of anything that happens below the carpet or tiles. Or indeed the vast city cement flooring.

'A broadstrap,' he answers, 'is a toilet-bowl shape with a cap on it that stops the rats coming back up the sewer.'

He begins to mime with loose arms and strong shoulders what he found when he unearthed the manhole cover in the gardens of expensive south Dublin homes.

'… those boys were ateing the back of private toilets. Imagine that … ateing the back of the millionaires' toilets. They can even eat the sewer brick, and have done terrible damage to the sewers over hundreds of years. Sometimes they go on long holidays to their favourite places under the best food outlets, eating houses, hotels and houses. I have seen rats so big that they can pull at their traps and move them.'

I am captivated by his knowledge.

'When you are down there,' he continues unabated, his memory and daily work alive and instant, 'you are aware of the grey misty air they create and you are breathing it in. You can also get caught between the rats. There is one every ten feet. They can pop their heads out of the connections at any time as you move. You'd bang your shovel off the wall to move them, or shine

your light on them, illuminating their bulging glass eyes. You could not see down the sewer. It was pitch black outside your own lamp or torch.'

'But how could you possibly contend with that? How was that possible?' I ask.

'When I started,' he replied, 'like I said, we did not have protective clothing. We didn't know what we were breathing in, and we couldn't go down dressed as astronauts because the sewer is too confined and you wouldn't be able to move around and be flexible. The torch and gas unit get geared up now and they determine the levels of methane gases.'

The big, bulbous, tanker-shaped machine, solid, steely and rounded at the corners, engines up. Ready. Vincent is elated at the thought of the power Vactor and jet machine equipped to unblock the deep choke.

'This blockage is twenty feet down,' he says. 'We need this machine to move it.'

'It's like one of those machines from *The Day of the Triffids*,' I say.

'I don't know what that is,' says Vincent. 'Come on or we'll miss the suck.'

We move nearer the action.

The suction pipes are like gigantic black, overfed snakes, meandering along the ground at our feet. They loop around us and drop down into the manhole like beasts from another world, slurping and drinking all the blockage and gunge out of the sewer caves, up into the body of the Vactor. Grease, debris, food, paper, sanitary ware, wipes, dirt and human waste roar up from the bottom of the city. Everything we have left behind over weeks or even months is drawn up into the Vactor, accompanied by a powerful drumming noise. Black, obese liquorice pipes slop and flop from side to side at our feet as the filth gets swallowed into the hungry roadside tank.

'There's a filter system in there,' says Vincent, pointing to the heavy-stomached tanker. 'It separates the solids from the debris.'

'I'm glad there's no window,' I reply, unable to imagine the contents nor what is happening to them.

The tanker is now full. I approach the manhole once again, as water begins to pump with the force of an underground Niagara Falls, strong and full and lush, down, down, down into and around the spaghetti caves of the sewers. Cleaning them.

'These machines can blast sixty-five gallons of water a minute,' shouts Vincent above the noise of the water power.

'I'm delighted they can,' I roar back. I'm thinking of the hundreds and thousands of toilets used by everybody, every day. He notices my satisfaction at the move of the choked debris. But he doesn't let it last long.

'The force of these cleaning pipes can destroy the walls of the sewers. There are many times that we have to go down and literally shovel the grease and the debris off the walls. We still have to do this despite all our modern machinery.'

'Where does it go after it's sucked up?' I ask.

'Solids from the Vactor unit are all tipped at the treatment works in Ringsend and the treatment lads take over.

'I know you like sanitation. You don't like to think about what lies and lives and is left behind and beneath. I'll take you to the sump at Clontarf. That's where much of the sewage comes in and is cleaned to a sparkle.'

The sump is a vast underground chamber on the coast road. It is warm as toast, machine-laden

and enveloped by a heavy lingering air. Gigantic pumps that could propel rocket engines into space start up and pump the raw sewage until the solids settle out. The pumping happens furiously and the sound is deafening.

I look down into the bowels of the pumping chamber.

'Where did all those potatoes come from?' I ask Vincent.

'They're not potatoes,' he laughs, 'they're balls of grease, our greatest curse. That's what it looks like when the pumps have driven the foul down and down and separated out all the solids.'

'It's certainly a much better way than what you had to contend with for years,' I say.

'That may be so,' he replies, 'but there are guys here who have to clean out all those solids, and this sump chamber, after the pumps have released out the fluid.'

'So nothing changes,' I venture.

'Oh, it does and it has,' he replies. 'But there are still some aspects of our work that demand the human being and his hand and eye. The machine cannot do everything, and sewage and foul, waste and filth never change. They never ease. Cities are expanding and expanding with not enough attention given to our waste and its journey, creating bigger and more difficult problems.'

'What happens to the fluid when it is separated?' I ask.

'It is pumped to a higher level,' Vincent replies, 'then into the submarine pipe underneath the bay, and then directly across to the treatment plant at Ringsend where it is separated once again. The solids become what is called "Biofert". The waste water is cleaned and fit to drink. It is pumped into the bay. Clean.'

'That's some progress since you first went down the sewer with a bucket and a shovel,' I suggest.

'Yes,' he replies. 'Waste treatment has been modernised from foul to fresh. It has become an engineering feat, and a very successful one. But with all our modern equipment, we still have to go down into the sewers when there is a serious blockage that no machine could tackle or even get to.

'Dublin, when the sewers were built, was a much smaller city. It stopped at the North Circular Road. It was fields from there. From the 1950s, with the great housing expansion, sewage connections were built as pipelines. And they have been added to and added to since, to a system built in 1860 to 1870. The result of this constant adding is flooding when the main pipeline gets overloaded. Floods are the most dangerous. If you put your hand down in flood water, it will be full of sewage. That's what happens in floods and we have to go into the sewer to unblock it and free the foul.'

He speaks as though it will always be so. As though we have never learned that how and where and what we build affects all we leave behind. And because of that, no amount of technology or engineering will ever be able to compete with the capacity and capability of manpower when problems arise.

'Certainly we have machines, vast machines that can suck up and suck out and wash down all the material, saving us from having to go down and shovel it out bucket by bucket. But the machine does not and cannot do it all. Something will get caught in the mouth of it, rags and other materials, and you have to pull it up manually. In the sewers now, it is mostly baby wipes and

facial wipes and sanitary towels. Millions of them. And they all wrap up and grease and solidify. They create modern waste boulders, and are the curse of everywhere. Wherever and whenever such a choke occurs, we have to go down the sewer and dismantle, trowel and shovel the modern mountains out. Over the last ten years, since I've been an inspector, I have tackled jobs that couldn't be tackled at all with the Vactor machines, no matter how powerful.'

'Do you blame people for not wanting to do a job such as that?' I ask.

'It is a difficult job. In every way. Young people are trained now to have huge and far-reaching expectations outside manual work, and certainly the kind of manual work that our job demands underground. Blame was not the word for me when I was young. The word was need.'

We make our way back across the city. I begin to look at its vast expanse in a different way. Vincent has taught me what real public service is about. The kind you cannot see and don't want to see. From our skyline we might consider what he did and does as a grade below and apart from all others. We would be very wrong. He breaks the silence.

'You might not believe this, but I will miss this job when I retire this year. I'll miss it because I have an interest in it. There's a manhole here in the North Dublin drainage system that has not been opened in one hundred years. I want to open it up before I leave. I know the system it covers backways. I've studied the maps and the drawings, the sewerage system of Dublin.'

'If we were to imagine, Vincent, that all the sewers were cleared and cleaned out and nobody was pooing, could you climb down into them and walk and bend and crawl your way through much of the city? Could you do it?' I ask, with a new-found enthusiasm.

'Yes, I could walk through a lot of them, between the two canals, down as far as the Liffey and maybe from Temple Street down to O'Connell Street. When I was working I crawled from Dorset Street, down North Frederick Street, down to the Parnell monument. I crawled through it. And the reason was, I wanted to see how it got under the statue. And I found that when it gets to there, it reduces down to two feet wide and you couldn't crawl any further.'

I began to imagine Vincent creeping and edging his way through most of the sewers around Dublin town. Snaking a path through a spaghetti junction of tunnels and passageways. Unafraid and interested in the genius of their build and complex walled networks.

We are getting near the north city drainage depot. I am looking at Vincent's profile across the car. He is neat of face and ever-boyish. It is not often I can use the word 'inspired' about somebody, but I find it easy to do so about Vincent Sherwin. More especially because of what his life's work has been, and because he has faced and completed this tough, dirty work with such energy, responsibility and charge. He interrupts my thoughts.

'I used to be called a shite shoveller with a bucket, then a labourer, then a general operative, and now I'm an inspector. I was with the river gang in tin huts across all seasons, and the angel gang, who filled in for everybody else below ground, and the Maw Maws, who did the worst of jobs. I used to have deep-orange-coloured overalls with "Sewers" written on it. Then they took the word

"Sewers" away and called us "Main Drainage". It sounded better.

'I have a deep interest in everything within the drainage department. I always say, show me something that I don't know. When I arrive on the job as an inspector, I always ask the lads to show me the problem, not tell me. Show me. And I'll go down with them to have a look myself. If you have a look yourself, you'll be able to detect what's wrong, and not forget why it happened.'

We arrive back at the depot and drive in. It's a dull, inoffensive, stone-blocked building. But it conceals a human waste underground control centre for much of the city. It is time for me to leave. Before I do, I'm anxious to know what Vincent will be doing with his future years, outside and away from his work. Will he cope? Does he want to retire? What will he do? Will it be enough?

'When I retire,' he says, 'I'll have a pension, so I'll relax and enjoy my life and my family. I've worked for forty-seven years. You can't go on forever. I have two daughters and a wife. I'm happily married, that's the main thing. I live in the inner city, in Church Street. I've a bit of a Mickey Mouse garden. Here's a photo of me sitting on my back roof. That's my extension. Not great, but it's mine. I sit there on a lovely day on the roof. That's my retirement. My small garden on the roof. And fresh air. Open, fresh air. Lovely, open fresh air.' ●

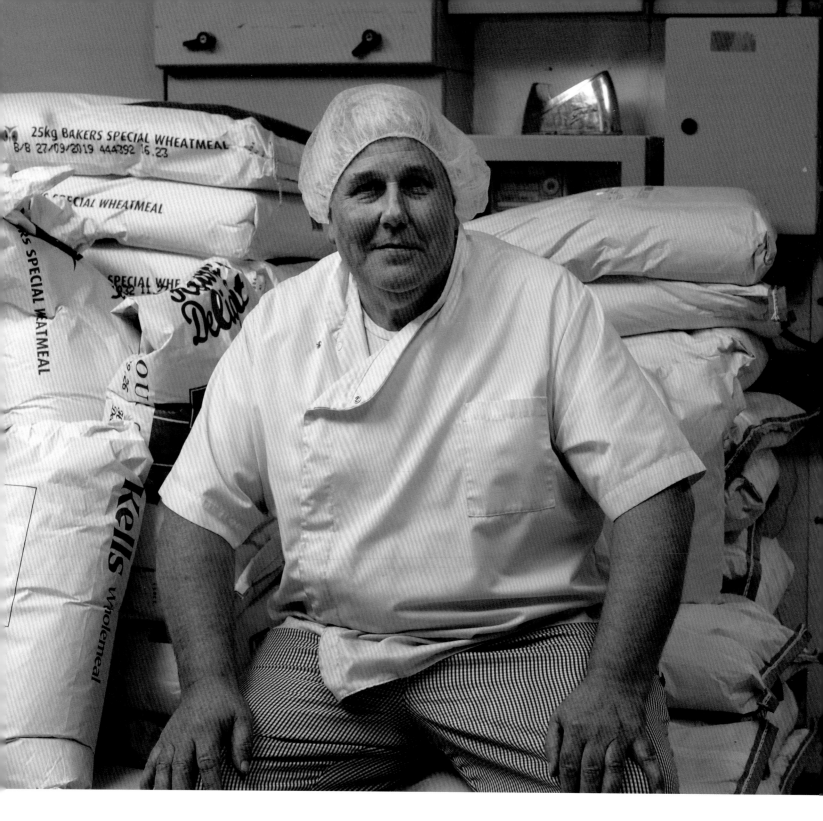

THE BAKER

Frank Brudair

THE DIET ENDS HERE

Apple squares and turnovers, coffee fondants, lemon curds, jam rings, shortbread, apple Danishes, cream doughnuts, meringues, eclairs, apple slices, chocolate Viennese, coffee butter cream logs, custard slices, Black Forest gateaux, lemon butter cream logs, chocolate mandarin Swiss rolls, pink slices, chocolate butter cream cakes, apple tarts, jam and fresh cream sponges, double chocolate logs, rhubarb tarts, fresh cream Swiss rolls, flaky pastry, cappuccino cakes, coffee walnut, farmhouse fruit cakes, scones, (plain, fruit and brown), pear and almond tarts …

The window of Brudairs Bakery in Charleville, Co. Limerick, is a visual feast. The smell of heaven. My face is near the window. I can't move. I stare at the celebration of sumptuousness. I could climb in the window and live there among these taste pleasures. Forever.

This was my smell of memory. My memory as smell.

Brudairs Bakery, created in the kitchen of Betty Odell's family home in Dromcollogher, Co. Limerick, is now a national luscious spectacle in the windows of her son Frank's shops in Charleville, Mallow, Cork, Tralee and Tipperary. What would Betty say now, I wondered. What a sweet legacy she has left her county, and beyond.

Dromcollogher is a town bordering north Cork. It is designed around a wide central square, allowing ease of movement for people and vehicles. Within the housing and retail space you can see visitors and strangers coming into town, and observe the town's colourful action. There is great symmetry in the design of the shops and the lived-in homes above them. The town emits a sense of character and grand decency. It is a town you could get anything in.

Frank Brudair and his five siblings grew up in Dromcollogher in the home bakery of great oven smells and around the skill, art and craft of the natural baker, his mother, Betty. She was his university. As a young boy, he watched her bake milky rice puddings with meringue tops, sponge cakes, baked Alaska, marble cakes with the colour running through the seascape-like sponge, queen cakes with a thousand different icings, half-moon buns, puff pastry slices and big-bowled butter-cream and icing combinations.

'Come in here now, you can make some soda bread and sponge cakes with me,' she'd say after his breakfast, or 'Go for the milk in the creamery in Broadford'. As a young boy he was always given little things to do. He was old enough at ten to be of some use, he tells me.

I am sitting with Frank, in his childhood home, where it all began and where he now holds and carries on the title of baker.

'Shop out front, family in between, and a small room at the back which my mother converted into a bakery right here – that's how she started off,' he says, looking around his old home. 'She made apple tarts and queen cakes and she started half-moon chocolate biscuits. She created different toppings for them and different creams and unusual decorations. She filled the window with trays, and each tray was decorated differently. Her displays were mouth-watering. Everybody came in for Betty's buns. Teachers from the schools, children, workers, families, mothers, young girls, old men and young wives. She could turn Swiss rolls and sponge cakes green for St Patrick's Day, and at Christmas time every room in this house was full of fruit cakes, Christmas puddings made with breadcrumbs and whiskey, Guinness light golden puddings, and mince pies and shortbread and almond icing …'

I am listening to Frank wide-eyed. I am holding the cake-filled window of his shop in taste-wonderment in my mind, as he tells me of his mother's influence on him as a young boy. 'I spent a lot of time with my mother. I used to work with her in the morning. She'd show me what to do. She was a taskmaster and made me pay attention to detail, doing things right and using my imagination. I enjoyed learning from her and working with her. And I enjoyed baking. I liked doing things with my hands. Whereas my sisters were faster to run out the door, I was happy to stay and bake with my mother and try to learn more. When I finished school, I was unsure of where I was going or what to do. I decided to try the bakery, just for a while, and it ended up being for a long time.

'We worked together well. We never got too excited with each other, which is important when you're learning, and she continued to work with me for years. But she became ill relatively young, and died when she was fifty-eight. At that stage she had set me on my path. She had grounded me. And it went from there.

'We had opened our first shop in Charleville before she died. It had a stone front and "1849" over the door. And we were opening a shop in Mallow. She was thrilled about it. It was really all her achievement. She was so proud of it. She loved seeing it continuing on and growing. It's the only comfort I had after she died. I just got on with it. Her death was hard at the time. She died just before Christmas, which was the time her energy was powerful, and her brain would work overtime on baking orders, baking needs, and coming up with new ideas.'

This is a story of an early loss of a parent. But it is also a story of an exceptional making and creating life, gifted now from Betty to her son. The smell of the bakery and the confectionery and her history is everywhere. There is a flour gauze shadow in the air, and its dust lies like fairy snow across the cupboards, tables and presses in the original house. Behind where we are sitting, the bakery is still working. I can smell it. It may have expanded over the years, now with a staff of

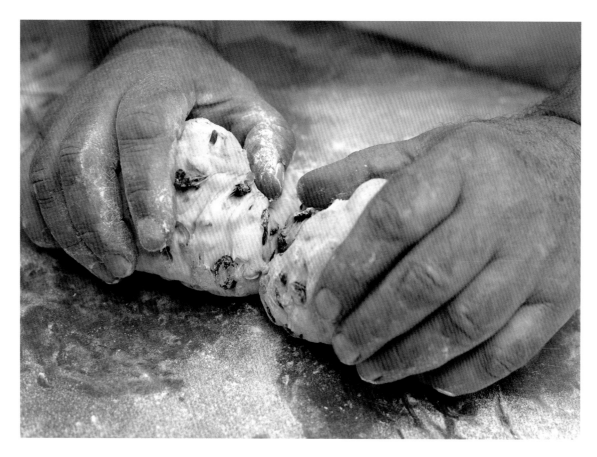

seventy and three vans on the road, but it has at its core what Frank's mother began.

'I'm very attached to this bakery,' Frank says. 'It's where I was born and raised. Even the physical presence of it has an attachment for me. I invest my time, my energy and my emotion into it. And my mother's enduring imagination. I work here more often than I don't.'

I can feel the presence of its history, his boyhood training and his parents' work ethic. His father drove a bus for CIE across Limerick, and through the country towns, while his mother created a world of sweet taste and delight that all ages loved and enjoyed. The spread of the delight began with Frank putting one small van on the road, selling scones, breads and tarts to shops around Limerick and Cork.

'I share your memory,' he tells me, as we walk through his old home to the bakery, 'the memory of the cakes and buns and breads we had when we were young. Very little has changed in this bakery.'

I step into the Brudairs Bakery universe of smell. Nothing can compare to it. I never want to leave. For me it is the smell of home and comfort and family. It is the smell of hearth, of welcome, of

living. The smell of willing you in at the door for good conversation. The smell of crust, heat, warmth, natural earth and new-mown grass. The smell of porridge and turf and soft, warm tweed. This smell is more evocative than any image. It is as potent and as poignant as any song or melody. And it sits in your memory as an eternal aroma, never to be forgotten. I am among the folds of flour, wheaten, coarse, fine, brown and white, waiting to be kneaded into the bread hall of the world. And among the butter, egg and sugar world, ready to create a confectionery city of pastry, sponge, tart and cream, to gladden and satisfy every palate.

There is much to do. We have soda bread, and spelt loaf and stoneground health loaf, and oat meal, and malt and barley loaf, and soda bread with a blend of flours, and basket bread and Vienna seed plain, and grinders batch, and farmhouse pan loaf, white and brown, and barmbrack, sultana and walnut, and tea brack with real tea, and iced tea loaf to bake through the night for delivery to the five shops, fresh and early tomorrow morning and every morning all year around.

'What makes a great baker?' I ask, putting on my white coat, trying not to look aghast at the amount of work to be done during the all-night bake.

'Standards, quality, attention to measure and passion,' says Frank, who has been doing it for thirty-five years. 'If you are making one cake, the measurement must be right. If you are making fifty, it is exactly the same.'

'What makes a good scone?' I ask, full of questions and ready to avoid the real work ahead.

'Appearance, texture and taste,' comes the reply,

'and the customer is always right. A scone should be warm. As close as possible to out of the oven. It should not have an aftertaste of the baking powder or the bread soda, or leave your mouth dry. It should be short enough that you enjoy the flavour of it, with no residue taste. And good-quality ingredients. Full buttermilk, the best of flour and plump sultanas. Or if you're putting a bit of cinnamon into it, make sure it's fresh. And don't leave the best of it in the oven, and bake the be'jaysus out of it!'

Frank mixes all the ingredients for the different stone breads. He measures everything in giant weighing scales. He cuts and weighs the dough. It is passed through a moulder, which with its iron arm, twists, moves and massages the dough around the giant steel bowl. It does what all our grandmothers did as they kneaded their bread with well-worn hands.

'The moulder makes, holds and refines the texture,' says Frank, above the noise of the low-toned machine. 'Textures are internal and external. There are very few machines in this bakery. And those that are here are just a notch above the hands because of the amount. The scaler divides and the moulder moulds, an intermediate proof and a final proof. You'd find my machines in a museum.'

The touch of the flour is like the touch of satin. It is smooth and cold through my fingers. I lift the flour and let it fall. The flour dust settles on my palms.

'We bring all the dry ingredients together. It is called the thread stage and we quicken the pace of the movement to develop the dough and the gluten in the flour. That's how we give it structure and hold the different flavours through

the different breads. Dough is always changing, dough is always growing. Dough waits for no man,' says Frank.

I watch the dough moving, now slowly and now quickly. I can see and feel the changes as the dough travels around the heavy-bowled spheres. We leave the yeasted dough in a warm space for it to rise and settle.

Then my work begins. Therapeutic work late at night. Out on the long cold table the dough is laid. We must knead by hand. I turn and twist and fold and turn. I press and turn and twist and fold. My palms move strong at the thumbs, curve to pancake the dough flat, bring it back to a mound and twist, turn, press and fold once again.

'When you start baking, you begin with your right hand, but all good bakers are ambidextrous,' says Frank.

He is moving the dough as though it was air through his hands. Country man's hands turned balletic. He stretches the dough out like a long snake, rolls in one end, turns and rolls in another underneath, over and under repeated all the way down, until it resembles an Irish dancing girl's plait or a figure of eight. I complete ten. I'm exhausted. Only another one hundred stone ground breads to go!

Racks of all other breads, pans, rolls and scones are placed into ovens the size of a small elevator. Depending on the bake, some are placed into deck ovens which are open-fired and fierce. Vienna breads are cut at an angle, others are cut straight across their top.

'It makes a difference in the taste and in the identification and shape,' says Frank, 'and the cuts let the air in in a certain way. Mrs Murphy in Cork thought my sliced pans were too airy. I tried everything to get them un-airy.'

The batch loaves on trays come out of the oven stuck together like miniature drumlins.

'You cannot leave the best of the bread in the oven, to overcook or undercook. Everything answers to time,' says Frank, as he continues to knead.

'And what about the apple tarts?' I ask. 'The staple dessert of every home in Ireland, and it is ageless. Pauper and prince love it. What is your secret for it?'

'No secret,' replies Frank. 'Use real butter, good flour, ripe, tart cooking apples, sugar and our lovely Irish cream. Don't murder the apples with sugar, they only need a little bit of kindness. And soften them a bit. Don't toughen the pastry. Treat it gently with nice cold hands. And roll it out. Go easy, softly, gently on the pastry. Talk to it if you like. All confectionery is more complicated than breads. Pastry and sponge is not dough and all must be treated, mixed, rolled and kneaded very differently.'

The confectionery is baked in the morning for freshness. It may be more complicated than the breads, but Frank maintains that the standards and processes are the same even though the ingredients are different. All confectionery must be baked with perfection in the different ovens.

I watched the confectioners at work as they made and cut choux pastry, rolled out the pastry for the apple and rhubarb tarts, cut and prepared the sponge cakes, Swiss rolls and buns, dipped the doughnuts into the sugar, and filled the apple slices and eclairs with glorious cream from Kanturk.

'How do you know what to bake, or how much of each variety?' I ask, mesmerised by the

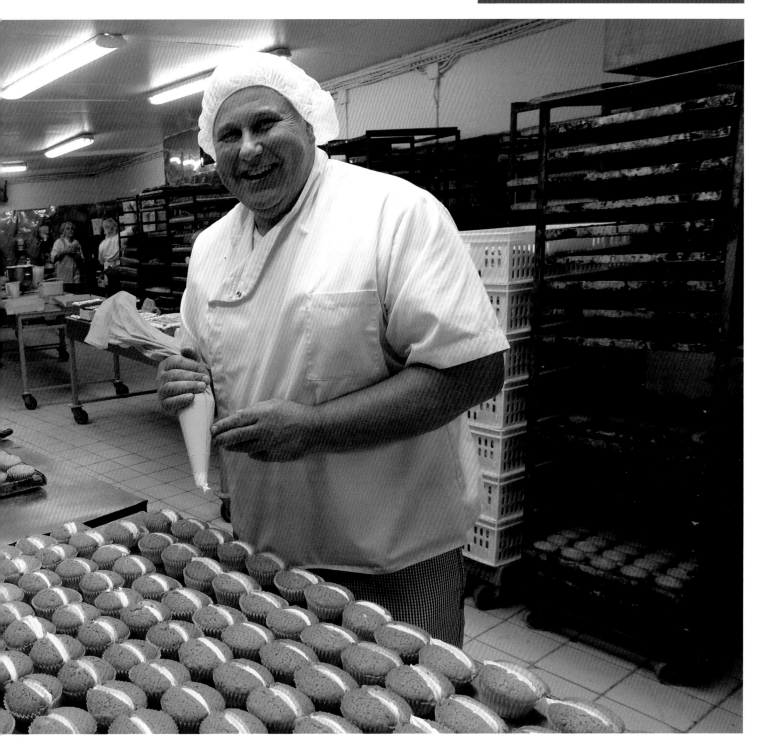

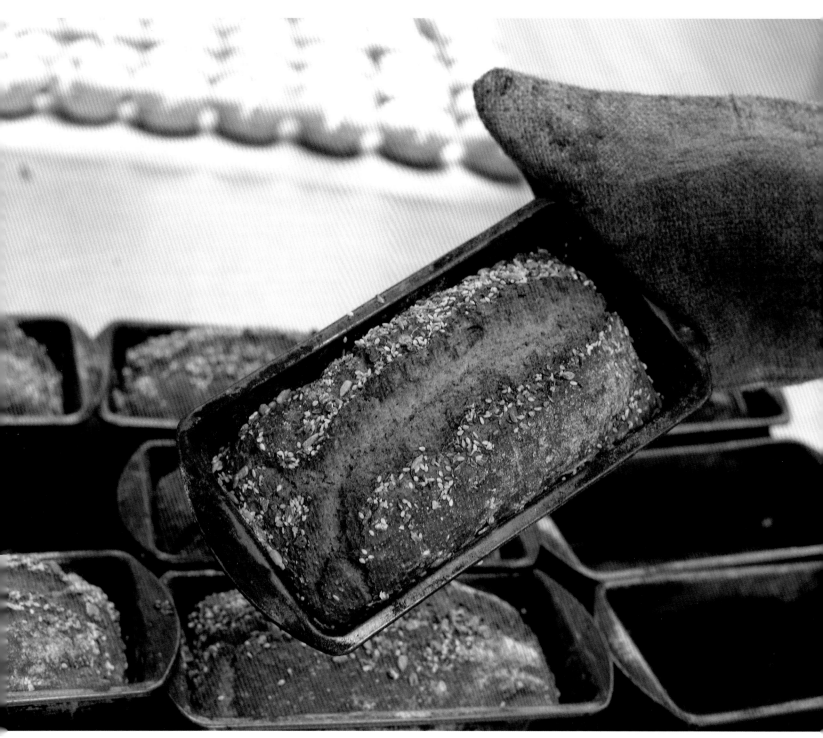

amount of cakes and buns, and by the freshness of everything and the thick whipped cream.

'You need to know when to make something, and how much to make. What ingredients to order and when to order them,' replies Frank. 'You cannot make two thousand doughnuts today – you may not sell them. You must be able to say, "I've just sold the last one, but if you come in tomorrow, I'll have one fresh for you." If it's gone, it's gone, and that's good. We'll have more again tomorrow. You make it today, sell it today and bank it today. That's it, and that will always be it.'

'Maybe I am just too romantic about it,' I reply. 'It's my memory of the co-op cakes and the bakery in the town where I was born.'

'I have the same romance and passion,' he answers. 'I grew up with that. But I also grew up with a real business acumen. You cannot just make lovely cakes as you see around us. You wouldn't last long. We call each shop every day between 5.30 p.m. and 6 p.m. and we take stock of what is sold and what is not, so we can control the freshness and the quantity and quality. This is a business and I can never forget that.'

'And what do your customers like?' I ask.

'The Irish love their fresh cream and loads of it. And they love little luxuries. In Tipperary, they love fresh cream cakes and fresh cream buns. And fresh bread and grinders and batch bread. In Dromcollogher, they like barmbracks and queen cakes and apple tarts. And fresh Swiss rolls with jam and cream. In Charleville, they like stoneground sodas. On a Saturday morning they come in for their custard slices. In Wilton in Cork, they like dry buns, which are like Viennese biscuits, and half-moon buns and non-cream buns. Anything that hasn't got fresh cream in it.'

'Did you know that we source all our ingredients locally for all our cakes? As well as the cream from Kanturk, we get the apples and rhubarb from Armagh, honey from Duhallow, flour from Odlams, butter and margarine from Daly's of Cork, and blackberry apple jam from Billy Quirk's fruit farm.'

No wonder the confectionery has ten people working in it through all the different stations – there is much to make and different skills needed to create such a variety. There are myriad cakes to fill, ice and decorate to satisfy all those palates and the extra orders each day: sixty birthday cakes to make for families across the hinterland; celebration cakes for all occasions; a cake in papal colours for a young girl who sang for the pope; and cakes for local football teams and clubs, decorated with emblems and flags, colours, badges and names. I watch as staff write dates and commemorations and congratulations, carefully scribing the coloured icings with looped italic precision.

'You're bringing the cakes to Cork and Limerick,' I say to the early van driver as he loads up his bake for his run.

'I am,' he replies, 'I am … sure, the day wouldn't be worth living without them. It's sunshine for everybody. See you later,' and he drives off into the county with a treasury of taste for all.

I set off with Frank to deliver the warm, soft and crusty breads to the shop in Charleville. At this early hour the county is green and quiet, but the country lanes, lined with thick berried hedges, are already alive with bird song. Fresh out of the oven, breads in all their variety begin to fill the long glass window in the Charleville shop. Early-morning mountains of buns and

scones surround the breads to tempt the waking town inside.

The fresh confectionery arrives. Rainbow-coloured icing sits on top of the sponge cakes and buns. Cream oozes out of the pastries, falling on to the doilies below, and soft chocolate coats the top and hugs the sides of the long eclairs. The Swiss rolls are heavy with sticky jam and dusted with white icing sugar, and the ringed sugared doughnuts loop and lounge in baskets on the counter. High up on the shelves, the rounded, heavy chocolate sponge cakes sit like emperors, surveying all beneath their glass thrones.

'The bread here is as good as my home cooking,' says Peg, arranging the scones. Peg has been with Brudairs for years. She, like all the aproned women behind the counters, knows all her customers.

All through the day, town and country come in for their orders and selections. They all know what they want, as the breads, buns and cakes fly off the shelves.

'You need to know your customers, and what they like, and keep up that standard of fare every day, all year round,' says Frank, as he butters, jams and creams a fresh scone. 'We certainly know nearly all of them in most of our shops.'

We sit to enjoy the warm scone and a cup of strong tea. It is glorious and comforting.

'There was a tall, striking-looking man came in here every Saturday morning,' continues Frank. 'He'd buy four chocolate rings, two chocolate circles, a soda cake and a loaf of bread. He died recently. And we missed him. Another man comes into the shop in Mallow daily. He buys six queen cakes, and a basket loaf. Another here in Charleville buys eight large white pans and an apple tart every week, and a lady buys a pink

and white layer cake with coconut around the side every Friday. People ring in the morning to have stuff put away. The first hour here is spent putting things away. We know everybody's order and who they are.'

'You must be very proud of what you have achieved,' I say. 'From your mother's bakery in the back room of your home, to this stone-fronted cake shop, with leather seating and round tables for all, and five other similar shops around the county. Do you ever sit back and think about what you have achieved, and how your late mother might view it?'

'My daughter was going to Dublin on the train recently,' he answers, 'and when she got off, she saw a lady with a cakebox. It was one of ours. She took a photo and sent it to me. I was very proud of that.

'My mother taught me how to bake and make. We need to spend more time learning to make things. We don't make enough. We are born to make. We need to make. We need to manufacture. It's a way to feel good and useful in yourself. And you are testing yourself, your hands and your brain. We could make far more for ourselves. We are constantly buying food to throw it out. Throughout my whole family background, we have been either makers or fixers or people who have produced something.'

I watch Frank as he walks through the shop, stops and talks to the townspeople at the different tables enjoying their coffee and buns. He helps box the exotic cakes and cream buns, finishing off their encasement with red and white twine and placing the breads, scones and dry buns in fresh brown paper bags. The customers greet him as though he is family.

'Is there any other cake you might like to try before you leave?' he asks, as he passes.

'A sugary doughnut and an eclair,' I reply, as though there is to be a shortage in the county bake.

It arrives. The perfect final taste delight. The sugar on the doughnut sparkles like miniature stars in a dark golden ring. And the eclair, with the finest combinations of cream and chocolate above and through the crisp choux pastry, has its own eye and mouth-watering reward.

'I can see you're going to enjoy that,' Frank says. 'It is possibly the greatest, if not the only real reason I have this business today. I make to sell, but I always want my customers to enjoy every bake. I want them to like it. Life has dealt me a good hand. I have had a chance to work for myself. I never started off in business to accumulate a lot of wealth. It was not my ultimate aim. My ultimate aim was to make quality cakes and bread. To have my own shop that I could be proud of, and people would enjoy. And it is still my aim.'

It is time for me to leave Brudairs Bakery behind. Satiated.

'And what about you?' I ask Frank. 'What is your favourite cake of all? Or is that the best-kept secret, along with many of your recipes of old?'

He whispers to me.

'A couple of times when I am in the shop late in the evening, there just might be a chocolate ring sitting on the corner of the counter. I would feel it calling to me. On the way out, unnoticed, I'd take it with me and I'd eat it on my way home. Happy out.' ●

THE
WEATHERMAN

David Meskill

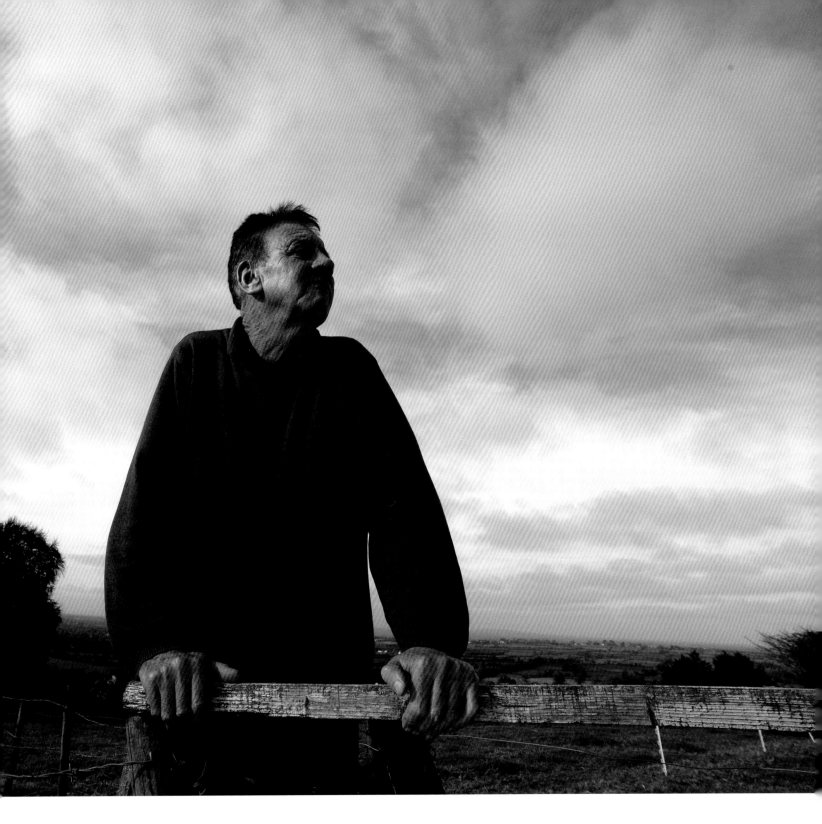

SMELLING THE WEATHER

I climb the hill at the back of the small farmhouse. The morning is as cold as iron. Steely and clear. The air against my face is as though I have opened an industrial fridge. The sun spreads like milk over the landscape. I continue to climb, up to six hundred and forty nine feet above sea level. I am on the shoulder of the Ballyhoura Mountains, above where the farmhouse nestles in its great arms, beneath. I look out over the vast terrain below. Charleville in Co. Cork, Knockfierna in Co. Limerick and Croom Tory Hill over towards Co. Clare lie like a giant tweed rug for miles beneath. And in the great distance the golden vale of Tipperary, lush and green, edges up to all their borders like the robe of a golden earthy king.

The grass is crunchy and steadying under my feet. I can see for fifty miles in front and one hundred miles in length. Frocked fir trees cluster together on the rise and fall of the glens and valleys of Ballyhoura, all around me. A coloured quilt of green and gold and brown has been thrown over the open land. Its rural patchwork is only broken up by little fat bushes, hedges and stone walls.

Sparkling white specks are the buildings and houses in the distance, and the odd coal-black church spire rises like black icicles between the hills and drumlins.

Every morning of the year, David Meskill climbs this hill at the back of his house and small farm. He has rarely left the place where he was born and raised here in Ardpatrick, Killmallock, Co. Limerick, in fifty-nine years. He has been observing and reading the weather from this vantage point for years.

I arrive very early so as not to disturb his weather measurement routine. His house was hard to find, tucked away and standing sideways on a sloped drive behind some well-worn hedges.

A tall and strong-faced man with dark hair answers the door. His welcome is mannered and shy. I sit in what I know must be his armchair, huge and bumpy, beside the warm, large black range. His farmhouse is old, small and basic, with a stone floor and two tables, with oil cloth covers. I notice that one table under the window is set for tea. There is a welcome iced cake in its box in the middle of the table, and serviettes.

The room is both a kitchen-dining and sitting room, with occasional small tables, one of which has a fridge on top. Old biscuit tins, boxes, newspapers, kitchen pots, jugs and cups sit on and in all available spaces. They all have a unique function. Dozens of hooks hang on every wall and behind doors. Each has a use, as ties, belts, caps, beads, coats, dishcloths, kitchen instruments and utensils are all held up on them, like paintings or ornaments. Washed clothes hang on an internal clothes line, above the range. Drying.

Old photos of his now deceased family members sit on the walls, and there is a smell of turf and long-living in the air. There are religious icons everywhere, holy pictures, holy plates, framed prayers, photographs of priests, bishops and monsignors. The Sacred Heart statue and red lamp are a colourful relief among all the black and greying clergy. On the windowsill of the porch, miniature statues of St Christopher, St Patrick, Jesus of Nazareth and popes old and new stand on watch, preparing for visitors. But they are not intrusive. In fact, they are welcoming and gentle. Like David Meskill.

We sit down at the table and he pours the tea. He begins to tell me about his life under the protection of the mountains. His summers as a young boy and the days of haymaking and silage-making, over in Toor at his Uncle Jimmy's, when child and adult worked hard together, and there was no big machinery, just human energy, the odd horse and the long days of heat and sun. He was formed by his rural and farming environment. Nature and the seasons have taught him so much, moulded him to a truth about a cycle of life, and how to be close to it, believe in it and get the best out of it.

He talks of his love for the seasons and especially April and May, when the countryside is beginning to come alive again and to change into a light green colour, with an optimism around for everybody. He remembers the smell of hawthorn coming into bloom, of elder blossom, honeysuckle and woodbine in the hedgerows and the divine aroma of his world after a light shower of rain.

He speaks like a poet about bird song in Glenmore. The dawn chorus of May and the dusk chorus at the end of the brightening days. Thrushes, various blue tits, coal tits, and the twittering of small birds, when they first arrive, flying through the farm and nesting in the cow house. Nesting in the cow house to the present day, generation after generation after generation. Migrating at night from the south of Africa, on hazardous journeys, to arrive back to the place of their birth, and staying only a while to rear their broods. When mid-September comes, they pack their bags and are gone, overnight. He is saddened at this thought and leaves the table to take an old Irish book, *Jimmy na n'Ean*, from a shelf.

'*An mbeidh mé ann nuair a bheidh siad ar ais arís?* Will I be there when they come back again? he asks himself, as he crosses the room to make fresh tea.

He looks around the walls at the history of his small family, and speaks of the influence of his parents, his neighbours and, most importantly, his religion in all that he is and does. His faith means everything to him and it is unwavering. He practises it with pride and purpose. Prayer was always part of his life. Rosaries at home, the Catholic ethos in school, serving at Mass as a young boy, and the religious rituals of his community. In his twenties and thirties it wasn't habit that sent him to Mass, it was his strong belief in God.

He feels his faith in his heart and soul. He finds it in nature every day. The huge masterplan of creativity and life and knowing that God is there, dovetailing it all. He has visited Knock Shrine and Lourdes and knows each of their histories not as myth, but as a reality.

He has remained a pioneer all his life, but it hasn't dampened his enjoyment of music and his great love of set-dancing. He went to classes when he was younger, and was taught by a man from Ballyheigue. He set-dances on winter week nights, and he recites like a ballad the sets linked to Munster, West Cork and Co. Clare. Sliabh Rua, Sliabh Luachra, figures of eight and four and all the different rhythms and swings and spins in each. He tells me of his love for his community and his small parish of four hundred and twenty seven people, from a grandfather who is ninety to a new baby girl of eight months.

Then he thinks back to his school days. School days as chalk and talk and no technology until Sean Lenehan from Co. Mayo came to the school as principal and introduced fifth and sixth class to rudimentary science. He was in that class. How lucky he was. Part of the teaching was observing the weather. Twice a day, as a young boy, he went out to take rough observations of rainfall, temperature, wind direction and weather conditions generally. That is where the seed of a lasting interest in the weather was sown. He speaks of the diaries he kept every day as a young boy and through his teen years, because he had no equipment of measurement.

He remembers a pivotal day: 12 July 1983.

A severe thunder and lightning storm began in the morning and continued during the day with unabated ferocity, damaging property and killing cattle in south Tipperary and south Limerick. He wrote to Met Éireann telling them of the damage with accompanying photos. They were so intrigued at his interest that they offered to set up a rainfall station on the farm. A rain gauge was installed in a field.

But David was eager for more. A climate station with a Stevenson screen perhaps, and thermometers. They declined. Undaunted – and his eyes light up as he tells me – a man from Swinford, Alan Maurice Roe, who had built his own Stevenson screen, built one for him. He remembers the day he purchased the thermometers from England.

And he has been recording rainfall, temperature and weather conditions ever since. He climbs to his weather station, whatever the conditions, three hundred and sixty-five mornings of the year, for Met Éireann, even though they had little to do with it, and he remains an independent contractor.

'What time is it?' he asks suddenly, awakening from his story.

'8.30 a.m.,' I reply.

'We must go. I have measurements to take,' and he lifts his heavy coat from the back of the door. We leave the warm kitchen and begin our climb up the hill behind the farm house. This time I am in the company of the self-taught weatherman, David Meskill.

As we climb, I marvel once again at the lush beauty of the surrounding counties and the panoramic views from his home.

'Yes,' he says, 'I see my world in all weathers. Every day. And it is never the same.'

'Do people stop you and ask you about the weather?' I ask.

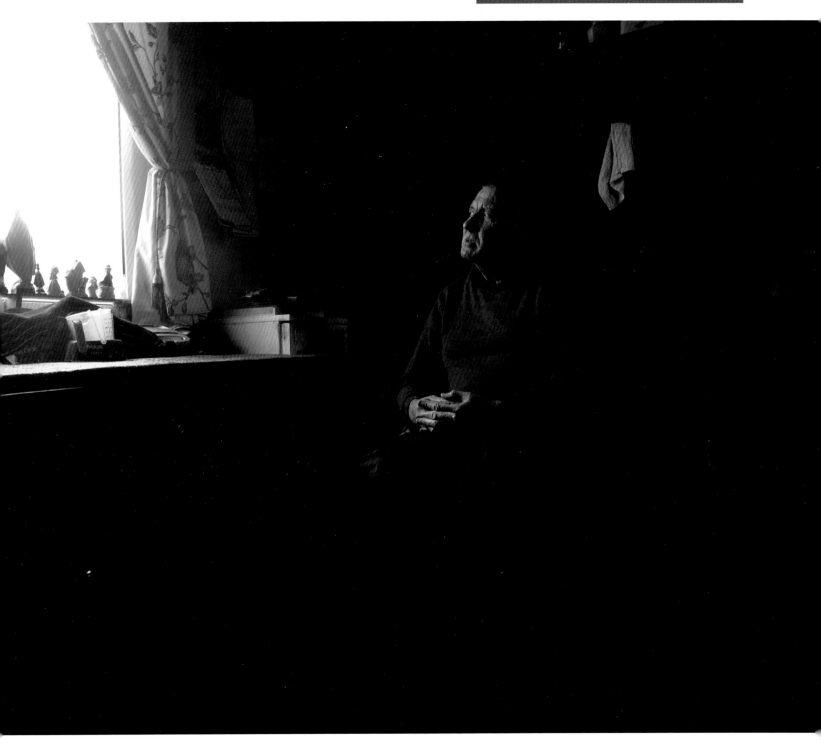

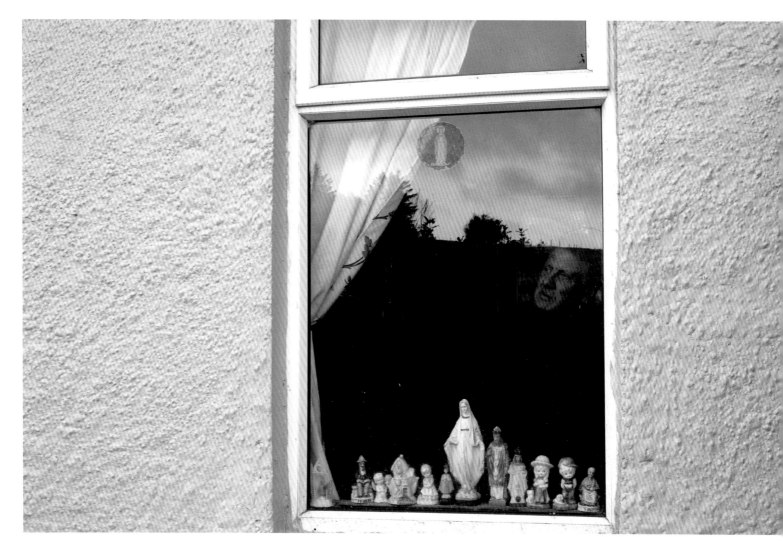

'No,' he replies, 'that side of my life is worn quietly.'

He looks around his homeland, elevated now towards the heavens, but he is less inclined to speak of views and landscapes and is more factual about his world.

'The farmland is quite good around here,' he says, 'northerly facing, so springs can be late. Growth can be held back for a couple of weeks, but land is good. Dairying was and still is the main industry in this area.'

We near the top of the hill.

'This is the Stevenson screen,' he says with great pride. I am surprised as I had expected a large, elaborate structure, but the Stevenson screen resembles a white-painted wooden beehive on stilts. A simple structure, white and light.

'It doesn't look as though it could do anything of importance,' I say. 'It looks insignificant and slight.'

'That's where you are very wrong,' he answers. 'This structure is built with slatted sides so that the air can flow in through them, but the sun cannot shine on the thermometers inside. It is painted white because white reflects sunlight rather than absorbing it. So it gives a neutral profile of air temperature in the shade. If you were to put a thermometer out in the sun, while the air temperature might be about eighteen or nineteen degrees in the shade, the thermometer out in direct sunlight would rocket up to about twenty-six or twenty-seven degrees. This would not be representative of actual temperature. This screen may look simple, but it is very clever. It was developed by Thomas Stevenson in the 1800s. It's the standard thermometer that's used in every meteorological station all over the world. So he must have done something right.'

And the lesson puts me in my place. I am well chastened. We all have such notions and opinions and beliefs about the weather and we feel we have nothing to learn about it, and certainly a structure such as this simple one might not be sophisticated enough to teach us. But it is.

I watch the weatherman as he opens up the Stevenson screen to check the temperature and humidity.

'What is the air temperature now here on the hill?' I ask excitedly, looking in at the shelved thermometers.

'It is 3.8 degrees centigrade. Quite cold,' he replies.

Muslin wicks saturated in water lie on top of little containers.

'What are they?' I ask.

'They are thermometers with a bulb, one wet and one kept dry,' he answers. 'Air causes the water to evaporate off the muslin. The faster the rate of evaporation, the drier the air. The humidity is calculated from the different readings of these thermometers. The rate of humidity is the amount of moisture held or suspended in the air and it is seventy-nine degrees.'

He checks the maximum thermometer, which shows the maximum temperature attained during the previous twenty-four hours, and the minimum thermometer, which shows the lowest temperature reached in the same period.

'The maximum temperature yesterday was 8.5 degrees,' he declaims as he calculates the measurements on the thermometers. He sets the thermometers carefully back to get a new reading for the following day.

David then turns his attention to the open earth, bends and locates a thermometer set in the grass, which records temperature measured on the tips of the blades.

'In winter,' he says, 'temperatures down the tips of the grass can be at three and four degrees, and the air temperature may still be above freezing. Grass, of course, conducts heat very badly. So when night comes, the outflow of radiation into space means that the tops of the grass cool very quickly, and frost will develop on them, and the thermometer will record it.'

He walks away from me, further out on the grass plain. I follow him and his knowledge. I am beginning to become aware of the variety of measurements needed for weather and forecast accuracy.

'I also have soil thermometers, which are set at six inches and twelve inches below the

ground,' he says, leaning down to check them, his voice echoing through the light wind. 'This measurement is most important for agricultural meteorology, because grass growth stops or starts at six degrees centigrade, and I can tell you it was slow to get off the starting blocks this year. It was only at the end of April that any appreciable growth began. For farmers, the weather is everything. Harvest, crops, silage, fodder. All life on the farm is weather-dependent. And farmers do not like inclement weather. … It is 2.9 degrees this morning, so there's plenty of frost.

'In summer,' he continues, writing down all his measurements to send into the national climate centre in Dublin, 'your average soil temperature would be about fifteen or sixteen degrees at six inches, which, combined with moisture, will give excellent grass growth in most places.'

I had never given a moment's thought to agricultural meteorology or grass-measured forecasts. My ear was only ever attuned to the farmers delighting or decrying our variable weather conditions on TV and radio.

'I check the rainfall every day,' he says. 'This is the famous rain gauge, which was my first instalment, prior to the Stevenson screen. It's a copper-framed bottle inserted into the ground, five inches in diameter. Simple but a great measure. 2.9 millimetres of rain has fallen overnight.'

'It's always raining in Ireland,' I exclaim. 'Always. It's as though it just can't stop. Such a small instrument for so many long days of deluge.'

'Well, you're not standing in the wettest county,' he replies. 'Kerry, Donegal, Mayo and Galway are the wettest counties. Wexford less so, and Mayo can be the warmest at times when the heat moves westward.

'You are right that generally we have a greater amount of rainfall now in Ireland, and we have heavy episodes resulting in floods, and a greater intensity of short-term rain. Global warming is playing its part, and there are subtle changes happening. In this country, we have been neglectful of the planning of the built environment, with more areas of concrete and less water run-off, and building on what were once floodplains. We have huge weather variation because we are on the western fringe of Europe with the great Atlantic at our side. We are a coastal community, and when the sea rises we will have flooding, and plenty of it. Our weather has become more extremes of hot and cold. Our seas have become a plastic world for poison and choke, and we are still burying our toxic waste. We think we are not part of the earth, but we are the earth. We forget this at our peril.'

I listen carefully to what he is saying. It is simple and direct, and it is very well-informed after years of observation and scientific measurement. His is a unique voice and one we should hear more often on the public airwaves. We might pay more attention to it.

'I also do an observation of the amount of cloud, types of cloud, wind direction, wind speed and visibility from the station.'

'It seems to me that you are running a science laboratory up here on this hill,' I say. 'When I think or speak about the weather, I'm more inclined to rely on what I see in the sky, and the feel of the atmosphere in my bones. That's not exactly science, is it?'

'Well, there's nothing wrong with that,' he replies, looking out at the terrain of the counties laid before us in freshly knitted gold and green colours. 'Uncle Jimmy could tell the weather from the height of the stream through the farm. Cad O'Sullivan could tell of incoming rain from the density of the sound of the rustling in the trees. The old people talk of a sure sign of rain when their arthritis is bad or their joints are constricted. Indeed, when the dampness lingers in the air, it has a history and memory of TB, and for some it is known as a falling evil. If soot was falling down from the chimney, it was always a sign of rain. If the cattle across the valley from me were going down towards the river, it's often a sign of broken weather. Whilst if they're going away off up the mountain, it's a sign of fine weather. They have their own inbuilt intelligence. As do the trees. *If the oak is out before the ash, the year will be a splash. If the ash before the oak, there will be a soak.*'

We stand together on the brow of the hill under a long stretch of morning sky and surrounded by a seasonal colour of grass, leaf and foliage, as he recalls these weather piseogs.

'Can you smell the weather?' I ask, breathing in the new air through my nostrils and feeling the soft wind rising against my face.

'Sometimes I can,' he replies, 'through the changes in tree bark smells and what is wafted in the wind. If I'm up the mountains after heavy rain, I can smell the wet peat in the air, especially in autumn when the weather is out. I get a sense in the air before heavy rain, a clamminess or humidity, which is a key to thunderstorms.'

The weatherman continues to check his thermometers, replaces some, moves others and notes everything in his diary.

'But cloud is the serious indication,' he says. 'Look up.'

And I do. The sky is vast and cloud-full directly above us and over the distant counties. I know these Irish skies well. They have been the inspiration for painting and verse and song.

'Why do we have such invasive, low-lying clouds in Ireland? You know the ones that lie just above our heads, like grey, boxed-in ceilings,' I ask, remembering all the dark and heavy mood changes such a lowering of a mousey-coloured sky can bring.

'Oh, I know those clouds,' he answers, 'we all know those clouds. They can bring terrible effects with them. They block the sun, and a lack of sunlight affects serotonin and therefore our mood. Sunshine is life-enhancing and life-enriching. We all need light, and these clouds block the light for days. The cause of them is huge amounts of moisture in the lower atmosphere, and usually very little wind to move it on in the winter. An anticyclonic condition, or if you live in a hilly area and have low cloud, it will result in hill fog, which is even worse for mood and can be very frightening.'

I look up at the moving cumulous cotton-wool bundles. The sky in the distance is light blue, with a waning silver-grey hue, but darkening at the edges.

'Five-eighths of the sky today is covered in those cumulus clouds. They are known as puffy woolpack clouds,' David tells me. 'If they are growing rapidly in size, showers will occur. I can see that there are passing light showers on the way. But we will have sunny spells in between. When the cloud is thickening from Ballyheigue, then I know that rain is on the way.

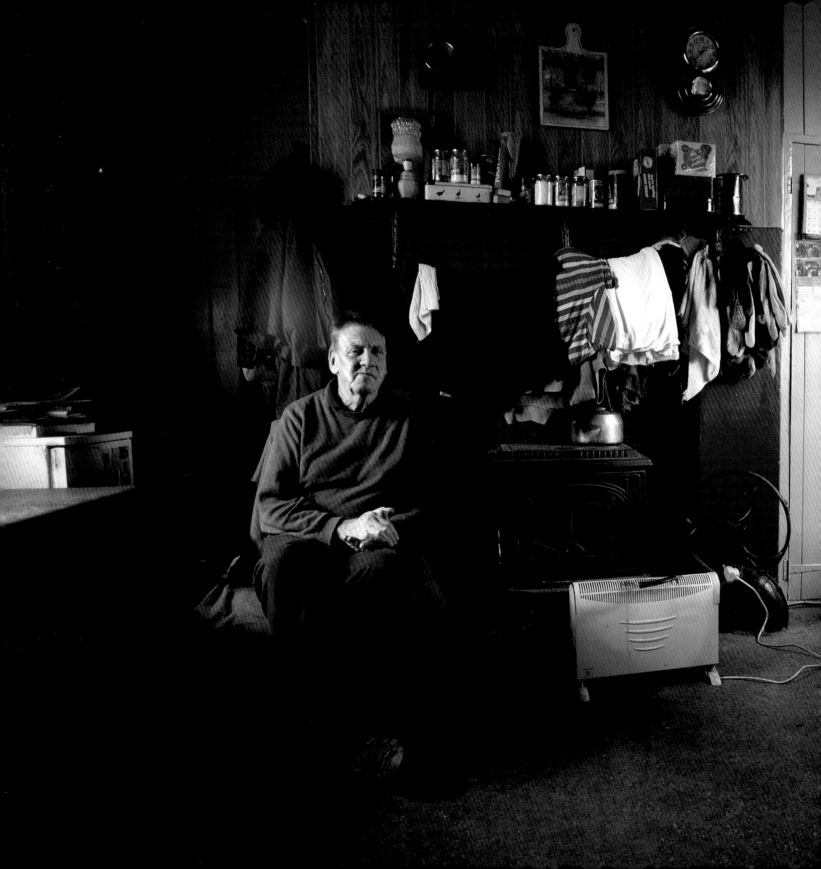

'And always ahead of frontal rain belts, there are high cirrus clouds. Cirrus cloud is a wispy type of cloud made up of ice crystals. They can look like rigs of hay, and are always the leading edge of rain belts.

'And when you see the sky lowering with altostratus – that kind of grey over there to the west – there's rain on the way. Variation of cloud has a good bearing on what the weather will bring. And there's a north-west wind around.'

'The fishermen say that all weather depends on the wind. Do you believe that?' I ask.

'Well,' he answers, 'farming is my life, and wind does not impact that as much. Farming and fisheries differ. Fishing is more at the mercy of the wind, on the seas and the lakes. But wind is an element that I observe each day. It is rare that it is detrimental to your work or dangerous but it is a most important element.'

'Why?' I ask, as I roam around the hill top like a new planet explorer, as though learning for the first time how our globe inhales and exhales.

'Weather,' he answers patiently, as though he is back in the classroom as a young boy, hearing it himself for the first time, 'is about air movement and wind. This earth draws energy from the sun. When the earth is heated, fire radiates out. The air above it is forced to rise, and when it rises in one area, the pressure falls, and to replace that warm air, colder air has to run in from the sides. The process is called a vortex motion or a spinning motion. As the spinning motion develops, depressions are born. Depressions bring unsettled weather, and Ireland is an island of unsettled weather. Our prevailing winds are south-west generally and usually at around thirty thousand to forty thousand feet. However, there may be a steering

wind at the same height or higher and these are the winds you really have to watch. Simply put, the wind that's blowing your hat off is not necessarily the same wind that's blowing higher up.'

The weatherman has a measurement and observational picture of what the day will bring as regards rainfall, cloud amount, wind direction and wind speed. He collates all the information in a synoptic coded form, like a kind of shorthand log which is used and understood by meteorologists all over the world.

'I learned how to do this myself,' he tells me. 'You must know it, as there can be no weather language barriers across countries and continents. There are about three hundred and forty symbols which all meteorologists can read anywhere in the world.'

All this knowledge will be forwarded to Met Éireann before the hour has passed.

In the fresh light and bracing air, we both stand and look around our country in the near and far distance, as though we own it. In one way he does, in that he tries daily to understand its rain, sky and air and forecast their moods. And share the information he has gathered with all its citizens, in a way that helps them to deal with and understand the effects it has on their lives. He is also acutely aware of the effects of our disregard for and ignorance of weather change, nationally and globally.

'I love this glen and its surrounds,' he says. 'I know every inch of it, every townland and curve of it. And all who reside here across the farmlands big and small. I'm very lucky. I love what I do. It is part of my life. I have huge pride in it. Everybody should have pride in their work. It is what makes you content.'

With his morning work completed, we begin our descent from the hill. The weatherman walks slowly and silently beside me. If I had spied him walking on a distant hill, I would never have envisioned him to be a man of weather measurement and calculation. I am saddened that with the advance of technology, I may not see his like for long more, checking his beloved Stevenson screen, his rain gauges and his soil moisture thermometers, and gifting us our weather forecasts.

I share my worry for his future. He is philosophical.

'Forecast technology is outstanding, but we will always need the opinions of the natural observers, or the Carlow man who tells us, "We will have snow at Christmas." Even with all our scientific instrumentation and advancement, weather prediction is only ten to twelve days in advance. And we constantly get it wrong because the atmosphere is very fluid. We can have the latest radar weather reports, satellite reports, upper air observations and international data, and in three days it can all be upturned. We have to work hand in glove with technology and gut feeling from out and about in the countryside. The environment of the world is fickle in that if there is half a degree fall or rise in temperature, it can have quite a global effect.'

As we descend the hill, I am suddenly aware of the aloneness of his farmhouse. 'Would you like to have married?' I ask him bluntly.

He answers me quietly.

'I would like to have married. It didn't happen. But I enjoy life. I enjoy my work and most specially my community. Yes, I would have liked

to marry. I had to care for my parents in their older age, so maybe that thwarted things. Life throws you variations.'

He pauses and looks around his homestead.

'Yes,' he repeats, 'I would have liked to have married and settled. Yes.'

I say goodbye to him at the door of his small farmhouse. The miniature religious statues watch our parting from their home on the porch window.

'I hope you can continue to read and measure our weather well into the future,' I say.

'I hope so, too,' he replies, 'but if not, there are sixty-two of me all over Ireland reading and observing the weather, and one hundred and thirty rainfall stations.'

This is the only incorrect information he has given me, during all my time with him. There is actually only one of him. One David Meskill. The Weatherman. ●

THE CHIROPODIST

Susan Fitzgerald-Giffney

Susan Fitzgerald-Giffney

WALKING ON AIR

He took off his sock. His foot was as black as soot. The nails on his toes were the colour of ashes. 'Go home and bathe your feet,' she said. He went home. He came back a few days later. He took off his sock. His foot was clean. Sparkling and baby-new. She worked on his foot, paring, shaving and cutting. 'Now the other foot,' she said. 'No,' he replied. 'I only cleaned the one.'

Susan Fitzgerald-Giffney pares, shaves, cuts, massages, strips, trims, slices, reduces, prepares, curtails, peels, pores, creams, severs, chips, files and thins the toe to heel and the in-between of all feet. Beautifully.

Susan loves feet. Everybody else's feet. She looks after them every day in her chiropody room at the back of her husband's shoe shop on the main street in Gorey. She examines them all day. Scrutinises them, tends them and soothes them. Lovingly.

Susan doesn't care what feet look like. It doesn't bother her if they're bockety or they smell. Her only worry is whether they hurt, and if she will be able to nurse them back to health and easy walking.

Susan thinks feet are attractive. All kinds of feet and all kinds of attractive. Susan asks me, 'Which would you prefer to break, your arm or your foot?' It's a good question. 'My arm,' I say. Excellent answer. I'm hoping my feet will be as perceptive.

Susan is full of information as well as talent. She tells me that 25 per cent of my bones are in my feet. I take on average nine thousand steps a day and in my lifetime I will have walked one hundred thousand miles or four trips around the world.

I'm exhausted listening, and my feet hurt at the thought of their journey so far, and the walking still to come. I may be right to be worried as women have at least four times as many foot problems as men, and 75 per cent of people will experience foot problems in their lives.

'Why?' I ask.

'Because of their footwear,' is her logical answer. 'Women are foolish about the health of their feet. Fashion dictates and causes their feet huge problems. And a great percentage of children have flat feet.'

This is not good, I think, as I look down at my foot, level on the polished floor.

⌣

Annie puts her foot up on the black, dipped in the middle, leather bench at Susan's lap. She is full of chat.

'My feet are sore,' she says. 'Hard work all my life. Today people have too much. There is not enough silence. Everybody is shouting. No respect.'

Susan rubs and massages the ninety-six-year-old feet. She cuts the nails and pares the hard heel skin. Annie cannot reach down.

'Ah … that's lovely, Susan. Soothing.'

'What's the secret to a long life?' I ask Annie before she leaves.

'I kept a good house and insisted on home cooking. And when I was making an apple pie, I always put egg in the pastry.' She walks out with a bounce.

⌣

Your corns are back,' says Susan.

'Why wouldn't they be,' answers Bridget. 'Sure I never sit down.'

'What exactly is a corn?' I ask.

'It's a circle of compacted, keratinised skin as a result of pressure or friction,' Susan answers. 'Little seeds that can live on the surface of your toes or become more acute with their own blood supply and nerves.'

'Like little drumlins on your feet,' I suggest.

'Don't be dramatic. You'll frighten my client. You can watch me pare it out.'

Susan uses a very fine scalpel. She pares and shaves and slices as though she is cleaning a carrot. Shavings of hard skin around the raised cornfall like flat snowflakes. The scalpel is razor sharp as it shears the skin down to the central core of the corn. Susan inches its piercing tip right down to the corn's pith, with the precision of a clockmaker, to get the root out. She delicately cuts around the core, bit by bit. No blood so far.

'You're very skilful.'

'You have to know what you're doing. I don't want to cut or make the foot bleed and do further damage.'

Bridget reads a magazine during the excavation.

'How big can a corn become?' I ask. I'm thinking of the fields I passed on my journey to Co. Wexford.

'A corn could start like the head of a pin and grow to a small nut if it is not treated,' says Susan. 'Plasters don't work, they macerate the healthy skin that keeps the corn in its position. You may get the corn out, but you have damaged the normal skin around it, and when your foot goes back into the shoe the same friction begins again.'

Susan's intricate mining finds the root. She inches it out.

'There you go, Bridget, it's out, root and all.'

'I'm off,' says Bridget. 'I've loads to do and the day is young.'

And with the lingering scent of disinfectant, she's gone.

⌣

'My toes won't move. They're crooked and very painful. They're worse today. It's raining. I had beautifully turned out feet when I was young.'

'You still do, Joe,' says Susan.

'No I don't, they're full of arthritis and they're swollen in places with my warped toes.'

'I didn't think people get arthritis in their feet,' I say, trying to be helpful. 'I thought it was in their arms and knuckles and knees.'

'Yes, you can, and thousands do,' says Susan. 'It can be genetic or from wearing bad shoes when you were young, or as you age. Sometimes, the condition can be chronic and requires steroid injections to ease the pain. We'll warm them up, Joe, and massage and cream them and I'll clean and cut your nails.'

Joe's pain begins to leave the room.

'Walking on my feet is like walking on swords,' says Michael, as he takes his place on the great leather chair, 'especially in the morning until I get going.'

'I have that pain at times recently,' I interject, getting totally involved.

'It's plantar fasciitis,' says Susan.

I'm not so sure about my involvement now. I become very worried. It sounds appalling and untreatable and difficult to pronounce. Susan sees my worry.

'You'll live,' she says.

She runs her hand in a full grip down Michael's leg and under his foot.

'Our calf muscles come down – the biggest tendon in the body – under your heel and then it branches into the fascia, which is the little band there going into the back of your toe.'

Susan holds Michael's foot between her two hands like a vice.

'It's inflammation of the tissue that runs from the heel to the toe. It presents as heel pain. People try to walk through the pain, and tear the plantar even more. Trying to reverse the damage is difficult. You need to continue to wear your good support shoes, Michael. With laces. Your foot needs to be encased and protected. You'll be wearing them for a purpose.'

Michael is sorry he did not take her initial advice. I'll have to take it too.

'Did you ever see anything as bad as those hammer toes?' Margaret asks, as she hobbles into the room. 'The top of my toe hits the ground. Imagine. Crunches over and meets the ground. They don't bend where they should bend and they're shocking sore.'

'Are the silicone toe separators I got for you working?' asks Susan.

'Yes,' Margaret replies.

Susan begins a long session of paring, shaving, cleaning and massaging the tired and curved toes. She is exact and professional and tends to every bump and lump and sharp-edged nail as they talk.

'Let me check your pulse through your foot, Martha.'

'Go ahead, Susan. I'm not feeling that well and my feet feel like tree trunks when they hit the ground.'

'My feet are like a pyramid. They've grown into a squashed point that makes it very hard to walk,' Nancy says.

'You should not have been wearing those pointy shoes when you were young,' Susan says.

'Ah, I loved them, and I spent the best part of my life dancing in them.'

'Well, its wide, flat shoes from now on,' says Susan, without sympathy.

Derek takes his time getting to the chair. 'I have rheumatoid arthritis in my feet. An awful condition whether I walk or run miles; it's here to stay. I have swollen sausage toes that won't move. I was a law and order man, and my feet are past fighting back now. I come for massage and relief.'

Susan bathes and nurses his feet. She creams them as though she is cleaning and polishing Georgian silver. She cannot reverse the condition but she can make it more bearable, at least for a time.

❧

'I come here for everything below the Mason-Dixon Line! A lower limbs refit.' Robert is delighted to be sitting in the great leathered chair.

'You've picked up a verruca,' Susan informs him.

'What's that?' I ask.

'It's a virus in the foot that develops like a wart. It is very easy to pick up.'

'Where did I get it?' asks Robert.

'You got it from a swimming pool or golf club shower. Verrucae need water to transfer.'

'Can you get rid of it?' he asks.

'Yes I'll treat it with acid and burn it off. But you'll have to be careful for the next few weeks.'

❧

'Susan, if you don't file me toenails, me nylons will be snagged all week.' Treasa puts her foot up on the cleaning and cutting stool.

'Your nails are too long,' says Susan, choosing the best scissors for the job. 'Originally when we were barefoot, toenails actually came up to the top of the toe to protect it. That's not useful anymore. You let them go just barely into the white area. You don't cut them too low. You never cut them down the side, ever. The biggest mistake is people start poking and digging down the sides of their nails and they set up problems with ingrown toenails for themselves. You must cut them straight across.'

Susan shapes each individual toenail into a straight line. Treasa's nails are sharp and hard. Strong enough to hang up pictures.

'That's powerful,' she says, as Susan finishes off the cutting, and creams and massages her individual toes and heels.

'Can you do anything for this ingrown toenail, Susan?' Treasa asks.

'I'll have to begin to treat it,' she replies. 'It's infected. Your toenails should be pink and healthy. Right down to the bottom. With no black or dark marks. There are suckers between the nail and the nail bed, which is your blood supply. Nails are alive. If you damage them, the nail can die, and when it dies, it has two choices. It either grows forward and a new nail replaces it. Or you've broken the armour. If you damage the armour, fungi can get under the armour and multiply in the base of your nail. This is a challenge for a chiropodist.'

Treasa's nails are filed and her ingrown toenail removed. Her tights are safe for the winter.

❧

We're on a coffee break at the back of the shop.

'Toenails are very precious,' says Susan. 'Women at this time of the year like their nails long, because they're getting pedicures and are out in sandals. They just like the nice length on the nail. I have a couple of patients that have bad fungi on their toenails, and normally during the winter months I'll cut out the whole damaged piece of nail completely. They can then apply the anti-fungal paint down under the nail because this is where the fungi lives. Fungi need darkness, heat and moisture to survive. It's important to expose feet to the air when we can. The air and sun and sea water are great cleansers, purifiers and healers.'

Susan says we are born with perfect feet. How we treat them and what we do with them creates the problems. We never look after our feet. We

never cream our feet. We look after our hands, nails and face, but not our feet, which we stand on all day.

'We produce half a pint of sweat through our feet every day. People rarely take baths anymore. In the bath, you can put your feet up and see your feet, heels and nails. Standing in a hot, sudsy shower, which strips away natural moisture from the skin, we don't attend to our feet. Some of us cannot even see our feet, and we certainly don't dry in between our toes,' Susan says.

All morning in her sterilised preparation and treatment room, Susan observed, checked, felt, managed and advised her footy clients.

She looks down at my shoes.

'You have no supports for your arches,' she says.

'And what's an arch?' I ask stupidly. I've heard about foot arches for years but didn't think I was old enough to warrant support.

'An arch is a series of bones in your foot that's elevated to a bridge,' Susan replies. 'Its function is to balance the weight of your body on different parts of your foot. We take walking for granted. Did you ever think about the rhythm of your walking?'

No. I hadn't. It always seemed to come naturally to me, except now that I have the plantar fasciitis – a condition I had definitely picked up since I arrived in Gorey – I better start thinking about it.

'Well, to walk,' she begins, 'you use your heel and your fifth metatarsal and your toes. It's a rhythm. Heel, fifth metatarsal head, on to your big toe, off, and then the other heel hits the ground to take over the same process. It's very important to walk correctly, starting on your heel, as the shock rises up through your knees, your hips, to your lower back. If everything is working,

that is a normal gait. If it is off kilter, your knees and hips will be affected. We all walk differently and we all have little oddities. Throwing a leg out like a grandfather or parent did. Genetic shaping.'

After the nails, problems with foot bridges begin to arrive into her clinic towards lunch. Foot bridges over-crossed, foot bridges not crossed, and some with no crossing at all, resulting in flat feet. Loads of flat feet of all ages. I am surprised. When we are alone again, Susan becomes very animated about the problem of flat feet.

'Children must have decent shoes. Parents have stopped spending money on their footwear. In their formative years, children's arches must get a chance to form. They cannot depend on ligaments and tendons. Dolly shoes and slippers are of no use for everyday wear when you are young. Girls between the ages of eleven and sixteen are losing their arches and their support wearing cardboard pumps and large woolly boots, allowing their feet to flop in and out of their footwear as they walk. Children's shoes are like vaccinations. They may not like them, but footwear must accommodate feet, otherwise there will be problems as an adult.'

I am reminded of my shoes when I was young. Bought at the beginning of September, and worn for the year, through the seasons and beyond. Brogues, leathered, heavy and laced.

'There are three arches in the foot. Everybody knows about this one, the metatarsal arch, which runs across your foot,' says Susan, as she holds my foot in her strong hands to demonstrate. 'But nobody knows about this one, the external longitudinal arch,' and she rubs her hand down the side of my foot. 'There's the internal longitudinal arch, the external longitudinal arch,

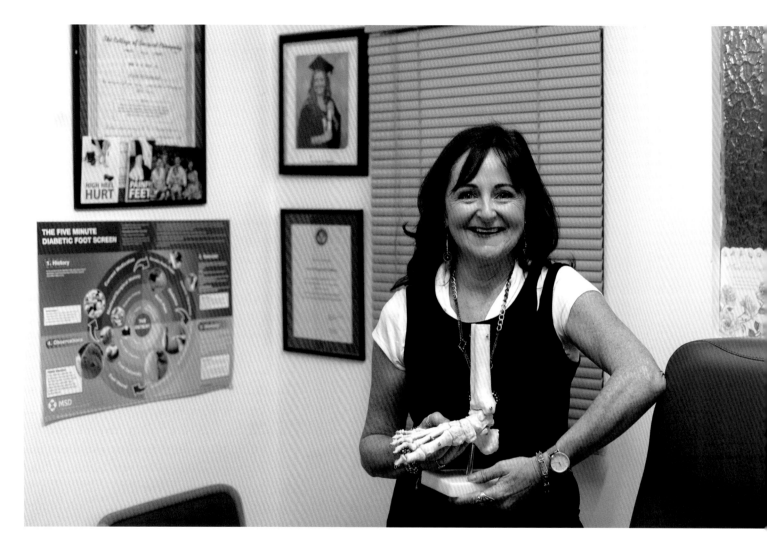

and then there's the metatarsal arch here. It's like a big triangle. That's why you need a shoe support. So many of us have got problems, and feet are generally getting bigger. We don't wear shoes that are comfortable. It is interesting that boys and men do, and have less general problems with their feet.'

'You did what, John?' Susan asks, aghast.

'My heels are hard and yellow. It's like walking on cardboard. I tried to cut the excess skin off with a scissors.'

John sits cowed in the great chair.

'I don't want to hear you telling me this,' chastises Susan. 'You might as well have used broken bottles and Stanley knives on your foot. If you want to do that, go down to a hardware store and buy this.'

She holds up a small sanding block.

'You never cut the skin on your feet with scissors, blades or camping knives. You use this, a sanding block, and you sand the extra skin off your feet.'

She begins to lightly sand John's heel and the side of his foot. He is silent and sorry, as his skin dust falls like powder on her towelled lap.

'John, look at the distance I am from your foot,' says Susan. 'I'm right beside it. Your foot is in my lap and it is raised. I have a scalpel. I am trained and I know what I'm doing. You cannot see your feet properly. I will remove the thick calluses, which is extra hard skin and not as flexible as our normal skin. So it needs to be removed. But it is a protective mechanism for a joint that was put under too much pressure. It didn't deserve a scissors.'

She sands his feet with great arm strength and without a break, up and down and across and back and forward, relentlessly, until his heels look like smooth butter. He leaves delighted. Elated in fact, and without a scissors.

'Sometimes when I am in the supermarket,' Susan says, 'I see middle-aged women, on the heavy side, standing in the queue, and I notice calluses on their feet and heels and I think to myself, that's my homework. I could do something for you. It took them a long time to build up those calluses. It will take me a long time of sanding, shaving, oiling, greasing and massaging to get rid of them. But it will be worth it.'

'Does weight play a part in your feet?' I ask, looking at myself in her large and long mirrors.

'Yes,' she answers, with a sense of tolerance at the obviousness of my question. 'It very definitely does. It can cause your feet to splay a lot more. If you carry around a bag of potatoes on your back,

it is going to put extra weight on the bones of your feet, on your heels, and on all your joints.'

Susan's five children are grown up now. She may be fifty-seven, but she looks like a young girl. She wears a pretty green summer dress with a light silver-grey bolero top. Glass beads hang around her neck picking up the shades in her dress. Her own feet are neat, perfectly pedicured in open-toe sandals. And she wears an ankle bracelet. I noticed her feet first. Susan walks as though on air. She is dressed for a day out, not for a job that entails having naked feet in her lap. Susan has great respect for her work. It is not just her job, it is her passion.

Betty delays taking off her stockings.

'My foot is so ugly with this bunion,' she says. 'I think everybody is looking at it sticking out like a broken furniture leg. It's very painful, especially in the evening.'

'It not as evident as you think,' says Susan reassuringly. 'It's very common, and it is not a reason to hide your feet. It's just a bony bump at the base of your big toe. You cannot wear such tight, narrow shoes. You bring unnecessary stress on your foot.'

'My grandmother had a bunion,' I tell them. 'I remember it.'

I am trying to be supportive.

'Yes, it can be genetic, and linked to general arthritis,' says Susan, ignoring me. Betty's bunion is red and looks very sore. Susan begins to examine it more closely and spends her time tending to it without speaking.

I sit in her room in the high-backed treatment chair while she has some time off for lunch. She tells me about her family and upbringing.

'I was born in Limerick and have seven older brothers and four sisters. My mother and father were sound, decent, lovely people. They really grounded us with basic morals, honesty, decency, hard work and a Christian religious ethos. My father began selling fruit and vegetables from the back of a van. He had a great rapport with people. He built it into a very successful business. He worked very long hours, loved his customers and loved his job. I got that work ethic from him. A big family teaches you to share, get on together and roll with the good and the bad that every day brings.'

The room is simple even though there are trays and trolleys and presses full of scalpels, scissors, files, sanders, cotton wool and instruments of paring and picking and foraging and cleaning. I know there are secret drawers where the deep burrowing utensils lie hidden, somewhere. The room is calmed by candles, fresh scents and white, spotless towels. It is stainless-steeled, antiseptic and professional. And very welcoming for tired feet.

'Did your parents influence you greatly?' I ask.

'Yes, they did. You didn't ever want to make them ashamed of you in the world, and yet we had huge freedoms.'

'Are they still alive?'

'No.'

'Who influences you now?'

'My children. My grown-up children.'

Ingrown toenails, calluses, corns, sports injuries, skin infections, hammer toes, fallen arches, verrucae, nail infections, warts, athlete's foot, bad ulcers and, worst of all, feet and legs affected by diabetes arrive and leave all day. Susan says diabetes is a huge challenge and the long-term consequences can be very serious. In some cases ulcers don't heal and in the most severe of cases toes, feet and legs may need to be amputated.

'Now,' Susan says, as her last patient leaves, 'let me have a look at your feet.'

I'm nervous as I take my place like the ruler of a small country on the great black chair. She clasps my full, naked foot in her strong hands. Within her clasp, I feel I am wearing an expensive leather shoe.

'That's how your foot should feel in your working shoes,' she says. 'Secure, encased and comfortable.'

She begins to assess every nook and turn, crevice and gap, running her hands across my feet, heels and toes. Feeling and separating. Pushing and prodding.

'Your toes are good. No corns, and your nails are pink,' comes the examiner's assessment.

I'm beginning to feel like a beauty queen. Delighted with myself but aware that people rarely look at your feet, and if they do, you know they are not paying real attention, or there is something choking their communication.

'I always feel my toes look like chips,' I say hesitantly.

'Don't be ridiculous,' she replies. 'They are very well proportioned and clear-skinned in between. Your heels need just a little softening.'

I knew it. I knew it. An appointment with the paring scalpel. There is fear in the air. She begins to pare and scrape, holding my foot firmly in her competent hands as though it was a precious gold bar.

'Why did you become a chiropodist?' I ask.

'Well,' she replies, using her foot scalpel with the dexterity of a magician, 'I was a country girl

and used to hard work. I first did nursing and specialised in midwifery. But it was only when I sat down in front of my first pair of feet that I knew this is what I wanted to do. I can make a difference immediately to somebody's life. I had a training in anatomy and physiology, and you need it as a professional chiropodist. You need to know what goes where, and what belongs where in relation to your bones, your ligaments and your blood supply. How it all works. And when it doesn't work, why?'

'I don't pay much attention to my feet,' I say, feeling that Susan will renew and replenish them to last another few years.

'You should,' she replies. 'Your feet tell a story about you. Your history, your genes, your living, cared for or neglected.'

'I never thought that working with feet would be so intricate and complex and indeed such an exercise in human communication,' I offer.

'It has everything to do with communication and understanding,' she says, 'more especially because my conversations with my patients are always confidential. Feet are private. I work in a very personal environment, and a very intimate environment. Patients tell me things. Maybe because my job is about touch and healing, they feel they are in a place where they can be free to express themselves honestly and openly. Because of that, I have learned from them the power of human resilience. How people of all ages come back from the most traumatic, life-threatening events, illnesses and losses. Regardless of what happens in their lives or to their families, they still aspire to exude joy and hope, behind the pain. That has been such an education every day here in the clinic.

'I also have the opportunity to see people age over the years. I am conscious of widows and widowers living alone out in the country, and very lonely, and others who are ageless and always on the go. Whether feet are new, young, old or aged, I love my career. Every foot I see every day is an individual foot. I listen to feet. Feet are my forte.'

My session is finished. My feet have been pared, shaved, massaged, stripped, trimmed, sliced, reduced, prepared, curtailed, peeled, pored, creamed, severed, chipped, filed, thinned, disinfected, massaged and creamed toe to heel. And I have been advised as to what my next shoe purchase should be.

I leave the foot world of ugly, too small, too big, offensive, funny, lopsided, crumpy, crunched, gnarled, bony, unusual, twisted, genetically badly shaped and genuine foot problems behind. I leave behind my own negative thoughts about my feet, their shape and structure.

Susan has convinced me to be glad of my feet, to appreciate their muscle, their power, their strength and their daily work load. I leave the clinic, ambling away up the town on soft new baby feet, feeling for the first time in a long time as though I am strolling on a cumulus cloud. Susan the chiropodist is a sorcerer. ●

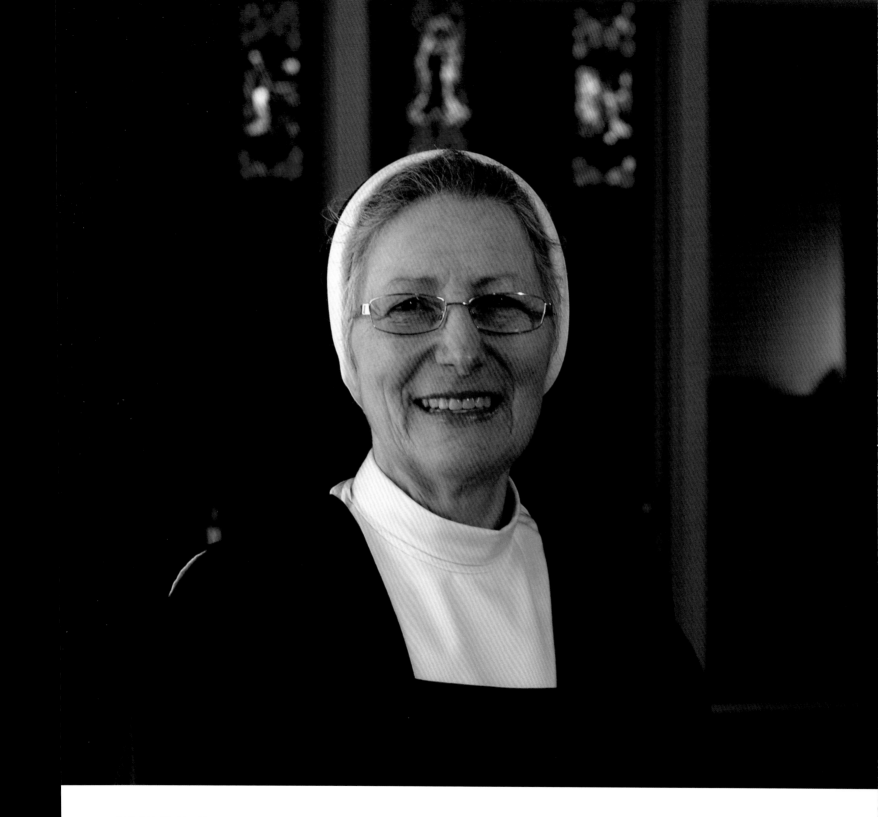

THE
CARMELITE

Monica Lawless

Monica Lawless

THERE ARE NO WEEKENDS

The Carmelite convent is set at the foot of the Wicklow hills in Delgany, Co. Wicklow, and looks out directly towards the sea. This reverential gaze towards the waves has been held in time since 1844, but the building is now a simple, square, low-lying structure, adjacent to an old, heavy-stoned church.

In the front garden, in full view from the road, is a large, white, sculpted statue of Jesus's death on the cross. His mother and Mary Magdalene are painfully held in stone at the foot of the cross, watching the crucified Lord.

I sit beside the sculpture in the morning sun. I am also watching. It is warm and peaceful. It is also quiet. I am unused to that.

Early Carmelites were not. They were hermits and observed silence, seclusion, abstinence and austerity. And despite centuries of revolutions, repression, changes and developments, this Carmelite order in Delgany still do.

I am here to meet these descendants of their sixteenth-century mendicant founder, St Teresa of Ávila and their present abbess, Sister Monica Lawless, and to experience their way of life.

I ring the doorbell and it is answered by Sister Monica. She is gentle in demeanour and is very welcoming.

In a simply furnished room the nuns – Sr Catherine, Sr Gwen, Sr Anne, Sr Benigna, Sr Cecilia, Sr Majella and Sr Bridget – are waiting for me. They are sitting in a large semi-circle, so I can greet all of them with ease and openness. This is a rare privilege. They age from fifty to ninety years old, and joined the Carmelites from the civil service, teaching, farming, nursing, some as very young girls. I sit in the middle of their circle and begin my information journey with some urgency. I launch into a questioning regime about the nuns' place and purpose within an enclosed order in the twenty-first century. Short, sharp questions all embroiled in why they are in the order at all. Their answers are confident.

'You grow into it.'

'There is an appeal.'

'A draw.'

'We are called to be here. A strong call. An irresistible call.'

'An un-quenching faith to live the life of St Teresa of Ávila.'

'This is a cloistered, silent, hermitic life. We have all chosen it.'

'Freely.'

'But what do you do all day on your own?' I interject. 'What do you do with your lives?'

There are once again a multitude of secure replies.

'We pray. We are silent. We read. We do our duties. We work.'

'We only speak twice at a particular time or not at all.'

'We reflect and we pray about what we hear. Headlines are enough. We do not need the details or an overload of information. Somebody will tell you anyway.'

'We had to be told that the Twin Towers came down, as we do not watch television.'

'Outside world news is mostly sensational. Overwhelming grief shifts in an instant to something else, the next thing.'

'But why do you continue to live here?' I insist.

'We live here in a supportive, structured, communal, silent, prayerful life.'

'You are hermits,' I suggest.

'You could say that.'

'But are you running away?'

'What do you mean running away? Running away from what?' comes a clear reply.

'Running away from life,' I announce with great conviction.

'No, we are not running away. If we were running away, we would not last here. You cannot run away here. What you are, and who you are, will follow you and surround you. Your heart and mind will remain with you.'

'We are immersed in the world in a different way. We live in the world in a different way.'

'People come to us to share their concerns and worries.'

'You cannot run away from your worries. You could not stay here if you were running away. What you were running away from would come up in your prayer.'

I must look bewildered because Sr Monica interjects.

'There are no magic answers to your questions. There are no magic answers to your own life. We go away from the world as you know it and we give away everything. We are called to a different kind of intimacy. There are no big reasons as to why I am here. There are no big, all-encompassing answers to that question. My reasons are internal just like our internal needs to have children, or to sing, or for physical touch and sexuality. I don't think your society is all that great. I sometimes wonder if people really know what they are losing.'

'What do you mean?' I ask.

'Standards, values, crafts, skills, manufacturing, all the energies you are re-valuing or undervaluing. And what are you actually replacing them with? Europe was built on morality, work ethics, standards, pride, hard work, community and, may I suggest, prayer. We also now communicate with the public. We may be cloistered but we do sometimes meet family and friends, one to one across a table. My young nieces ask, as you do, "Sister, why are you in prison?" Another young niece gave me a banana. She thought I was in a kind of zoo.'

Sister Gwen continues.

'Our reasons for being here can be vague and inarticulate. They can take many years to grasp fully. The Carmelites are not an answer to loneliness. We are not a security blanket in difficult times. Nor does it confer you with a new identity. There are no weekends at the monastery. Religious life can intensify past personal conflict. Neglected or repressed aspects of your life. They must be dealt with inside here or outside in your world.'

'Vocations are always about holy ground,' says Sr Monica. 'They are about God's call and God's voice. We all heard it.'

I find myself beginning to listen. What they are saying is different and provocative. They are unlike the people I meet every day, and these are certainly not the kind of conversations I am used to across politics, or panel discussions, or in the general media. They are also outside all my securities of a certain way of thinking and living. Most of the time, and I find myself admitting this to the nuns, I create illusions about what will make me happy, and most of the time, I'm wrong. I listen to a society that tells me every day that choosing anything from breakfast cereal to deodorant is what constitutes a kind of happiness. I know it doesn't but I still listen. I'm bombarded with it.

'Are you not as naïve as the rest of us?' I ask. 'Even with all this prayer and commitment, are you not bowed down and ruled by some power, political or otherwise, in this sense by your God?'

There is a chorus of incredulity.

'Bowed down? No, no, no. We are not bowed down by anything. We are elevated by faith and belief in our God.'

'We provide future generations with reasons for hope and living.'

'We lack your reference points. That is what you do not understand.'

They were right. I didn't understand it. But I was awed by it. Fascinated by its freshness and clarity.

'We give care to ourselves and to souls. We counteract the restless, relentless activism. There is an educational emptiness around, when young people are not helped to know themselves,' says Sr Monica.

'And how can you learn to know yourself?' I ask the group.

'Well, you could begin with silence,' came the answer.

I did not want to hear this answer as it was too dangerous.

'And what about heaven? Do you really believe there is another world? Science would think differently.'

'It is not your place to minimise another world,' Sr Monica replies.

'There is a journey as people get older, and grow into the next life. It is not your place to minimise that journey. God is about the beginning and the end. If you want to know us, you must know about that rhythm. We follow all the cycles of nature and prayer, Advent, Christmas, Lent, Eastertide, ordinary time.'

'But are you not missing something? Anything?' I ask. 'How can you be so sure?'

'We are not missing anything,' replies Sr Anne. 'Before I entered here, I thought and I felt that my life was spare. I no longer feel that. My prayer is my energy and my life.'

'And is that your relevance now today?'

'Yes, and much else,' she continues. 'We are important in the local community even if we are silent. We believe in the contemplative life. Contemplative means to be human, to know yourself.'

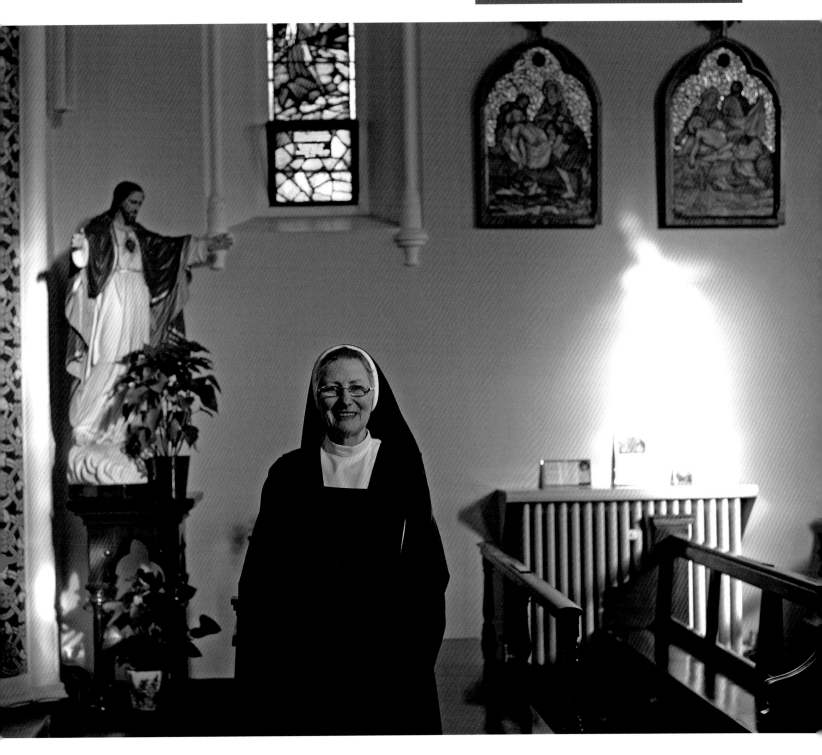

'All people, as they get older, become more silent,' says Sr Monica. 'You must learn not to judge. To take things as they are, where they are, and as they come. Do not judge. We do not judge. Your world is full of judgement. You are full of judgement.'

I had a strange feeling, sitting in front of the sisters, that I was the loser, when I had thought it might have been the reverse. They seemed so content and peaceful and devoid of any semblance of anxiety. What was evident was their complete commitment to the world that they had actively chosen for themselves. They left the room without noise or speech.

My room in the hermitage attached to the monastery was sparse and small. A single bed with crisp white sheets, a chair, and a clear tiled bathroom. Myself and the room laid bare among minimal essentials. No TV, no radio, no phone, no internet, no voices, no traffic, no noise. Just the psychological and psychotherapeutic pounding of my own silence. As Sr Anne had suggested, 'Observe yourself and others through the silence.' My only comfort was a hot water bottle.

I found the stillness very difficult and very distracting in that I began to hear my heart beating in my chest. I watched its rise and fall. I sang hymns quietly to myself, hymns I had learned at the Corpus Christi processions of my youth. I sang them over and over again to counteract the stillness, and I finally fell asleep.

At 5.30 a.m, I sat on my own pew in the chapel. The nuns were already there, smiling-reverent and wide awake. I sat with them for an hour and prayed, a personal prayer at this time every morning. The exquisite stained-glass windows above the altar elevated the mood, as the light came up, and began to illuminate the lush bejewelled windows shapes. These windows were made in the Harry Clarke studio, and as the light got brighter and brighter, the windows became a glory of deep reds, blues and green, and their majestic beauty in shape and form became a prayer in itself.

I knew, in an instant, that there was no need to be anywhere else. What I saw was the artistic hand and mind of some creative God at work. Sitting on the edge of the light rays as they shafted through the windows must be how artists are uplifted by the idea of a God or something outside and above themselves, and how through their artistry they bring us into their imaginative elevation.

Everybody who knew I was going to the Carmelite monastery asked me to pray for them, believers and non-believers alike. I prayed for them all. I prayed for the living and the dead. I had not done so for such a long time.

I remembered Sr Monica's words. 'You cannot teach God from the outside. If you believe, you must believe from the inside.'

I envied the nuns their unfaltering faith. The Carmelites are attracted to prayer. They are drawn to prayer. Their motivation is complex. Their life of prayer is not a spiritual cloud floating above their heads. It is the messiness of everyday existence. It is something very real that surrounds their faith.

Their Divine Office is an example of this. It is repeated seven times a day for fifteen minutes and its main core prayer is 'Glory be to the Father'. It is done silently for yourself and your life, and can be read and studied morning, midday, afternoon and evening.

I opened my page for the day and it read:

That you may be justified when you give sentence.
That you may be without reproach when you judge.
In spite of your anger that you may have
compassion.

I spent the Divine Office thinking about what I had read. I had heard that word 'judge' before and knew about 'judgement'. I have lived that word 'judgement' through my youth and adulthood. The lines had a deep effect on me. Our lives, and indeed my own life, can be so caught up in the judgement of myself and of others, and always with our pockets full of metaphysical stones and rocks. The breath of the critic so ready to be aired.

I spoke to the abbess later in the day about what I had read and how it had moved me. She told me:

'Something always comes to you when you need it. But hold your reactions for another day.'

Breakfast was silent.

Mass began at 9 a.m. and the congregation from Delgany came into the main part of the church, while we remained out of sight behind the brass side-altar gates, only coming into view briefly to receive Holy Communion. There was no sharing of words.

After Mass, I walked with Sr Monica through the Carmelite graveyard, which dates back to 1844. Monica grew up on a farm in Swords, Co. Dublin. She became a nurse in Jervis Street and then a midwife in the National Maternity Hospital, Holles Street, before going overseas to Bangladesh for three years with Concern.

'I found this very transforming,' she began. 'Being and living with the poor. Aengus Fanning told me to bring back to my own country what I had learned. But when I came back from Bangladesh, I had no answers. Coming home was a huge contradiction. The gulf between midwifery here in Ireland and the poverty of Bangladesh was very hard to comprehend. I was offered the opportunity to go back to India. I said no, and I decided to look at contemplative life. I entered the Carmelites in an open spirit and the sisters invited me to live with them for two weeks. Entering the Carmelites was like coming home to myself. I said to myself, I can do nothing until I do this. This is of service to the world. I believe that my life is given over to a contemplative search. It has a positive effect on others. It is for others.'

'Are you talking about finding a kind of energy?' I ask.

'Well,' she answers, 'you are making a journey to God and it has an effect on others. You are responding and praying for others. You are carrying in your prayers the despair and the hope of others. Not everybody is a success. What about when we fail? Where are our resources? That is where we meet God, when we fail.'

'What do you understand by prayer?'

'Prayer is a relationship with God. It is a friendship with Christ. It is a time to make yourself available to God, quietening down to be in God's presence and to be faithful to God. This has a function right now as more people want it, and are searching for something like mindfulness, meditation, a kind of a search for God. Looking back on life you might ask yourself the question, when were your God moments? When was God in the good and joyous and bad times? You might ask what is your life all about.'

'I ask myself that question quite regularly,' I respond.

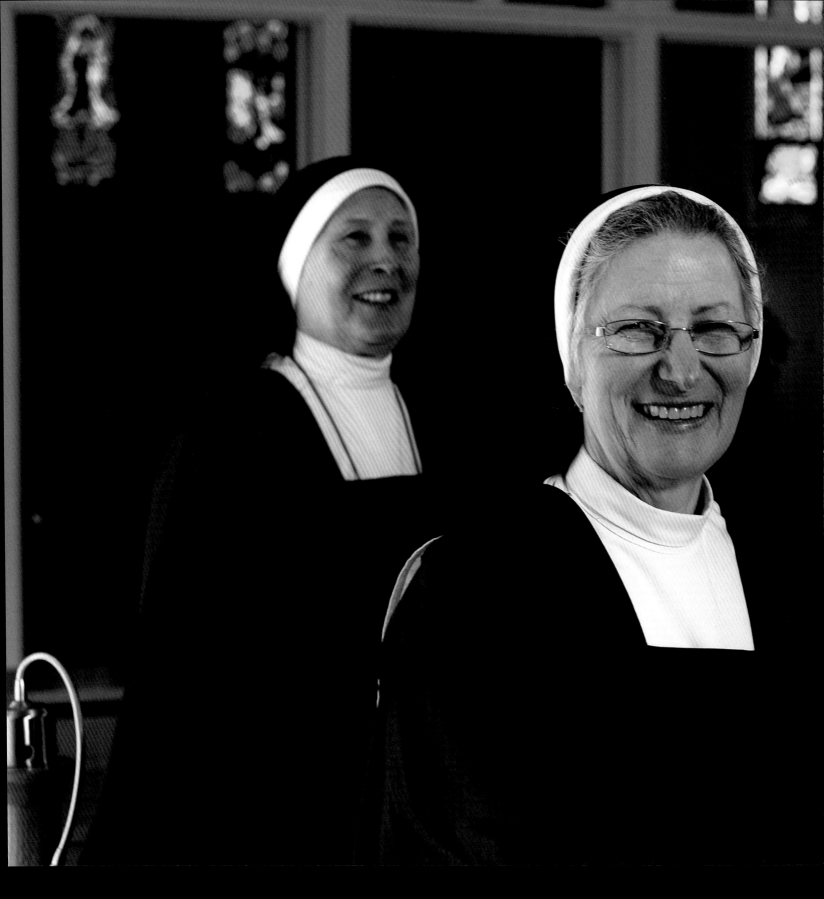

'Well, this is what my life is about. This is my cycle. My way of interpreting who I am. It begins internally for me and is not dictated by things. It is a daily search as my drive is inner, and this is reflected deeply in our lifestyle.'

'Is there nothing that you miss from our world?'

'Initially I missed the noise world. In the beginning maybe, but not now. The world changed for me. I found something deeper. This is my calling. My friends are called in a different way. They are married and single all over the world. Everybody is so busy in your world. Everybody is "on top of it", or trying to get on top of it. What exactly are they on top of? Why do we all have to be into the same game? With all our democracy, we don't have a lot of room for the dissenter.'

We are walking past Sr Gwen's donkey sanctuary. The donkeys are brown and fat. Plodding and quiet and munching on the young grass in the morning sun. Ignoring us.

'Has the Carmelite life been good to you?' I continue.

'I have no regrets. I made the right decision. I live this life in the warmth of the sisters. Women can work things out very well. We are better communicators and we are more honest. There is always evidence of disbelief. For me, it is difficult not to believe. I have been opened up to the rich material of Carmelite spirituality. Prayer, Divine Office, Mass, daily chores, personal time and space, reflection, recreation, duties, communication, spiritual reading, meals and writing. A full day.'

'Do you think the next world will be better than this?' I ask quietly.

She answers with absolute certainty.

'Of course the next world will be better than this. If I didn't think that, what would this life be about? It is my hope that it is. We are all looking for heaven. I am content. I have contentment. I don't tell people about the dark, I tell them about the way out of darkness. I meet so many marvellous people. People come to us all the time for prayer and personal needs. They slip their requests, needs, hopes and desires into a little box. We never turn them away.'

'Will the Carmelites survive?'

'The Carmelites will survive. We must respect the other. Respect, respect, always respect. When I lived in a Muslim country, I watched the ordinary people in prayer and that image never left me. They prayed in small makeshift mosques, along side streets, but they stopped during their busy days, to pray. To kneel and pray is sacred, and nobody should make fun of that.'

There it was. Said and felt with generosity, faith and grace. No judgement. I spent the rest of the day with this thought in my head, in prayer, in reflection, on my own in the chapel, and in silence at meals.

Before I left I asked the assembled nuns: 'What is the greatest quality needed to be a Carmelite?'

They did not answer me immediately. Then one said:

'I will have to think about that.'
Another:
'Faith.'
Then another:
'Many qualities.'
'Humanity.'

I said, 'I suppose it was a stupid question but I thought I might as well ask it.'

'Let me ask you a question,' said Sr Monica. 'What is the great quality needed to be a mother?'

'Love,' I said, without hesitation.

'Yes,' she said, 'and so it is for us.'

I left the Carmelite enclosed order through the simple convent door I had entered. I embraced each sister as tightly as they embraced me. I was very unhappy yet very fulfilled leaving. I had felt so safe there. I could say anything, question anything, or carry my own beliefs very comfortably within their walls. This is becoming far more difficult in our world.

Silence can teach us much more than noise or daily prattle or the awful glut of information which we cannot even store. And our world is so full of it. I think being a Carmelite is about something that actually defines love. Having been with the sisters for two days – a very short time – I came away thinking that the greatest and most necessary quality to be a Carmelite is surely selflessness. It is what the Carmelites give up for what they believe. That is their extraordinary sacrifice. I was not able to give up the radio for one night.

The Carmelites live completely and entirely outside any sense of competition. Imagine that! I cannot name anything in my personal world or my career world that is not about competition. Whether I like it or not, we all compete hourly for everything, from exams to space to personal attention.

The Carmelites don't. That is possibly why I felt such a freedom there.

Their world is also a world outside an all-invasive cynicism. We live around an intellectual cynicism which seems to pervade how we think, and even how we imagine. It is now on par with how we define intelligent thinking. It has become a kind of art form. The nuns speak of

such cynicism in terms of a constant sense of judgement of ourselves, our lives, but mostly of others. If you are naïve, soulful, sentimental, innocent, graceful, spiritual, positive, romantic, prayerful, gullible, or see the world through such eyes, there is some weakness within you. I think such cynicism is a kind of intellectual violence. It chokes freshness of response, and indeed the idea of beauty.

The Carmelites do not understand cynicism. It is not of their world. In our world we have made it into a kind of god of communication.

I left a contemplative sisterhood who were full of joy and who were content with who they were, and what they were doing with their lives. Which of us can say that? And if prayer is about human energy, they gift it to all of us every day. And we need it. I need it. ●

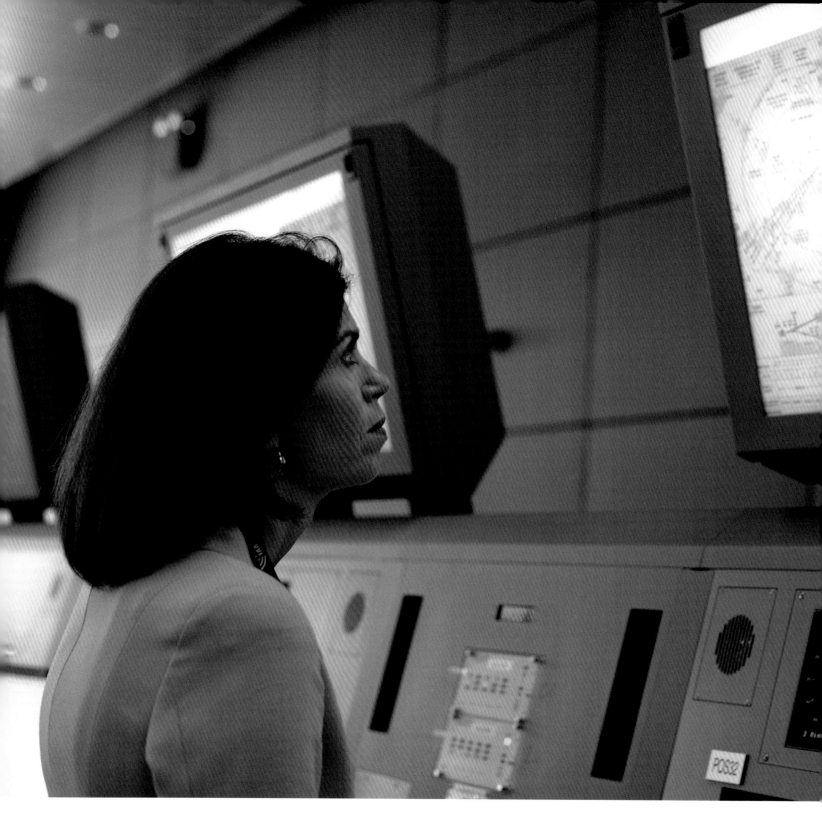

THE AIR TRAFFIC CONTROLLER

Lillian Cassin

OFF THE GROUND

"Aer Rianta are recruiting for temporary air traffic control assistants and it's for six months in Shannon. Lillian should apply," said a friend of my mother. I was to study arts but I had no passion for it. So I applied and I was accepted. I was eighteen, away from home, free and learning something different and very interesting. That was twenty-eight years ago.'

Shannon Airport is magnificent. Flights of enclosed steps, a long elevator rise, and more heavy encased steep stairs to climb, before I emerge into the middle of a windowed panoramic view. The Control Tower. The two thousand acres of green and greener land below look like an earthly heaven.

Clare and Limerick lie beneath us like a green picnic rug. The western landscape lifts and falls, broken up only by thick fir forests and low hedges. I can see for miles across the varying shades of green pastures, lime green, post office green, oily green pastures, to the dark blue of the River Shannon. The Shannon estuary drinks in the mountains and drumlins and hills, their uneven shadows thrown across its full and fast flow. This wide muted silver river meanders through the fields urged on by the strength of the Atlantic Ocean. I am on the edge of Ireland and the world. Europe, the Middle East and America await our departure, and we await their arrival.

Lillian Cassin looks like an international model. Tall and willowy. She introduces me to the tower controller and the approach controller. They are very courteous but don't have time to give me much attention. There are aeroplanes to line up, to take off, and some on their way through the clouds. I listen to them speak to pilots, guide aircraft, land aircraft, issue landing clearances, and departure clearances, without clamour. They welcome craft to Shannon Airport and speak to the emergency services who are on one of the runways picking up a dead rabbit. The responsibility of the tower controller extends in a fifteen-nautical-mile radius, so their focus has to be without fault. The tower controllers are official and mannered. They speak in a certain mystifying phraseology involving numbers and letters, distances and heights.

I look around and marvel at the power of the tower, an enormous controlled aviation space for

flight take-off, landing, speed and safety. Nothing happens without tower permission or radar permission. The aeroplanes look like toys sitting around waiting to be told when to pull back and taxi, for their journey above the clouds. I hear the pilots asking permission for take-off. They wait for the tower to respond. That is the protocol. They are finally given permission. They may take their place at the end of the long runway. The great aircraft on its way to the Middle East taxis out slowly. It turns as though on a swivel, swinging itself and its wide, stiff, metal wings around as its full body readies itself on the main runway. The controllers ignore my evident excitement. They remain official and observant and give and receive the final affirmation. The great man-made, wide-winged bird roars down the runway. It takes my breath away. It passes me by at the tower window, as the fat bulbous nose heaves slightly up, the wheels lift, and the enormous load lifts itself into the bird-filled air. It is as though I have lifted it from earth to sky in the palm of my hand and set it free. I follow its path with my eye, and in a minute it has disappeared into the west of Ireland clouds.

Through binoculars, about three miles out, I can just see an aircraft on its way towards our island from the United States of America. Its lights are flickering pins in the distance, appearing and disappearing through a thick grey sky. The approach controller is quietly guiding its aerial path into Shannon. Its lights become larger and larger as the carrier appears through the now rain-filled clouds. A big bird with no swerve, swish or dive. Its mechanical and technical direction is straight, forthright and definite. Approach control leads the silver bird into Shannon, on a daisy-chain-linked approach line. Its staged descent becoming visible over the fields and farms, over the villages and church spires, over all low hills, houses, country roads and airport buildings. Down at last towards the tarmac and tower, until finally its fat black tyres screech on the long runway. The aeroplane passes us by on its brief grounded journey to the arrivals terminal, still under the watchful guidance and direction of the tower. The passengers stare out the rounded aircraft windows, like little dolls, full of smiles and anticipation.

There are three more aircraft for immediate take-off, two international flights coming in at high-level over the next fifteen minutes, local traffic, training traffic, helicopters, small planes, charters, European flights and air-sea rescue helicopters to clear, take off and land. There is not a lot of time for chatting.

'My first air traffic control qualifications and discipline, after all my training and exams, was here in this tower at Shannon. I loved it here in the tower, especially when it was busy,' whispers Lillian over my shoulder.

I look out at the sky. It is deep and vast and never-ending. How could you possibly understand and learn what is necessary to control activity above the earth, in its unending boundaries, I wonder.

Lillian explains. 'You have to think of the airspace like a jigsaw, broken up into different sections. They all have their disciplines and boundaries. Here in the control tower you are looking out the window at aircraft landing and departing. But this is only one aspect of all the essential disciplines. The radar room down the road in Ballycasey is responsible for the overflights between Europe and North America. All of those

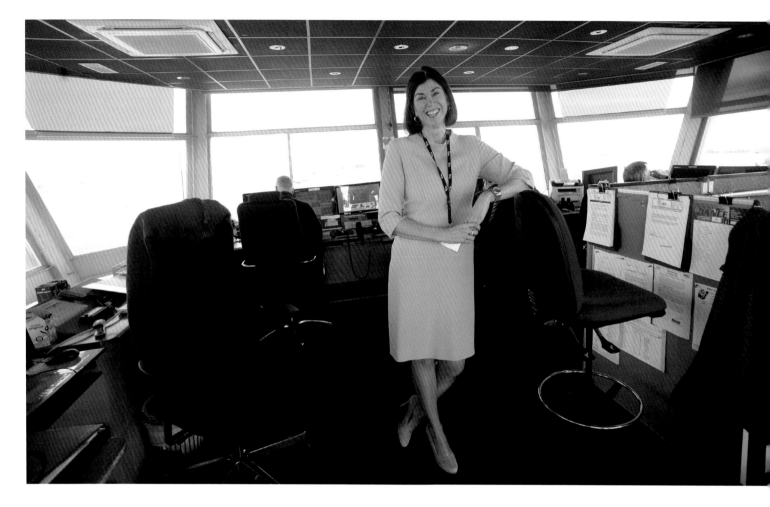

flights come through our air space because of where we are located geographically. And in between the radar room in Ballycasey and landing at Shannon, there is an approach controller here in the tower controlling the aircraft from approximately fifty miles out. He takes over from Ballycasey. And that approach is on the radar as well. All of these areas are completely different disciplines and somebody who's working in one is not automatically qualified to work in another. If you're moving from the tower to work in radar, that demands months in the training centre, and

months of on-the-job training, even though you may be a qualified controller. It is a very specific training. For every aspect of the job. Specific, general, continuation and refresher training and new European directives and regulations which have increased the duration of training.'

'Training is key,' I suggest.

'Training is key,' Lillian confirms, 'and it never stops. It is unique as well. You learn by osmosis, by assisting for years, by being mentored for years, by study, by classroom training, by exams, through the culture of this world, and after all that, when

I finally came into the live environment, I had a coach at my shoulder for months. In this job you are never alone. Ever. This is the great strength of the job.'

I sit in the corner of the tower quietly. Planes continue to land and take off. The light is fading. I think of the great responsibility of being an air traffic controller and the communication and camaraderie among colleagues intrinsic to the job, coupled with extensive training. I think of the thousands of people who depend on Lillian and her colleagues as they leave the earth for the air, without a care in the world. She seems to take it all in her stride. I feel it is overwhelming.

'What kind of person is suitable for a job such as this?' I ask. 'It is certainly not for me. You might have all the interest, the fascination and passion in the world, but there must be a suitability, a certain aptitude.'

'Yes, there is an aptitude,' says Lillian, as we walk very quietly around the tower. 'I don't know whether you can be trained to acquire it. I doubt it. When I was assisting for years, I didn't really know whether I had an aptitude or not. I was young. I didn't think about it. But I got through all the study and training. I didn't think about the responsibility or the aircraft activity, or even the visitors here to the tower, I just controlled away happily.'

We look out the tower's spherical window. The emergency crew are driving on the runway. There has been another sighting of a carcass on the tarmac, this time a bird. It must be cleared. For a moment I forget that we are in the heart of rural Ireland, in the home of wading and migrating birds who have been taking off and landing long before Shannon Airport was opened in 1935.

'It's probably a meadow pipit or a swallow,' Lillian says. 'We've had the odd pigeon, and bats. Very few seagulls – they're probably too busy eating. But bird hazard is frequent.'

The sky looks enormous around me. Beautiful and inviting. Its majestic crown of grey and white and hints of deeper blue create a painting above my head. The grey is low against the land as it always is in Ireland, sitting like a house-roof and touchable if you stretch up just a little. Plenty of room for everybody, I imagine, aircraft and birds. Or maybe not. The great transatlantic flights hover high above the clouds I'm told, but so too do the swifts who live on the wing, in the skies most of their lives, and only land to breed. It makes me wonder how aircraft manage to share the skies or even hold a safe distance from each other.

'You may think the sky is expansive,' says Lillian, 'but it is not when aircraft populate it. The job of an air traffic controller is to provide a safe, orderly and expeditious flow of air traffic, to keep aircraft safe, and to keep them separated from each other laterally five miles and horizontally a thousand feet. That separation must be maintained at all times. However, they cannot be so far apart that you will not be able to get your aircraft through your airspace in a working day. There are prescribed separations. But they have to land. And they do. You need to be able to judge the speeds of aircraft. Not all aircraft will be travelling at the same speed. You must know where the aircraft will be in two minutes' time, relative to each other and their speeds. Our endless hours of training prepare us for this. We are assisted at all times by the tools of our trade, by safety tools, by radar and by modern technology.'

I begin to become very nervous. I know now that I would never be able to imagine doing a job such as this. I found it impossible to work out train speeds and rates of arrival and departure in mathematics class. I find it even more terrifying that I would have to learn how to do it while thousands of people sit together watching television thirty-five thousand feet above the earth.

'I don't think I would have the personality for this job,' I offer as an excuse.

'The majority of air traffic controllers that I know are assertive personalities,' she replies. 'They're not meek or hanging back in the corner. It tends to be a room dominated by alpha males and females.'

'Are you an alpha female?' I ask.

'My mother was a farmer, a very intelligent and a very independent woman. She was a pillar of the community and on the boards of management of various schools. I grew up with her energy and independence. Women just got on with things, and didn't talk about it. I am sick listening to "woe is me" and "everything is so hard" and the repeated mantras about working mothers. I find it hard to be a mother and do this job. It is full-time work. I left my house at 7 a.m. yesterday morning, drove to the tower at Dublin Airport, did my day's work, left at five, and got home here to Shannon at 8 p.m. This job was utterly dominated by men. Ten years ago the balance became seventy/thirty, and that was replicated in the applicants. Now it has gone backwards. There is a class of ten training at the moment, and there is only one woman. I do regret the decrease in the numbers coming through the system now. We would be a better place with more women in the organisation.'

We leave the tower as it continues to take aircraft in, 'climb' them out, and give them over to area radar, who will manage them in the sky.

I enter the radar room in Ballycasey. It is the management of the sky and known as the 'centre'. It is cool and airy. A wide semi-circular space. The lighting is low with a blue hue illuminating the room to a twilight, and adding to the clear, clean, calm atmosphere. With banks of computer screens surrounding the room, it is as though I have stumbled into the Batcave, or the Starship Enterprise. The blue hue gives depth and clarity to the screens visual information. It is vivid and instantly readable. Essential information of air travel and its safety across our skies.

I expected the activity in the centre to be frantic. It is not. There is no clutter or clatter of conversation. It is serene. Voices are low and focussed at their sections. I pass the desk for the watch manager at the top of the room and follow the controller radar screens around the outer walls. Two big consoles sit in the centre of the room for the co-ordinator and the support staff.

I sit on one of the big comfortable chairs and look around at the national and international sky travel activity. Ninety per cent of all transatlantic traffic flies through Irish airspace, and through these computer screens. A flying world, controlled here in front of me, as twelve to thirteen hundred aircraft fly across our sky space in a twenty-four-hour period. Ballycasey is responsible for a very large area of airspace. It boasts a cohort of one hundred and forty controllers working in shifts, to cover national and international skies. Lillian sits beside me.

'Here we control the transatlantic flights between Europe and North America,' she says.

'High-level and low-level. High-level traffic are transatlantic flights flying above twenty-five thousand feet. Flights from Germany or Chicago, London or Europe that enter our airspace. Flights into and out of our regional airports such as Knock or Donegal are controlled by Shannon low-level. Leisure flights, pleasure flights, helicopters, and search and rescue helicopters are all controlled here at low-level. We watch out to two hundred and fifty nautical miles off the west coast, two hundred miles off the south coast and the same off the north coast. If you calculate this watch, it is about half a million square kilometres of airspace that is controlled from Shannon.'

Headsets, phones, buttons and screens of various sizes surround the blue-lit spaceship. It is a comfortable room that does not encourage visitors or interruptions. The controllers manage their sections, communicating directly with pilots in the sky or collectively and quickly with colleagues and teams in one turn or twist of their high-backed leather swivel chairs. Departure teams, in-the-air teams and approach teams. The radar controllers work in pairs and are orderly and professional. The radar room demands that.

I approach one of the screens and quietly sit looking at hundreds of moving moths in front of me. I have no idea what they are, or where they are going. The moving moths are surrounded by lines of latitudes and longitude. Obtuse angles, right angles, isosceles triangles and parallelograms, lie in mathematical sequences on the screen, telling some tale of travel, like the great ship maps of old. The moths move across, up and down, and sometimes out and off the screen.

'This was my second qualification,' Lillian whispers once again over my shoulder. 'Approach radar, learning how to look at these screens.'

'Is this a very different skill?' I ask, following the moths as they move.

'Yes, very different,' she replies. 'You need spatial awareness. You need to be able to look at a flat screen, which is two-dimensional, and think three-dimensionally. That is a specific skill set. And you must know where aircraft are in relation to each other.'

I am unable to read a map. Even if I put it on the ground and stand on it in the direction or map line of the motorway or road I hope to follow. I still don't know which way to go.

The radar controllers speak clearly and calmly to pilots thirty thousand feet above them in the skies, giving them instructions. Instructions are instantaneous and they are obeyed. What is said is most important, but what is read back is even more important. Altitude and pressure setting, read back, turn, descend, read back again, all communicated with a clear speaking voice. The radar controllers can detect all information on the computer screen. They can zoom in and out to see all aircraft or just those in their space. It is a huge communication operation, both human and technical, where information is passed with order and specialism from one team to another. No individual controller or team of controllers gets overloaded. Twenty-eight staff work together when the centre is at full air traffic capacity.

'Your moth, as you describe it,' Lillian tells me, 'is a label on the screen, and it gives you the identity of the aircraft, its altitude, speed and its destination. Indeed the technology has evolved and developed so much since I began controlling

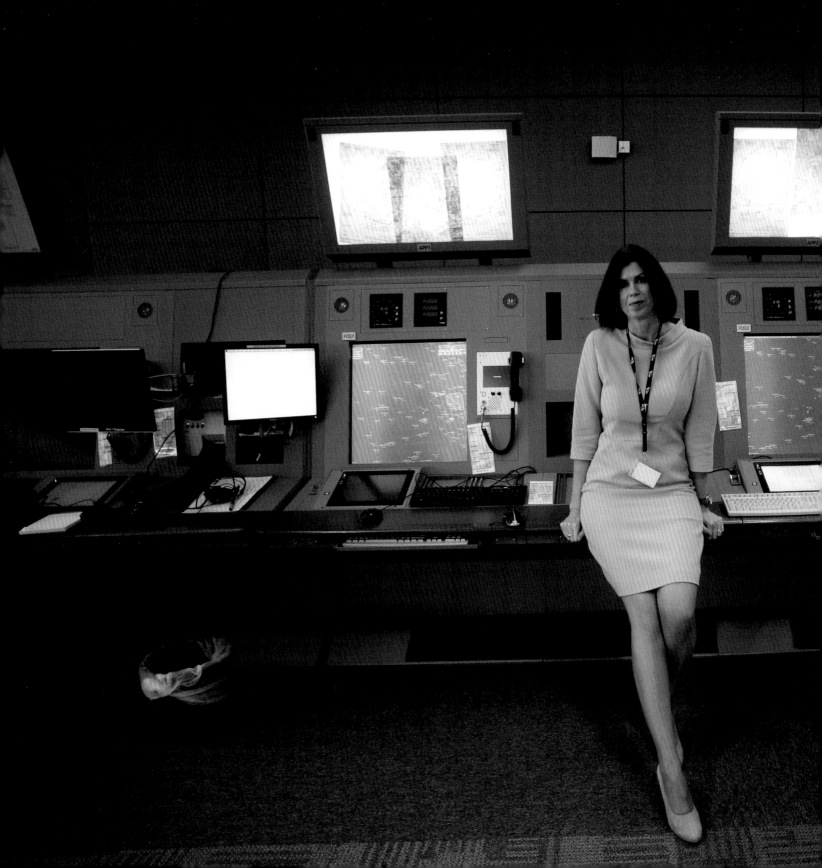

that there is now a whole raft of information available within that label, that a controller can get to and select.'

She moves the cursor over a moth on the screen. A whole box of other information opens up as though by magic. The type of aircraft, the aircraft's point of origin, its destination, its weight and its overall flight plan appear. Each aircraft's internal transponder parallels these readings. 'Technology has developed all our systems. It is constantly changing. This is a job of constant great change,' she says.

'What did you do when the technology was not so advanced?' I ask, staring at the moving screen.

'Many years ago, I had to train in non-radar environment. It is a very serious training as you had to work the ranges out in your head. But the principles were instilled in you through training. You had to rely on your head and trust your head as opposed to the technology. I don't think I ever had to use it. It was training for crisis situations. Is the technology correct and does it parallel what you have worked out mathematically? That's what you had to decide. It gave me a sense of resilience. You had something else to fall back on if you ever needed it. This training has been fazed out now. It is not relevant anymore because the equipment is so reliable and sophisticated.'

'At that stage,' I suggest, 'you could have flown your own plane, or at least built your own airport. You must have been the most qualified air traffic controller in the country.'

'Not exactly,' she replies. 'I had four qualifications, which was unusual. I had the tower, approach radar, low-level procedural and low-level radar within about seven or eight years and consolidated them with the minimum

number of hours in a particular position, in order to maintain my currency and my competence.'

'That was some achievement. You must have been unique in the world of aviation. And you are ignoring my flattery.' She continues to do so.

'My four ratings were all in adjacent airspace. They were all very complementary to each other. Having a thorough knowledge of one really lends itself, feeds and benefits the next.'

'But you left all that training and knowledge and experience for a corporate job,' I sigh.

'I didn't leave the Irish Aviation Authority. I became its corporate communications manager, covering media relations, press, and internal communications. It was the year my mother died. That might have had something to do with my decision. But it was another adventure.'

'You are full of adventures,' I say.

'This was a completely different adventure,' she replies, 'taking press calls and fielding press calls. The authority is the safety regulator and responsible for the Dublin Airport Authority and the airlines, everything from licensing to aircraft worthiness, to delayed and cancelled flights, to low-flying helicopters over my cows who are in calf, to noise pollution. Even balloons. And most importantly, translating technical language into understandable conversations.'

I preferred Lillian's world of the tower and radar, I think to myself, as we walk around the periphery of Shannon Airport.

'I know you are delighted,' she says, as we climb up into the tower once again, 'that I'm back in a management role in air traffic control for both Cork and Shannon. Who would have thought it?'

'I would have thought it,' I reply. 'And I am delighted.'

But I'm also delighted because I'm back in the tower. I look out the windows at the training craft doing circuits, Aer Lingus, United, Air Canada, Delta, Ryanair, Aer Arann and Stobart, landing and taking off on their scheduled passenger flights. There are military aircraft and executive business jets pulling back from the stand getting ready for departure. Passengers are climbing the external steps to aircraft on their way to Malaga and Faro. The whole theatre of the tower comes alive for me once again. I am caught up in the training, in the skill, in the focus, in the aptitude, in the knowledge and in the experience of this serious job. And I am caught in the romance of the great passenger hawks flying from all over the world, landing and taking off in Shannon, when they are told.

'Are you not thrilled to be back at the coal face, where you began, at management level?' I ask, thinking about my own feelings and my delight at her return. She replies in an interesting way.

'Flying into Portugal recently with my husband, Tom, and our children for a holiday, my children looked out the window and said, "Look! There's the air traffic control tower. That's where you work, Mum." I got a great kick out of that.'

'You have had such an interesting career,' I venture. 'Air traffic controller to corporate management and now back to management of air traffic control. That is some round-the-world flying circle for a forty-seven-year-old mum with three children.'

She thinks for a moment, walks over to the window and looks out on the moving world below, before responding.

'I worked hard, I trained hard and I took the opportunity. It is as simple as that. I enjoy all my

work here, every aspect of it. I like the airport, I like the atmosphere, I like my colleagues, I like the camaraderie, and I like the airport crew, ground crew and emergency crew. We all need each other in this job. We all respect each other, and we are never more than six feet away from each other.'

I tell her my aeronautical secret before I leave.

'Lillian, I am terrified of flying. And my terror has confined, if not closed down, my travel off this island to all the exotic places around the world that everybody should see and experience.'

She replies not with emotion and handkerchiefs, but with her history of training and experience in her world of air traffic control, a training and focus that has brought her and kept us safely above the clouds and beyond.

'There is no reason to be afraid,' she says. 'You are always in capable hands and your pilot is observed and communicated with at every stage of your flight journey. Let me give you an example. A flight out of Heathrow into Shannon will come over from London airspace, and be transferred to the Shannon high-level controller, who will, when the pilot requests descent, give descent, and that descent, once the aircraft goes below twenty-five thousand feet, is bringing that aircraft into the low-level airspace. The low-level controller will control that aircraft, and feed it to the next sector, which is approach control, in Shannon Tower, who will transfer it to line up for the runway, and hand it over to the tower control. It's ordered, very ordered, and very regulated, with extremely strict rules that must be obeyed. There is no need to be afraid.'

I leave Lillian Cassin to book a flight to the moon. ●

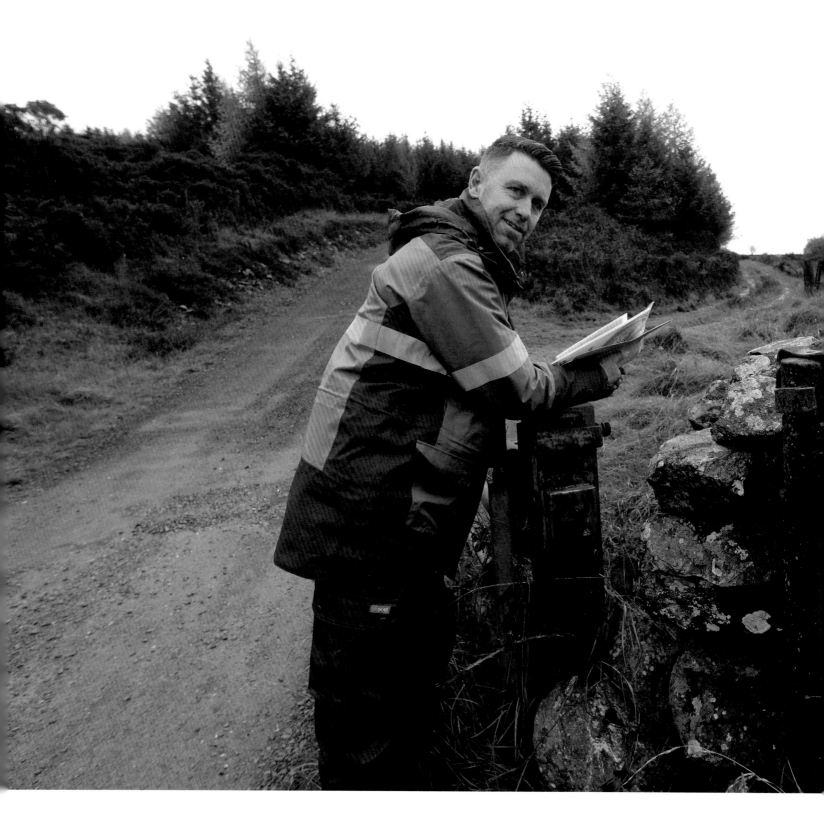

THE POSTMAN

Brendan Hughes

Brendan Hughes

FEAR AN PHOIST

And none will hear the postman's knock
Without a quickening of the heart.
For who can bear to feel himself forgotten?
W.H. Auden, 'Night Mail'

Everything comes through the post today. Even stuffed crocodiles and car doors. Just imagine it, and it can come through the post. African and Australian animal horns, stamped beer mats, slices of meat, prosthetic limbs, hotel keys, medicines, bikes, car tyres, squishy toys, luggage, alloy wheels, wedding dresses, and debutante gowns. Shop goods and warehouse goods from all over the world. Earrings, lipsticks, sunglasses, eye shadows, radios, shoes and televisions, costing less than in the shops, all coming through the post. The internet has created a new postal service.

And letters. There are still letters coming by post. Love letters, every-good-wish letters, longing-to-see-and-be-near-you letters, business letters, sympathy letters, letters from aunts who never married, official letters of debt and need, and timeless cards for every celebration and tragedy.

Everybody still loves to get a letter. I do. I have always taken An Post, the post and the postman for granted. Expected him to be there every morning. Without fail. Whatever the weather.

'When I was young, I remember being excited when surprises came in the post. I had an auntie in New Zealand. She always sent something for my birthday and it arrived on the very day, T-shirts and books and presents in different packages. I thought it was so exciting. The anticipation. And the journey the gifts made from so far away. What fascinated me most was how the whole system worked. The post trail,' Brendan Hughes tells me.

On the outskirts of Wicklow town, down the Port Road, behind large, green-painted railings, is the An Post Sorting Office for the Wicklow area. It serves Bray, Greystones, Wicklow and Arklow. Inside, a world of communication created by pen and parcel awakens. Brendan is

at his station. Waiting to be sorted for delivery are all of our letters, parcels, residential and business correspondence. They are fed into what resembles enormous cement mixers, where they get sorted out by optical recognition software. An extraordinary machine that can read individual addresses by applying a kind of paper DNA to every envelope.

Brendan is *fear an phoist*. The postman. There are twenty-four delivery routes in Wicklow, and everyone is involved in the general sorting of letters, parcels and packets. It is a militaristic operation that begins at 5.30 a.m. There can be little or no delay. If one area is delayed, then all areas are delayed. Brendan's route needs to be caged and labelled and loaded into his van. I watch him as he organises his morning's work. All the addresses are sorted into green trays or areas for delivery depending on whether you are in the van or on a bicycle. Letters are sorted to their cycle, to their walk or to their van. The route follows the sort. The route is the sequence of the sort. Brendan's route by van will span Glenealy, Kilbride, Rathdrum, Rathnew, Red Cross, Brittas Bay and Wicklow Town. He must get his post in order precisely and accurately for a successful run.

'And what about the dogs?' I ask, ignoring the complexity of his preparation. 'They are my greatest fear on the planet.'

'I'm not particularly fond of them,' he answers, as he packs his van with layers of letters and trays of parcels. 'They can be vicious and the owners always shout, "They won't bite", but often they do. I have been bitten many times, but I won't deliver if this happens, so most dogs are tied up now or they are used to me.'

I'm not convinced. But the morning run has to be done and I must be able for it, or at least brave enough to accompany him throughout.

I sit into the small van. We begin our postal-packed journey at the edge of the town, driving off into the dark velvet morning. Every early car that passes us waves in recognition. In the initial sleepy calm of the town's boundary, the delivery feels ordered and fluid. Hearing the van and watching the time, some people wait at their lace-curtain windows or front doors to receive their post. Others stand at their roadside gates; or if they are not there when we arrive, Brendan knows where to find them, down the back of the house. Everybody is delighted to see him.

The van begins to climb up hills and over night-light snow. We drive out into the countryside by the side of ditches, through gates and across mudded terrain, down tree-lined roads and past overgrown dales. The lanes are bumpy and uneven. Sitting is uneasy, and very soon the route begins to feel unending and uncomfortable. Brendan gets in and out of the van as though he is not hitting the ground nor feeling the weight of his body lift out or settle back on the seat.

He reverses the small van like a rally driver. Everywhere. Anywhere. Between trees and gates and large entrance stones. On a pin.

His reliability is unmatched. Nothing stops him delivering a letter. The long, thin avenues on which the van cannot turn, the difficult, rusty, unreachable post boxes, the high hills and enormous inclines, which make it impossible for the van to climb, he climbs and overcomes, in the slush and ice.

'I would have told most of them to come in to the sorting office and collect their post,' I say,

secure in the van and cross at the physical effort he has to make but does so, willingly.

'No,' he replies, 'I cannot do that. I would not do that.'

In the short time this morning, Brendan has been in and out of the van ninety times, with still two hundred and sixty exits to go. We have four hundred and fifty postal deliveries to make, over a fifty-mile route, which is a five-hour, non-stop workload. I get in and out of the van ten times. It is enough for me. I am exhausted. I feel a failure.

'You are young and fit,' I offer him as my excuse.

'If you were to work with me over a month, you would be fit too,' he replies, and off he goes again, running down a lane towards a hidden bungalow.

Whenever he parks the van, it is not done unthinkingly or casually, or for his convenience, despite the early morning with little or no traffic, and the roads old, bendy or secondary.

'There may be farmers around or other delivery men, and I don't want to block their work,' he says.

'Would you like some tea cake?' asks a woman who has been waiting at her red front door near the road as we park. 'I have some fresh out of the oven. I'll butter it for you. I was waiting for that letter.'

'Lovely,' answers the postman.

We eat the dark, moist cake wrapped in greaseproof paper sitting in the van. It is delicious. Hot and crumbly.

'Do many people invite you in for tea?' I ask.

'Yes, all the time. Sometimes even a full breakfast, or the best of homemade soup.'

'Can we make sure to deliver post to some of those houses?,' I say, delighting in the taste of the hot-oven tea cake.

'People are very generous when you are delivering a service. They always show great gratitude. But I cannot delay. I must keep going, keep on track, otherwise everything will be held up. I could spend the day eating and chatting, and get no work done.'

As we travel on, he tells me of the great and fast builders that raced through the Wicklow countryside in enormous jeeps during the Celtic Tiger, his little van often nearly forced into a ditch to accommodate their girth and speed. They are not there now, but he is still in his van, doing his job. It was how he began in 2002, during the boom, when An Post was recruiting and few applied because of the money to be made in construction. He applied and he got the job. The post started early and finished early, and he liked that. And he was out in the morning countryside, just like we are today.

'I loved it from the first day. I had no desire for big office jobs. I like being out in the air, seeing people, meeting people, not being stuck in a factory or a computer room.

'But this is not a job for everyone,' he says. 'There are many people who walk through the door and walk out after a day. They can't hack it.'

I hold the appropriate trays and bundles of letters and post on my lap as we drive. I am the divider of bundles at appropriate townlands, the keeper of the sorted wads for houses and farms. But it is his responsibility to deliver the post, no matter what, to the correct address on each individual envelope and packet.

We drive on through the snowed garden of Wicklow, stopping and starting at numerous gates and hedge openings. The postman disappears always from view as he walks to their doors or

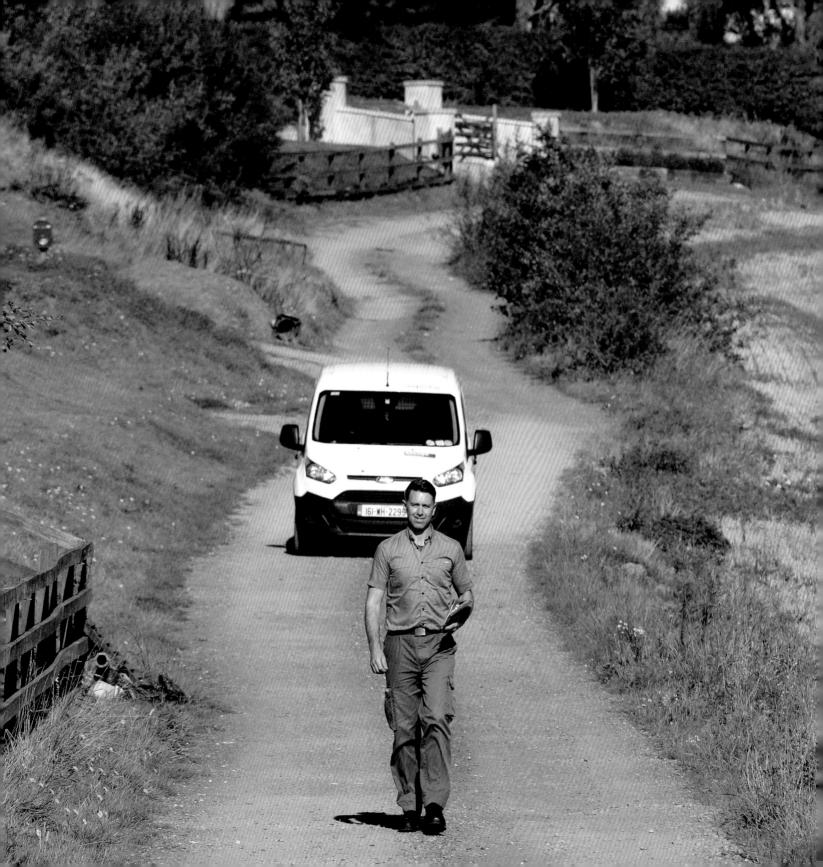

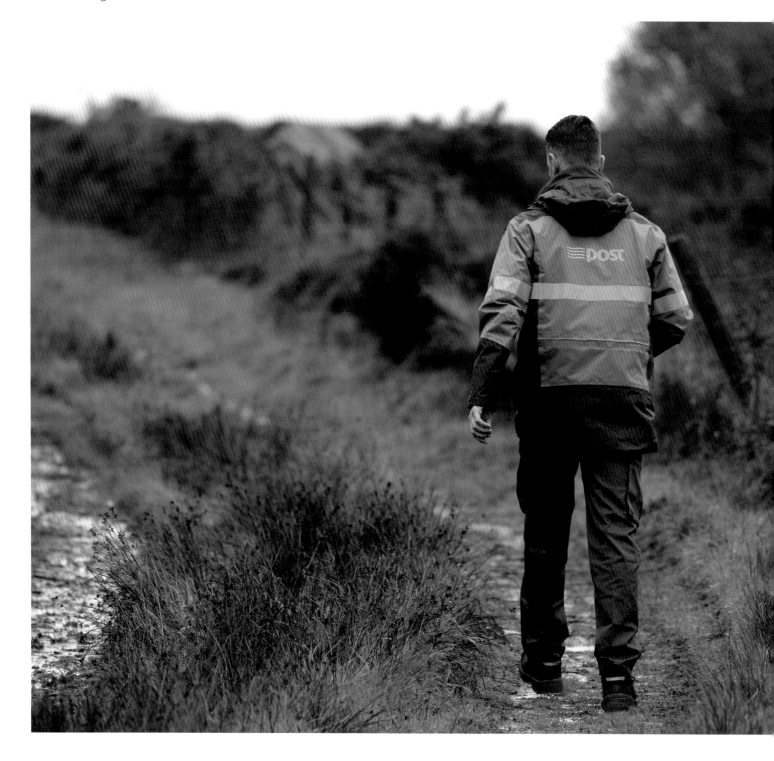

yards or through their farms, behind their gates and pillars, and alongside their gardens. There is rarely a door, entrance or letterbox near the road. The atrocious house numbering never upsets him. He knows where everybody lives. At the iron gates, old and ornate of the carriage sweeps and expensive avenues, he knows the codes to gain entrance to the properties. They trust him.

I sit in the van as he walks avenues to ivy-clad period houses and opens gates to modern monstrosities. Around me, the snow lies like a baby's christening gown across the land, laced and layered. The pointy Sugar Loaf mountain, coated in white heavy icing like a Christmas cake, lies to our side at every bend of the road. The sharp blue sea dips in and out of view and the silver-stoned lighthouse sleeps in the morning-light distance.

I have time to marvel at the handwriting on some of the letters. I feel I know the age of the writer immediately. Older people have handsome penmanship. It is recognisable always. It is looped and curlicued and usually of perfect symmetry. They were taught, as I was, to form their alphabet letters between the blue and the red lines of their copybooks. Even though some writing may be shaky with age, it is still legible.

'Do you get a sense of real communication when you see a handwritten letter?' I ask Brendan when he returns to the van.

'My memory of my aunt in New Zealand,' he answers, 'is getting her letters. Having her there in front of me in her handwriting. The memory of her was more instant.'

'There is something about the hand, something about what comes through the hand, straight from the heart, that is special,' I reply, thinking

of letters from my parents when I was away from home long years ago.

Brendan has a trained eye to decipher writing old and young, and to know exactly where each letter should go. He is able to recognise writing from family abroad, or from children who are away. His recognition is not of inquisition, but of a professional service for everybody. He knows immediately whether a letter's journey from Ireland, England or America has been prompt or reliable.

'Who lives there, and up there, and over there?' I ask, as we travel past cottages, new houses, gardens kept and wild, and holiday homes with nobody in them. They have little in common except their sleep, as the postman drops their envelopes of brown and white, of debt and love, through their doors. The postman has seen life in all its appearances and facades and always early in the morning. But it is not for him to comment or discuss. Nor does he tell me who lives where, what they do, or who they are.

'People see me every day,' he says. 'Many people become friends. You're talking, listening and inquiring and you become aware and know the lives of your customers. Trust builds up over the months and years. It's a privileged position.

'It is important to develop a bond with people. Some can be wary and very private, and it takes a while for them to respond to you. You have to be going to their homes quite a lot and then they may open up and talk. Other people just talk and don't stop for a breath about their break-ups, births, children, achievements, deaths and life stories. You must remain always private about their business, and never pass on what they tell you. That's my motto. Silence.'

But this natural geographer-postman can tell me in detail about his universe of boreens and laneways without hesitation. He has known this county as boy, man and now postman. His landscape is broken up into different routes. Townlands are defined and separated by fields and drumlins, and in an instant and around corners they come together or are divided once again by new pastures, landmarks, ancient trees, stone monuments, or meandering rivers to be freshly named.

'It's the way of the fields,' he says.

'Name some of the townlands,' I ask, as we drive through the early crisp air. And he does.

'Ballyguile More, Ballyhenry, Dunbur, Kilpoole, Tubbervilla, Blainroe, Aghowle, Castletimon, Killoughter, Knockrobin,' he recites, and the sounds of the place names lilt and fall off his lips like musical notes. A melodic harmonious tune of townlands spoken in rhythm as we drive through the garden of Ireland.

'All their names have a meaning,' he continues. 'Munduff, Ballybeg, Ballyhara, Ballinteskin, Coolbeg, Two Mile Water, Green Hill, Raheenmore, Annagowlan, Hawkstown, Kilmurray, Roscath, Killiskey, Glenmalure – all of them have stories and histories and surround my life every day. I love the knowledge of the different areas. I soak up what the job has to offer, take in everything and challenge my memory. When letters are not addressed properly, I have a determination to get to the person, to work it out, to do my best to get it rightly delivered.'

I am cold in the van, but the postman doesn't seem to notice or feel the temperature. The van does not have time to heat up with the constant opening and closing of the door at every postal drop.

'It's a cold morning,' I say.

'Not that cold,' Brendan answers. 'This van can sometimes fall to below freezing, or at other times, I drive the country with my elbow out the window enjoying the sun. I find it heart-enhancing to be out all the time watching the colours of the trees change and fall, or bud again in the spring, or people in their gardens digging and planting for the future.'

And he pulls in again for another delivery. He is some time away from the van.

'We'll have to call back there,' he says when he returns. 'We can try again later.'

'Go back?' I question, with astonishment. 'Why?'

'Well, all parcels must be signed for and there was nobody at the house, which is strange,' he replies, as we continue our journey. 'I know the family. They haven't gone far, maybe an early school run. You get to know people's habits. I might loop back around, try and deliver it later on. We always either return or leave a note, but you must try and deliver. Sometimes, I ring and arrange to bring an item out next day, or leave it with a neighbour. We have a standard and a quality to uphold. Courier companies can throw and go. We must ensure that packets find their addressee and be there, to see that they do. It is personal to me. I know the people and they know me, and rely on me. Anyway, your station must be cleared at the end of the day, everything marked, tidied, finished off, delivered or arrangements made for re-deliveries if necessary. Otherwise there would be chaos in the sorting office, and the post would not be efficient.'

'You're very thorough,' I say. 'Where did you learn that?'

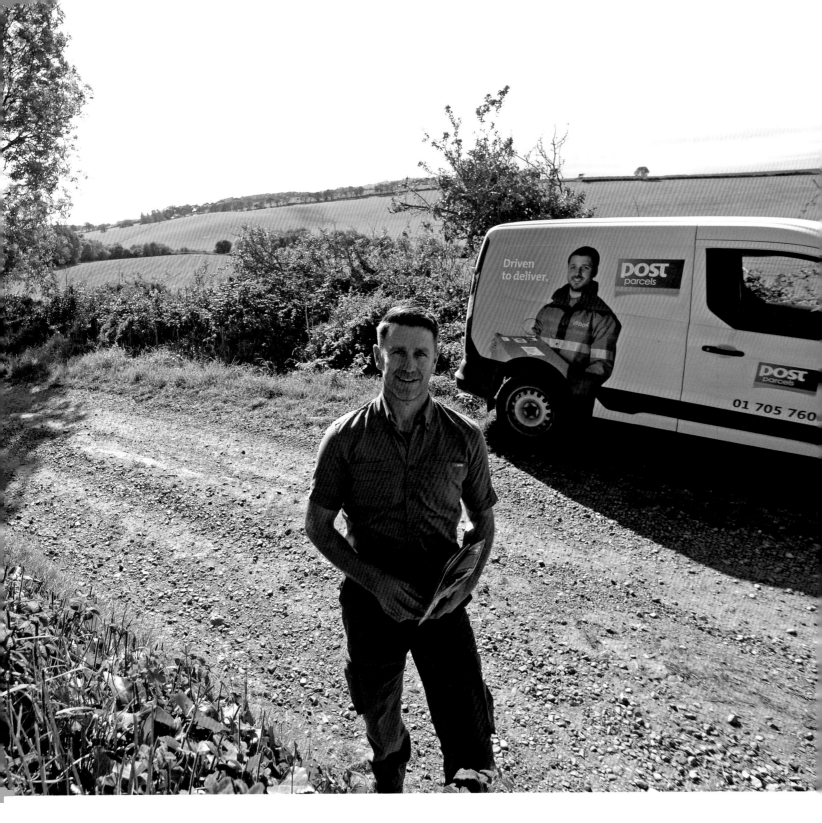

'It's part of the job,' he replies, 'a huge part of the job. I was also very influenced by my father. He was a plasterer and he worked in a factory. He had a huge work ethic and he believed that whatever you do, you must do it right. He had such pride in his work and he loved what he did. Sometimes I went with him when he was plastering. When he had finished a job, he always cleaned his work station. I never saw him out of work, he took no sick days, and was never idle. I watched him working hard for what he had. I got my work ethic from him. And I got my pride in my work from him. He died nine years ago. It's his anniversary today.'

I remain silent for a while to allow the postman remember his father with the same affection and love with which he has spoken about him. He starts and stops the van and continues to deliver his post without speaking.

I break the silence.

'Are they the kind of qualities you need to be a good postman?'

'Yes,' he answers, 'pride in your work is very important. Well, it is to me. And you have to be persistent and punctual, and be able for hard work. You also have to take care of people's items, and make sure they are not damaged. You don't know what those items or letters mean to them. They could be a world of feeling or need or comfort. You must be responsible and exercise discretion.'

We pass small farmlands, fields of sown potatoes and hopeful corn. The long clean beach at Brittas Bay sits at our side and we continue on in the thrown shadow of Powerscourt and Mount Usher's magnificent gardens.

'This is beautiful countryside and a great morning to see it,' he says, 'but behind all the beauty and the seasonal colour, I am very conscious of older people who might not answer the door or verbally respond. People who live alone will always speak to the postman. Out in the country they may not be driving anymore and see very few people during the week. Not too far from here, there are people living miles away from the town. They may be very lonely. Some of them are unable to leave their homes very often. They depend on their neighbours to call in and bring them things they need. I always bring a newspaper or bread and milk with me as they need it. I've collected prescriptions for people, changed light bulbs, car tyres, and even jump-started cars. Anyway if I can help, I will help.'

I begin to think of the certain privilege of his work. Being able to spend time with people, not machines or technology. Modern work seems to demand a screen as a friend, an identity and a reaction. We look to access and interpret ourselves through technology or the computer. But his work teaches him about human nature every day. The person, the family, the home and the letterbox. And those who live there. Old and young or alone. He is aware of the public and private breathing lives of his route. The letters of sadness, anticipation, joy, worry and regret, he will deliver and his customers will receive.

'This house has a unique way of receiving their post,' Brendan says, as we pull up in the centre of a small farmyard, on the last leg of our route. A large St Bernard lopes out towards the van, his fat pink tongue hanging down from his mouth, like a salivating ham. He pads up to our open window. Brendan places the post in the dog's mouth, and the St Bernard, with a certain gentleness and carefulness, and ignoring me, frozen in the front

seat, turns and waddles back into the farmhouse. He has been collecting the post for years.

We come back into the town's view from across the plains and landscape of Wicklow, like old pony express riders, arriving back at the Sorting Office almost at the same time as other postmen from other directions. We have delivered post and packets from all over the world. Delighted some families, saddened others, and hopefully worried only a few.

I leave the van stiff and tired. Brendan still has work to do. His station must be organised, late items sorted, undelivered post and parcels dealt with, and return routes selected. Nothing can be left to pile up in the corner.

I sit comfortably watching him. He is as energetic and even-tempered as he was at 5.30 this morning when we first met. A young man of gentle attitude and action. Calm and careful and focused on the standard and quality of his occupation. Protective of his work as though it was his family. And it is his work family,

commanding similar respect and value. I had a sense that he was dependent on the job and the job on him. This is rare. Very few of us could say that our employer would really miss us if we left. Nobody is indispensable. I'm not too sure. An Post would miss Brendan Hughes. Badly.

I remember the postman's words to me before I left. Words of a work life that we all aspire to but might not achieve. An attitude of gratitude for the best of every working-fulfilled day.

'I love my work. I don't overthink it. That's the way I am. I found a job I love. I have no problems getting up at 5 a.m. every morning. I keep my head straight and hope to be there until the end, as I have a great interest in what I do. When I was young, I was content and happy. I am just as happy and content now, as a postman in Co. Wicklow.

'Do you get a lot of post in your own door?' I ask.

'No,' he replies, smiling. 'I blocked mine up. I just bring it home.' ●